N A T I V E A M E R I C A N

EXPRESSIVE CULTURE

AKWE:KON PRESS
AND
NATIONAL MUSEUM OF THE AMERICAN INDIAN

VOL. XI, NOS. 3 AND 4

FALL/WINTER 1994

Akwe:kon Journal (ISSN 0897-2354) is
published by the Akwe:kon Press,
American Indian Program, 300 Caldwell
Hall, Cornell University, Ithaca, New York
14853. 607/255-4308. Subscriptions are
$18.00 per year. Back issues priced
separately.

CONTENTS

*Cover: Kwahu (Hopi Eagle Dance). Dan Namingha. Acrylic on canvas, 1994.
117x102cm. © Dan Namingha.*

THIS VOLUME
IS DEDICATED TO
ALLAN HOUSER

JOSE BARREIRO

Editor-in-Chief, Akwe:kon Journal

This double issue of our journal is the product of a special collaboration between Akwe:kon Press and the Smithsonian's new National Museum of the American Indian (NMAI). I am pleased to welcome to our pages a wide range of writers, and commend their efforts to interpret the great world of expressive culture found in native America. ✳ Bridging the cultural gap between the native and non-native worlds as well as the interpretation gap between cultural and research institutions and the culture-based communities is a concern shared by Cornell's American Indian Program and the NMAI. At Cornell, we have embraced the concept of the Full Circle, by which our instruction and our research is conceived, as much as possible, with a view toward understanding and helping to solve community problems. The NMAI, in its mission, presents the concept of the "Fourth Museum—the Indian communities themselves." As more communities engage in the interpretation and documentation of their own histories and cultures, native constituencies and the general public will benefit from greater access to information, and a more truthful approach. ✳ It was a pleasure to work with the team from the NMAI. Rick Hill and Fred Nahwooksy conceptualized much of the volume and got the project moving; Clara Sue Kidwell, Terence Winch, and Robin Rone contributed to the editorial quality; Caleb Strickland coordinated the business aspects; and Charlotte Heth, former director of the American Indian Program at Cornell, added her wealth of experience and reforged old links. I thank particularly NMAI director W. Richard West, Jr., for encouraging the project, assembling a good balance of rigorous scholars and energized new talents, and for leading this new national museum on the path of creativity and self-assertiveness. ✳ There is a growing regard for the conceptual and practical knowledge that continues to emerge from indigenous communities. Although under tremendous economic and political pressure, indigenous peoples increasingly represent themselves, their communities, and their cultures in national and international events. In a whole range of expressive arts, native peoples share diverse and profound world views. ✳ In keeping with the meaning of our name—"all of us"—we have found that sharing resources and skills and working together to produce a reflection of Native American expressive culture has been an invaluable experience. It has given each of us the opportunity to redouble our strength and productive capacity and to deepen our mutual sense of a transcending subject. ✳ After centuries of misinterpretation and outright denigration of Native American cultures and lifeways, it is refreshing to watch the progress of the new museum as it explores native creativity and the influence of its living traditions on contemporary American life. These creative impulses at the NMAI are evident in the willingness of its professionals to collaborate, not only with academic centers like Cornell, but directly with dozens of native communities and cultures. Long live the creativity inspired by the spirit of sharing; here's a wish and a nod to the NMAI to keep that purpose strong. ✳

W. RICHARD WEST, JR.

Director, National Museum of the American Indian

I n interpreting native cultures and peoples, the National Museum of the American Indian speaks on diverse subjects across a time continuum measured in millennia. No subject, however, deserves more attention than enduring native artistic traditions. They are important because the art native people have created represents a window into their minds and hearts. While the aesthetic qualities of native art are compelling, art communicates beyond its aesthetics. It articulates those fundamental viewpoints, ways of life, and states of being that shaped ancestral native cultures. As important, it also continues in the present to be a vibrant and dynamic fulcrum for native cultural expression. ✳ With these foundations in mind, I am pleased to join José Barreiro and the *Akwe:kon Journal* staff in presenting this commemorative issue. In this issue, we join in celebrating the opening of the new George Gustav Heye Center of the National Museum of the American Indian (NMAI), Smithsonian Institution in New York City. We also recognize ten years of cultural and scholarly publication by the American Indian Program at Cornell University—initially through the *Northeast Indian Quarterly*, and now through the *Akwe:kon Journal*. ✳ We have taken great pleasure in associating with Cornell's American Indian Program and the fine work of their staff. In addition to José, I want to thank Susan Dixon and Jennifer Bedell for their many long hours of hard work in managing the editorial and production process for this publication. I also extend deep gratitude to Tim Johnson who has served as coordinating editor for this journal. ✳ The essence of what you will discover in this publication is the thinking, reporting, and interpretation of many academic and community-based scholars, as well as program specialists, cultural practitioners, and fieldworkers. We offer our thanks to the authors who have set the context for our understanding of Native American expressive culture, and to the native people who have allowed us to share their expressive forms with a wider audience through this presentation. We have endeavored to remain true to their knowledge and practices in the way that we have presented information here. ✳ As you read and enjoy this commemorative edition, I hope you will see beyond the obvious and understand the highly integrated nature of native peoples and their cultures. It is through their daily lives that we begin to appreciate and understand more perfectly native history, art, language, and, ultimately, sheer cultural survival. ✳ Through our expressive culture forms—many of which incorporate, with an unmistakable native imprimatur, materials, techniques, and approaches associated with non-native forms—native peoples continue to address in a contemporary context the values and worldviews that have sustained them since time immemorial, and that will continue to sustain them in the twenty-first century. ✳

INTRODUCTION

Richard Hill

Most Indian languages do not have words for "art" or "culture." The idea that these concepts were separate from each other was unknown to the native people of this land. Art and culture were integrated into the daily life of the people, as were religion and economy. This holistic way of being has been called a world view—the composite beliefs that stimulate the thinking, guide the actions, and inspire the creativity of a people.

Indigenous cultures were so infused with creative expression that every individual was an artist of one kind or another. Being was manifested through the arts. The transformation of natural materials—clay, stone, wood, shell, leather, feathers, quills, copper, mineral pigments, native dyes, fibers, and bark—into objects of identity and belief were daily occurrences within the typical native home. Stories were told about the origins of things in the native universe. Songs were sung to recall gifts from the Creation. Dances were held to commemorate annual cycles of change and regeneration. Clothing was made to be both common tribal dress, and individualized at the same time. Even the houses were designed to be metaphors for the preferred way of life.

Out of this kind of life-style, the arts flourished. People remade their world with each generation. Objects of beauty and power were important carriers of tradition. Key to this is the concept that the creative process is in itself a sacred journey. Artistic ability is a gift. The individual artist has a responsibility to the family, clan, and community. Art ties the generations together. The objective of the arts is to explore the deeper meanings of the beliefs, traditions, and experiences of the people. Art is the record of the past, the thinking of the present and the hopes for the future.

With this in mind, the National Museum of the American Indian seeks to redefine the role of the arts for native people, looking at the creative process and expressive culture as experienced in the hearts and minds of the singer, the dancer, the craftsman, the elder, and the true believer. This is somewhat different from the anthropological or art historical approach. It is predicated upon the notion that cultures have always been in transition and that the idea of a "classical" period of cultural development is misleading. By looking at those aspects of expressive culture that still exist, we can see deeper into the arts of the past and learn to appreciate contemporary forms of expression. We see expressive

culture as dance, music, media arts, visual arts, theater, storytelling and oratory, and literature.

In this special edition of the *Akwe:kon Journal,* we commemorate the opening of the George Gustav Heye Center in New York City, by exploring native expressions in architecture, communication, music, dance, drama, literature, and visual arts. This publication serves to announce a new approach to understanding native cultures from within. Among our contributors we have assembled leading native voices to present a "state of the arts" overview of important aspects of native expression. We asked the writers to give a sense of where these traditions come from, what has shaped them into what they are today, and what we might expect from these expressive forms in the future. From these perspectives NMAI will present various aspects of expressive culture, not as staged performances, but as the living arts that exist within their own contexts in native communities. By no means is this volume intended to be a comprehensive examination of all major trends in each of these areas. We have simply asked our contributors to reflect on what they have seen. These reflections form the basis of the expressive culture program at the Heye Center, which features native colleagues in each of these disciplines to present their work at the new museum. Other contributors provide multiple perspectives on some of the larger social, political, and economic forces that have an impact on culture.

Expressive culture is our approach to looking beyond dance as simple entertainment, to consider the visual arts as more than an economic resource, and to look at the entire creative process as seen from a native point of view. It is a view that we believe will be inclusive. It is a view that will enable us all to see the inherent cultural value of such undertakings to the well-being of the next generation of Indians, Eskimos and Native Hawaiians and will contribute to a better understanding, appreciation, and enjoyment of native expressive culture by everyone. ✳

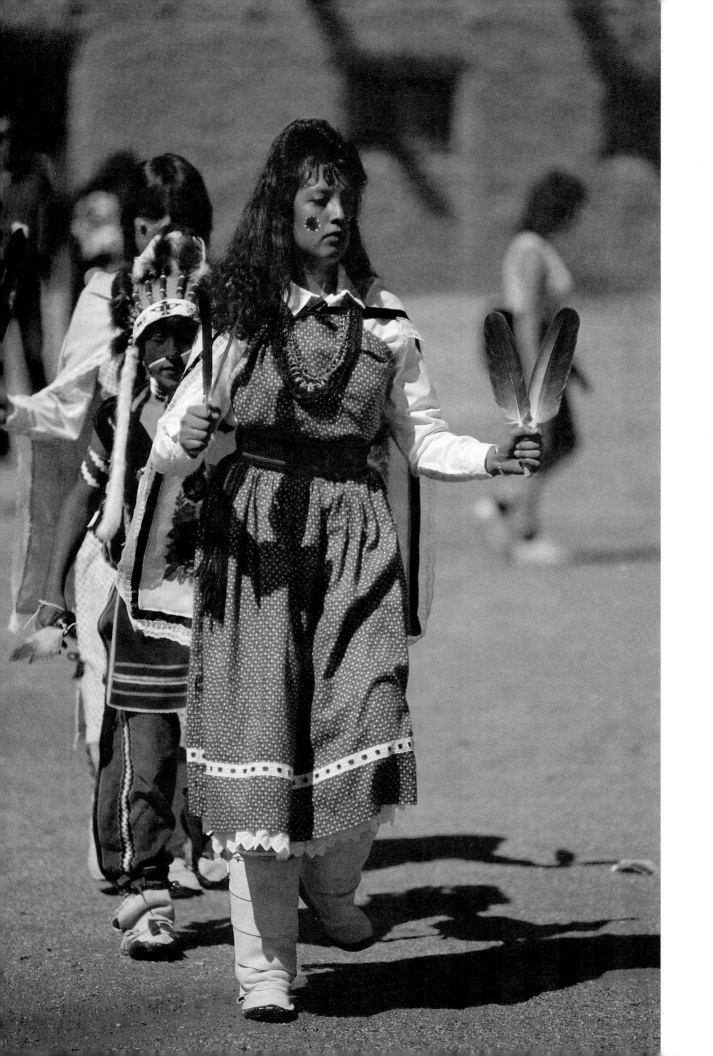

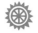

DANCE AS COMMUNICATION

Gloria Young

Dance is a visual medium of communication. Native American dancers "mediate" meaning, usually symbolically, through the mode of rhythmic body movement. The dancing human body appeals to many senses; along with visual symbolism, dancing sends subliminal signals through sound, smell, and texture, enveloping the dancers and audience in an empathetic experience.[1]

In addition to the human body, dance includes other elements that carry meaning. Dances take place in a space—a dance house, dance floor, powwow arena, stage, churchyard, kiva, or around a fire. A dance is a temporal sequence of movements. Each dance is a patterned structure of rhythm and motion. A dance is usually performed to a musical accompaniment—drums, rattles, songs, or the rhythmic clapping of hands. A Native American dance also includes an audience (who may or may not be dancers themselves), which is part of the process of communication. Furthermore, Native American dances are performed most often at a larger event containing other elements that carry meaning—the styles, the dress, regalia, and equipment, and the nondance activities (for example, a

ritual action or a giveaway). Richard West, director of the National Museum of the American Indian, writes that Native American dances "express ideas and feelings in movement while simultaneously suggesting cultural ethics and aesthetics shaped by a unique historical experience."[2]

NATIVE AMERICAN DANCES AND THE SHAPING OF AMERICAN HISTORY Contemporary dances are one of the products of complex and sometimes difficult historical experiences. From the time of European contact until World War II, Native American dances were often suppressed, and sometimes banned, by missionaries and government officials bent on assimilating Indians into the agricultural European-American life-style. The dances performed today are those that survived, thanks to the actions of dedicated people who did not merely react to historical events, but participated in their making. This legacy is evident in today's intertribal powwows. Powwows are commemorations and celebrations of choices people made during the nineteenth century on the Plains and during the twentieth century nationwide.

The most widely publicized Native American dance of the nineteenth century was the Ghost Dance, a religious movement that swept across the Plains. This movement was not an isolated phenomenon, but was part of an older web of interconnected tribal religious beliefs, individual visions and choices, and the age-old mechanisms for

BELOW: GRASS DANCER AT UNITED TRIBES POWWOW, BISMARK, N. DAK, 1991. PHOTO BY CATHERINE WHIPPLE.

OPPOSITE PAGE 9: TEWA "COMANCHE" DANCERS. PHOTO BY JEFFREY J. FOXX, NYC.

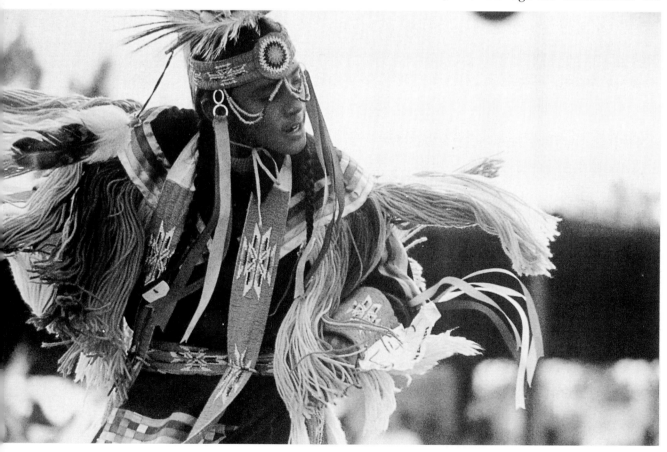

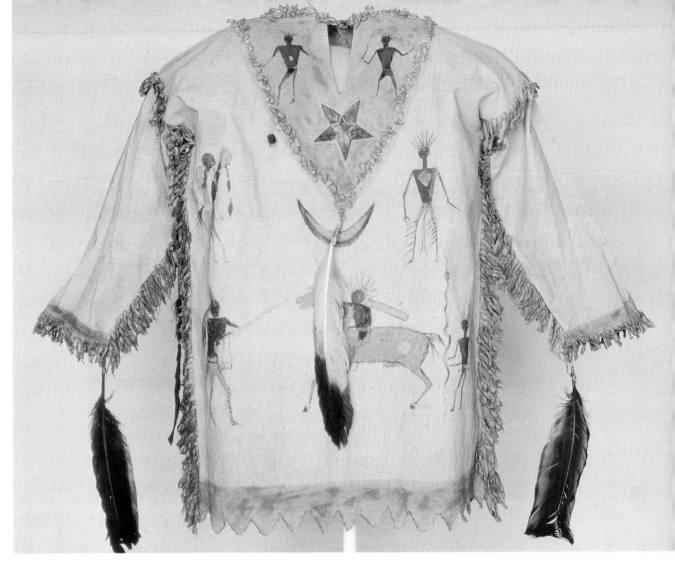

SIOUX GHOST DANCE SHIRT. PHOTO BY KAREN FURTH. COURTESY, NMAI (2.9359).

transferring dances among tribes. Its precursor was the Sun Dance, an annual religious ceremony held in the summer when people congregated to hunt buffalo.

The Sun Dance began as a religious movement, spreading from one tribe to another sometime after 1800. The Sun Dance may have begun among the Mandan and Hidatsa, and was elaborated on by the Cheyenne, Arapaho, and Oglala Sioux. It was adopted by the Sarcee, Blackfoot, Gros Ventre, Plains Cree, Plains Ojibwe, Crow, Assiniboine, Sisseton, Canadian Santee, Kiowa, Arikara, and Ponca.[3] Each group accepted the external features of the dance, but adapted the ideology and motive to its own tribal philosophy. For most, it was a celebration of earth renewal. At about the same time, another movement, the Grass Dance, was spreading among the Pawnee, Omaha, Iowa, Oto, Dakota, and Ponca. The Grass Dance probably started as a curing society dance, perhaps the Pawnee Iruska, which was said to have originated from the vision of a man named Crowfeather.[4] Sometime after 1860, the Omaha introduced it to the Sioux and, sometimes called the Omaha Dance, it spread to other tribes.[5]

The mechanism for transferring dances was gift-giving. One group took the dance, paraphernalia, and lore to another and received gifts in return. Like the Sun Dance, the Grass Dance changed as it moved from

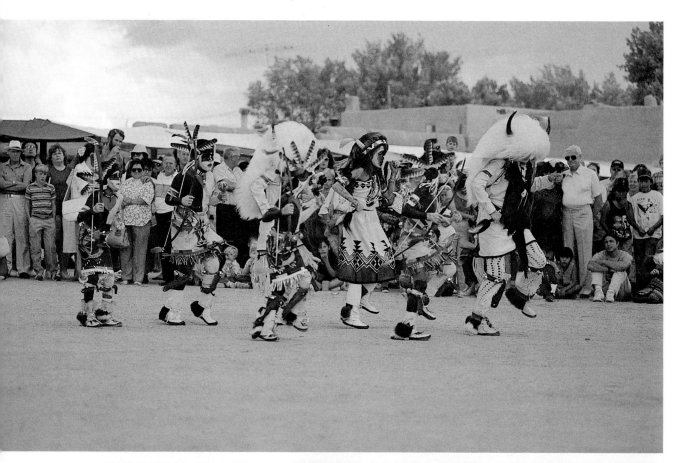

ABOVE: TEWA EAGLE DANCERS AT
THE OPENING OF THE INSTITUTE
OF AMERICAN INDIAN ARTS
MUSEUM, SANTA FE, N. MEX.,
1992. PHOTO BY LARRY GUS.

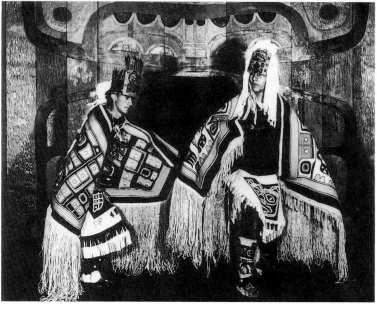

TOP: TEWA BUFFALO AND GAME ANIMAL
DANCERS. PHOTO BY JEFFREY J. FOXX, NYC.
RIGHT: CHILKAT TLINGIT DANCERS WEARING
CHIEF'S FRONTLET HEADDRESSES. PORT HAINES,
ALASKA. COURTESY, NMAI (20128).

tribe to tribe, eventually becoming a society for warriors rather than a curing ceremony. Individual ideas and choices were the catalyst for innovations, which the group accepted or rejected. By 1880, most of the Plains tribes from Oklahoma Territory to Canada had adopted the Grass Dance. In time, although the dances, dress, and paraphernalia of the warriors were retained, the dance changed again, becoming a benevolent association.

The Ponca Grass Dance, the He-thus-ka, was said to have taken on "a religious flavor" and admitted women.[6] This Ponca version was given to the Kansa, and the two tribes passed it on to the three bands of the Osage in 1885. The Osage chose to make it their major annual tribal ceremony (the In'lon-shka), abandoning other dances.[7] While the Grass Dance flourished, the Sun Dance faced strong opposition from the United States government. Tribes such as the Kiowa, Crow, and Oglala Sioux were forced to abandon it. The Cheyenne, Arapaho, Blackfeet (Piegan), Assiniboine, and Plains Ojibwe made the decision to more or less go underground, performing the Sun Dance in secret.[8] Among those tribes who lost the Sun Dance, the 1890s Ghost Dance took root first and best.

THE GHOST DANCE There was no break between the Sun Dance and Ghost Dance among the Kiowa. The last attempt to hold the banned Sun Dance, in the summer of 1890, was prohibited by U.S. Army troops.[9] But the first Ghost Dance was held later that summer and hailed as the fulfillment of a prophecy by the Buffalo Doctor, Pa-ingya.[10] Sun Dance elements were incorporated into the Ghost Dance. A feather was used to entrance dancers, just as in the feather dances of the Kiowa Sun Dance. Both the Kiowa and Oglala

danced the Ghost Dance around a pole like the Sun Dance pole.[11] In the Ghost Dance, the message of natural world renewal was intensified into a prophecy of the regeneration of the vanishing buffalo and a renewal of traditional aboriginal lifeways. This prophecy arose from individual visions of ancestral spirits, hence the reference to ghosts.

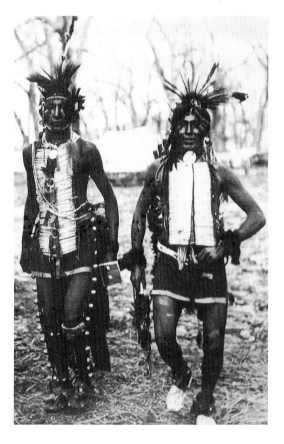

MEN IN DANCE DRESS. CROW. COURTESY, NMAI (36431).

The Ghost Dance, which spread from Nevada to the northern Plains, received a large amount of publicity among the general population of the eastern United States. Articles in newspapers and magazines predicted imminent armed rebellion by the Indians. A general panic led the U.S. Army to concentrate nearly half of its infantry and

cavalry on the Sioux reservations of the Dakotas in the fall of 1890. Confrontation was inevitable, climaxing with the massacre at Wounded Knee. Ironically, the original tenets of the Ghost Dance promised that peaceful adjustments with the whites, faithful dancing, clean living, and hard work would restore the days of Indian prosperity. There is no evidence that the Ghost Dance among any tribe had warlike connotations.

From its roots as a Paiute world-renewal ceremony, new songs and dances transformed the Ghost Dance into a classic Plains Dance. It was a four-day Round Dance for which dancers

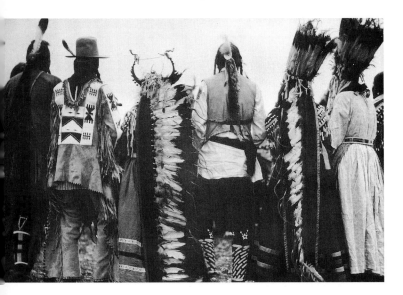

BLACKFOOT GROUP AT SUN DANCE, MONTANA. COURTESY, NMAI (21972).

wore special shirts and dresses decorated with symbols—usually stars, suns, moons, or birds—referring to their visions while in trance. The Ghost Dance was brought to the southern Plains by the Arapaho leaders Black Coyote and Sitting Bull. In September 1890, a great gathering of some three thousand dancers— virtually all of the Cheyenne, Arapaho, Kiowa, Wichita, Caddo, and Apache of Oklahoma— was held on the South Canadian River.

Commissioner of Indian Affairs T.J. Morgan visited Oklahoma Territory to assess the situation. Seeing no signs of an armed uprising, he made no attempt to ban the Ghost Dance on the southern Plains.[12] During 1891 and 1892, the Ghost Dance was taken to many of the southern tribes including the Pawnee, Oto, Iowa, Osage, Ponca, and Quapaw.[13] Each group composed its own songs and adapted the dance in accordance with its own visions. Ghost Dances were attended by individual members of tribes such as the Cherokee which did not, as a whole, adopt the dance.

Although Ghost Dances were not officially banned, the subsequent histories varied from tribe to tribe according to the Indian agents' views. After the arrest of their leader, Buffalo Black, the Oto gave up the dance altogether.[14] The Pawnee Ghost Dance leader, Frank White, was also arrested, but when he was released, he worked to transform the Ghost Dance into a religion that magnified Christian symbols. Other Pawnee leaders revived the Hand Game as part of Ghost Dance events and the old Iruska dances were revived after they were seen in visions. Blended with Ghost Dance elements, they were variously called Grass Dances or Ghost Dances. Among the Arapaho, Ghost Dance visions led to the revival of a version of the Grass Dance.[15] It was an afternoon dance before the nighttime Ghost Dances.

The Crow Dance, the Pawnee revived Iruska Dances, and the Ghost Dance all persisted into the twentieth century in Oklahoma. In 1918, Frances Densmore attended "Grass Dances" honoring World War I soldiers returning from Germany that were organized by the Pawnee in response to visions about the war and the servicemen. Kiowa Ghost Dances continued uninterrupted until 1912 or 1916.[16] These and the tribal Grass

Dances or Omaha Dances were incorporated in the annual gatherings of the 1920s, such as the Quapaw Homecoming, Osage In'lon-shka and Ponca powwow, from which the modern southern-style powwow emerged.

THE MODERN POWWOW The Oklahoma powwow was the intertribal event chosen after World War II to honor servicemen and bring together Native Americans in urban areas. Because the powwow had grown out of early intertribal movements and warrior societies, the dances it incorporated symbolized the appropriate history and values. Native Americans of the 1950s and 1960s took advantage of the post-war emphasis on national unity and the expanded networks of transportation and communication in the United States. They began to span regional boundaries to create a nationwide movement reminiscent of Plains dance movements of the nineteenth century. The southern-style powwow moved from tribe to tribe, city to city, region to region and was accepted, adapted, and transformed through individual choices.[17] Today some version of the powwow can be found in every part of the United States. There is a basic form for the powwow of the 1990s, including a certain kind of dance space, some required types of dances, and an array of music and optional dances from which to choose. Etiquette, dress and paraphernalia may differ from powwow to powwow, but a basic set of values is the foundation upon which individual choices are made. This heritage is an unbroken thread linking the present with the past. The powwow connects today's dancers not just with yesterday's survival, but with yesterday's powerful individual and tribal choices. ✳

Notes
1. Anya Peterson Royce, *The Anthropology of Dance.* (Bloomington: Indiana University Press, 1977): 192-200.
2. W. Richard West, Jr., "Introduction," in *Native American Dance: Ceremonies and Social Traditions,* C. Heth, ed. (Washington, D.C.: National Museum of the American Indian, Smithsonian Institution with Starwood Publishing, Inc., 1992): x.
3. Margot Liberty, "The Sun Dance," in *Anthropology of the Great Plains.* W.R. Wood and M. Liberty, eds. (Lincoln and London: University of Nebraska Press, 1980): 165-167.
4. James R. Murie, *Pawnee Indian Societies,* Anthropological Papers of the American Museum of Natural History 11(7) (New York: The American Museum of Natural History, 1914), 609-16.
5. Clark Wissler, *General Discussion of Shamanistic and Dancing Societies,* Anthropological Papers of the American Museum of Natural History 11 (4) (New York: The American Musuem of Natural History,, 1916), 865.
6. James H. Howard, *The Ponca Tribe,* Bureau of American Ethnology Bulletin 195 (Washington, D.C.: Smithsonian Institution, 1965).
7. Gloria A. Young, "The Dream Dance and Ghost Dance of Oklahoma," in *Songs of Indian Territory,* W. Smyth, ed. (Oklahoma City: Center for the American Indian, 1989), 18-25.
8. Liberty, "The Sun Dance," 164, 169
9. Mildred P. Mayhall, *The Kiowas,* (Norman: University of Oklahoma Press, 1962, 1971), 205-206.
10. Gloria Young, "Plains Intertribal Religious Movements of the Nineteenth Century," in *Handbook of North American Indians, Plains Volume* (Washington, D.C.: Smithsonian Institution, in press).
11. James Mooney, *The Ghost Dance Religion and the Sioux Uprising of 1890,* Fourteenth Annual Report of the Bureau of American Ethnology, vol.1 (Washington, D.C.: Smithsonian Institution, 1896), 921; Raymond J. DeMaille, "Introduction," in *The Ghost Dance Religion* by James Mooney (Lincoln and London: University of Nebraska Press, 1991), xxiii.
12. Mooney, *The Ghost Dance Religion,* 897-900.
13. Murie, *Pawnee Indian Societies,* 630-35; Mooney, *The Ghost Dance Religion,* 902; Addison Skinner, *Societies of the Iowa, Kansa, and Ponca Indians,* Anthropological Papers of the American Museum of Natural History, vol. 11 (New York: The American Museum of Natural History, 1915), 719; Alice Fletcher, "The Messiah Superstition," *Journal of American Folk-Lore* 4(1891).
14. Mooney, *The Ghost Dance Religion,* 902.
15. Mooney, *The Ghost Dance Religion,* 158.
16. Stecker 1912.
17. Young, "The Dream Dance and Ghost Dance of Oklahoma," 18-25.

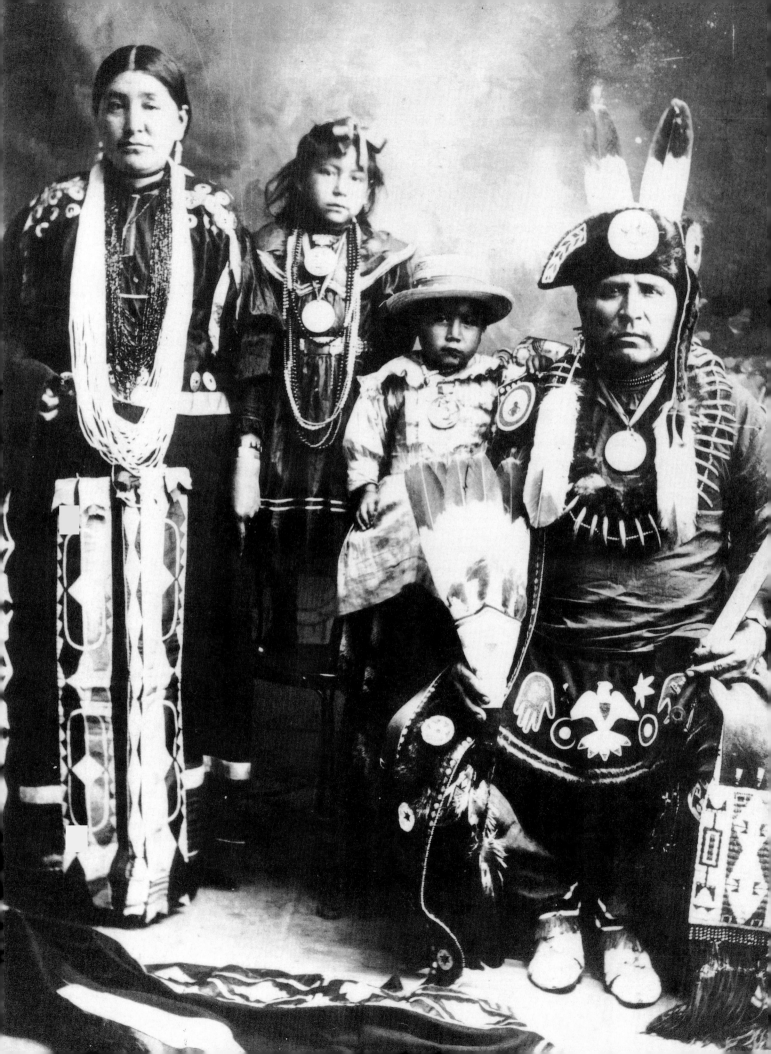

ORIGIN OF THE POWWOW
THE PONCA HE-THUS-KA SOCIETY DANCE

ABE CONKLIN

My name is Abe Conklin, and I'd like to tell you a story, as it was told to me. I will add none, and I will take nothing away. Years ago, before the Poncas moved south, there was a society called the He-thus-ka Society. Now there are many stories on how this came about. The one I like to tell is about a young man who went out on a vision quest. He was out there for many days when he saw these two buffalos about to fight. One of them was an old buffalo, and one of them was a young buffalo. The old one had a crooked horn, and the young man thought that the young buffalo was going to kill the old buffalo, but he didn't. The old buffalo won. After he had killed the young buffalo, he started dancing and singing. He came to this young man and taught him these songs and the ways of this sacred dance. It came from this buffalo, He-thus-ka. He taught him for many days, then he said, go back and take it to your people and make your own songs to go with it. So the young man did. So that's where we get He-thus-ka today. It was brought down by our elders from 1876 to 1877, when they came down to Oklahoma. They have been doing this ever since.

After the turn of the century, with the Wild West shows, they started calling this dance a powwow. It didn't sound too exciting if you called it a Man Dance or He-thus-ka. It didn't sound exciting enough because all these people were coming from the east by the trainloads to see the cowboys and the Indians. So, they said, War Dance, and that excited the people. They'd get out there and dance. And it was just a show then. But the Poncas still had their own. They called it He-thus-ka Society, and that dance they would do in a sacred way. They had a leader, and he had his committee, and he had whip men, he had water boys, and he had cooks and singers.

OPPOSITE: STUDIO PORTRAIT OF A PONCA FAMILY, PONCA CITY, OKLA., 1917. ADDITIONAL ARCHIVAL INFORMATION SUGGESTS THAT THIS FAMILY MAY BE OTOE. COURTESY, NMAI (22149).

ABOVE: OSAGE IN-LON-SHKA, GREY HORSE, OKLA., JUNE 1994. PHOTO BY GEORGETTA STONEFISH. COURTESY, NMAI (11.61394).

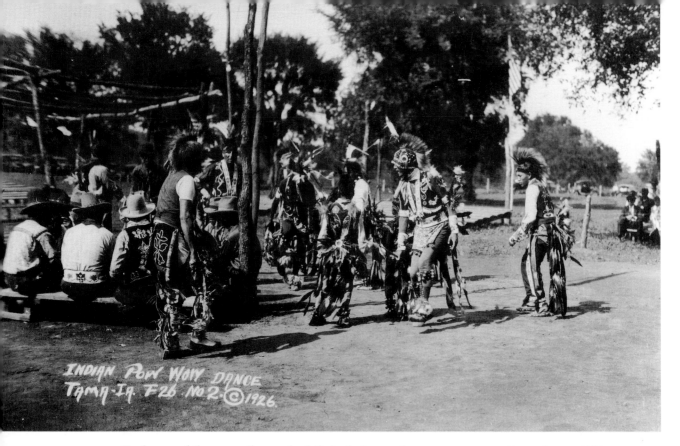

INDIAN POWWOW IN TAMA, IOWA, 1926.
COURTESY, NMAI (22568).

Each one of these gentlemen had their duties to take care of and they were there to support this leader, called the Nudahonga, which I am today, at the Ponca He-thus-ka Society.

In the dance, we come in from the east side, from the east entrance. We go clockwise with the drum because that is the way of life, the way the moon goes, the way the sun goes, the way our directional spirits go, the winds, the way of our teachings. First you have the introduction of the people that are there. You get up and introduce the people, and you thank them for coming, this is all the job of the Nudahonga. And you must remember it was hard to be this Nudahonga. In our songs it says, "this is good, but it is hard." If anyone falls short, then the Nuda honga has to dig up and make up the part that is not there. But it's a wonderful thing. This society was going on long before the coming of Christianity. We've had religion, and we've had sacred societies for many, many years, and this happened to be one of them. There were women's societies, and

there were different societies among the men; there was the Wajage Society and there was the *Pa ah ta*—a woman's organization. Then there was the warrior's society (He-thus-ka Society). This happened to be the one that survived.

After the depression came, the He-thus-ka stopped for a while, because they didn't have the finances to take care of it, but the powwow kept going on. The powwow seemed to take up most of the way, but the powwow was held in the ways of the He-thus-ka. The dancers came in the east entrance, and they had the head man and the head lady sitting right straight across from it. It kind of resembled the He-thus-ka. And the sacred instruments came into the grounds before anything ever started. Later on, they lost respect for those instruments and they just start coming in. One time, the Keeper of the Pipes, Aunt Grace Little

Warrior, said, "Since you lost respect for these pipes, and you beat me in to camp here, and I'm supposed to be the first one to come into camp, well, I'm not coming in anymore. And if you lose respect for these pipes, then you're not going to be a people anymore." But this society has been going on for a long time. The Creator has been with us, and the spirits. The grandfathers have been with us. They're protecting us, and they're looking after us, seeing that everything is done right. So that's part of the He-thus-ka that I would like to tell.

When the Ponca came to Oklahoma, they brought their sacred instruments that went along with this He-thus-ka. They made their songs to go with this He-thus-ka. They said that this was a gift of the Creator, a gift of *Wa kon da*, God. So, we treat it as such, and we respect it as such. When we go into the arena, we make everything sacred. There is nothing sacred in this world until we make it sacred. So, when we get started, we make everything sacred, and we treat it as such.

The duty of the He-thus-ka, years ago, was to look after the elders, widows, orphans, and to see that they were taken care of, that they were protected. They also protected the camp, years ago. It took an upstanding citizen of the tribe to be a He-thus-ka. They also received awards, like the crow belt. The crow belt wearer was the one that led the hunts, and led the charges. They were the bravest and the strongest in the tribe. It was like the Congressional Medal of Honor today in the army. That's what that crow belt meant. They also looked after the elders, the ones who had no sons, or no grandsons—so, they had food and a place to live. They did the same with the widows, and with the orphans. That was one of their duties. We still continue to do that, we respect our elders, we respect our widows, we respect our orphans, as they did years ago. We don't do things exactly as the old people did, but we try to keep it as close as we possibly can. These are not our rules and regulations. We're only keepers. We're only keepers of the order, of the He-thus-ka. We try to keep it like it was. We try to keep it as close to the old order as we possibly can.

We respect the drum. The drum is the main thing. The singers are out there, and they start the songs. They begin the starting song, then they go into the memorial song, and then the set of songs. Then, eventually, they get around to the giveaway songs, and the Nu da honga song, and the committee songs, and on down to the cooks' song, and the lady singers' song, whip man's song. A lot of times the head drummer will want to call a special song to help pay for the singers who have come from some distance to be with us to take part in He-thus-ka, because, you know we're not all in one place like we used to be. Then, they would come into camp in wagons and teams. I remember when they used to come to Gray Horse that way.

Other ethnic groups who want to take part with us, we let them take part with us; as long as they show respect, and honor this teaching and this way, and this faith, and this He-thus-ka. We try to do our best to uphold these things. We didn't know what to call our white brothers. We didn't know whether to call them white boys or hobbyists or…. Our old people—like my advisor, Uncle David Buffalohead called me and he said, "Sonny, these are not white boys, they are not hobbyists now," he said. "They're He-thus-ka, so call them He-thus-ka." That's what we are. We consider all who come as He-thus-ka. The visitors are still just visitors, and some people still come just to visit, but a lot of

people like to join. So, we created some organizations all over the United States so they could have a place to go and take part, whenever they feel like it. We're not prejudiced or stingy. We try to do the best we can to help our non-Indians, to teach them the best that we can. All we ask is respect, and to hold up dedication to the society, and to their own society. But the right belongs to the organization and the Poncas, because it is our dance.

Our own young ones are not paying running up and down the bleachers. And they don't have respect for this He-thus-ka, because they don't have the teaching that they should have. I stress that at the He-thus-ka, and every doings that I go to. At the benefit dances I tell them, "Years ago—you grandmothers that's here, you parents here—you remember how we used to do. Our parents used to put a blanket down, our grandparents put a blanket down. And we sit there and we watched. And we saw what was going on."

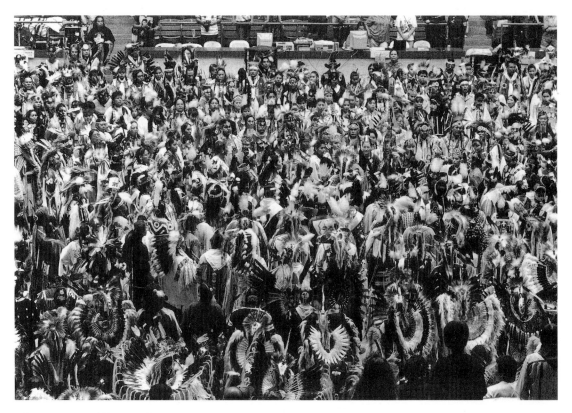

GATHERING OF NATIONS POWWOW, ALBUQUERQUE, N. MEX., 1994. PHOTO BY JANINE JONES. COURTESY, NMAI.

attention as much as they used to. We used to go to He-thus-ka, go to dance, [and] we would sit and watch. They'd put a blanket down by the bench there, and we would sit there and look. But now you have kids running all over, and they're on top of the buildings, they're

About the powwow, let's give credit where credit belongs. The Poncas came down to Oklahoma in 1877. When they got here, they celebrated that they made the trip, and that they got here with what they had. They believed in celebrating. They believed in taking part in dancing, in singing songs and being happy about it. And so, they continued this up until the Wild West shows came. Then the Wild West shows called it War Dance, and

powwow, that's where it got its name. There's no such thing as a powwow; it's a ceremony. There's no such thing as a War Dance; it's He-thus-ka. And then, just before World War II, when times started getting better, the Ponca powwow started getting better at White Eagle. We used to have cars backed all the way up the highway. I can remember when cars were way up towards Ponca City, wanting to get in there to watch the Indians, to come watch the powwow, and to look on. And that's the way they were at the Sun Dance and at the Wild West shows. Eastern people used to come by the train loads to watch the cowboys at the 101 Ranch Wild West Show. That's when the powwows started. In 1923, my nephew, Gus McDonald, went up to Lawrence, Kansas, and they had all these different tribal members come. They brought their best dancers. And the best dancer who won that contest was going to be the National Championship Dancer. My nephew won that contest. So that's the reason they call the Ponca powwow the World's National Championship War Dance. That's where it was supposed to be held.

When they started this powwow, they started it to celebrate They didn't do anything for nothing. Their children were starting school then. They [had] started building the government schools all over, including the Pawnee School, where the little ones went. They held that dance at the end of August and into the first of September, 'til Labor Day. They ended it up at Labor Day. Then, all the kids would go get on the buses and go to the Indian schools from there. That's why they held it at that time, to celebrate their children going off to school.

When the powwow was started, we had many people come from different tribes. They saw how the Poncas ran their powwow. So they went off and started their own powwow, adopting some of the ways of the Ponca people. The way the Ponca held their powwow, others held them the same way in other parts of Oklahoma. So that's where your powwow started. Up north they call it Omaha Dance. Like Grandpa Fools Crow said, "It don't mean nothing." And that's true; it doesn't mean anything because we keep the sacred part of this He-thus-ka, but we give the social part of it to the Lakotas. We gave the social part to other organizations. But they treat it in a spiritual way, which I think is good. And they can do it this way if they feel like it.

Ponca powwows elected their princess the first night, then they had the little boys' contest, little girls' contest. Then they'd have buckskin dress, then they'd have cloth dress, then they'd have the Fancy Dance. At that time, they didn't have the He-thus-ka—or Man Dance—contest. But I remember when it started. It started at Tulsa…I was there. That's where it got its name, Straight Dance. There was no such thing as a Straight Dance until they wanted to create a contest for these men that dressed in the traditional way of the Osages and Poncas. And so, they didn't know what to call it. They called the feather dancers Fancy Dancers, but these other guys were more graceful, dignified dancers, so they just called it a Straight Dance. Actually, it's not how straight you go, or how straight and tall you are, that had nothing to do with it. It was just a name of a contest: Straight Dance. Now, everybody calls it a Straight Dance. And every powwow you go to, they have Fancy Dance, Traditional, and Straight Dance. But Straight Dance is He-thus-ka, and I'd like for it to be known like that to the powwow world. The Fancy Dance came from the Poncas; they invented it. ✳

OBJECT, SUBJECT, PRACTITIONER

NATIVE AMERICANS AND CULTURAL INSTITUTIONS

Carla Roberts

Many people know the tale of Ishi, the last of his tribe, whose tenure as a museum display has been made famous by the television movie produced a few years ago. Not many people know about Minik, who was brought to the United States as a child by Arctic explorer Robert Peary.[1] Minik arrived in 1897, along with five other Inuit—Qisuk, Minik's father, and Nuktaq with his wife, Atangana, and daughter Aviaq, along with

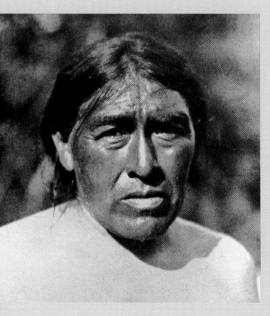

PORTRAIT OF ISHI, YAHI INDIAN, CALIF. COURTESY, NMAI (31460).

Uisaakassak, Aviaq's betrothed—because Peary had promised to return them a year later with guns, ammunition, provisions, and other goods in repayment for meteorites that Peary had removed from Melville Bay. Minik's story provides an appropriate starting point for tracing the historical relationship between native peoples and cultural institutions in North America. Within the last century, native people have evolved from object, to subject, to practitioner.

OBJECTIFICATION When Arctic explorers first came upon the Polar Inuit of northwestern Greenland, they were surprised to find that the people used metal tools. The

metal came from three meteorites known as "The Woman," "Her Dog," and "Her Tent." The explorers did not at first comprehend what they were told and searched many years in vain for an "Iron Mountain" until Peary was finally led to the meteorites by his reluctant guides. The Inuit were wary of taking him to the site because Peary had a reputation for removing objects from their lands, and they did not know of any other source of iron. Removal of the meteorites was also likely to bring bad luck, for when those among them had tried to take a larger piece to a location more convenient to their camps, disaster had befallen them. "The Woman" expected them to take according to their needs and they were uncertain what the greedy white man would do. Sure enough, as soon as he was taken to the site, Peary scratched the initial "P" into

one of the meteorites to mark his "discovery." The two Inuit hunters who left with him thought that the promised goods would compensate for the community's loss of these treasures, but neither of them was ever to return. All but two of the Inuit were to perish within six months of their arrival in the United States.

When the group first arrived in the United States, Peary allowed the curious public to come aboard his ship for a twenty-five cent fee and stare at the visitors from Greenland. Later, the Inuit were transferred to the basement of the Museum of Natural History where they lived and where special visitors were admitted to observe them. The curious public thronged to the museum and was allowed to peek through the grating to gawk at the "Esquimau." Peary brought these individuals back as "specimens" at the request of anthropologist Franz Boas. While numerous others studied and wrote about the group, Boas' published works never included more than two sentences about them. In fact, all of the museum workers engaged in this affair, as well as Robert Peary, later tried to

deny any involvement.

When Minik's father died, the museum staged a mock funeral so that Minik, with Nuktaq's guidance, could perform the appropriate rites. Unbeknownst to Nuktaq, the men performed their ceremonies for a log wrapped in cloth topped with a mask. Qisuk's body actually had been dissected by medical students and his skeleton put on display at the Museum of Natural History. Minik never knew that his father's brain was also examined and that Qisuk was referenced by name in a medical report, an unusual practice even at the turn of the century.

In later years, Minik became a regular feature at the museum, providing the anthropological staff with a wealth of information about the Inuit collections. He gives

his own account of being placed on display along with artifacts from his heritage. He was also often encouraged to perform songs or tell stories for the public. On one occasion his embarrassment was too great to perform for a group of New York school children who had come to see him.[2]

The tragic tale of Minik and his relations is just one example of the objectification of native peoples as cultural artifacts, a phenomenon that began when Europeans came

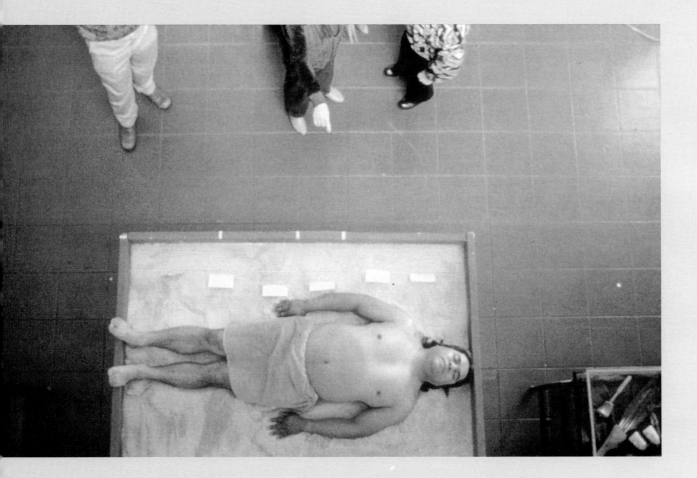

ARTIFACT PIECE, INSTALLATION, JAMES LUNA. 1987. PHOTO COURTESY OF THE ARTIST.

to this land and has continued until fairly recent times. The objectification of native peoples has also been the subject of contemporary native artists. In his 1987 installation, *The Artifact Piece*, performance artist James Luna exhibited himself in a display case at the Museum of Man in San Diego's Balboa Park, a venue normally reserved for anthropological and ethnographic display. The installation consisted of three cases, one containing the artist on a bed of sand and two others containing personal effects. Of these, one included his Motown record collection, family photographs, and other objects of contemporary life, while the other contained ceremonial objects used in Luiseno traditions.[3] The interpretive materials for the display case where Luna lay described the origin of scars visible on his body. The artist lay passively in the case for long intervals during the installation, and the sand carried the imprint of his body on those occasions when he was not physically present.[4] His commentary on objectification brought both tension and humor to a difficult topic.

SUBJECTIFICATION The relationship between native peoples and museums moved from objectification to subjectification at the turn of the century. Collections of this era, often of a "scientific" or "empirical" nature, were designed to preserve the "vanishing Indian."[5] In the following discussion, "subjectification" means the

interpretation of native cultures on the basis of Eurocentric standards and methodologies.

Collections accumulated from about 1900 to 1920 for the purpose of saving the remnants of the "vanishing native" carry with them the legacy of their time. Art was separated from life, and a collection of objects was often chosen to represent an entire people. There was no thought of a potential Indian audience, since, after all, no Indians would be around to enjoy these collections. There was also little effort to obtain interpretation from the native perspective, as the ethnographic view and the status of scientific inquiry were placed far above whatever knowledge might be imparted by an uneducated populace of individuals soon to be extinct.[6] These assumptions had strong implications for the ethics of collecting. When the focus is on preserving what would otherwise vanish, there is little concern or incentive to determine who holds legitimate title to property, or how an object had been treated in its culture of origin. Today, museums and native peoples are negotiating the

fate of many objects acquired in this way.

Sometimes museum acquisitions come from native peoples who "donate" objects to museums which, in turn, provide resources to continue traditional arts or loan their collections for ceremonial purposes. The objects themselves no longer belong to the community of origin, but to the museum. In this model, older objects would sometimes be sold to museums and replicas created for contemporary use. Museum programs might also revive a lost art by providing the environment in which to transmit skills.[7] These may be benign interventions, but are interventions nonetheless, which have an impact on contemporary cultural expressions.

Newer models of community involvement with museums move further along a continuum from object to subject to practitioner. Often, a native person is the curator, helping to select the objects or to interpret them. While not a new idea—the Brooklyn Museum planned to have a Zuni named Nick Graham assist with labeling the Culin exhibit in 1905—not all museums have embraced this

model.[8] Those who do may encounter a backlash from trustees and patrons who are more accustomed to viewing Indian art from the ethnographic perspective.

The native artist as demonstrator is a familiar sight in most museums. Usually the artist has an opportunity to discuss his or her technique and practice, and to offer items for sale to the general public. This model is intended to be symbiotic, rather than objectified. In theory all parties—the museum, the public and the artist—gain from the exchange. The artist as demonstrator can, however, slip back easily into objectification. This tends to occur when the audience is operating from false assumptions about contemporary native people, or when the museum is less than careful of the setting. A recent example can be found in the experiences of Nora Naranjo-Morse when she participated in a public program offered by a major museum.

Naranjo-Morse was asked to conduct a public program about her work as a contemporary Pueblo potter. The session was staged within historical dioramas, positioning her among the stiff mannequins that portrayed Pueblo women

among the public results in a battery of questions that can at times be insulting. While many artists view the artist/demonstrator as a job to supplement their income, the relationship can become uneasy when museum-goers discuss artists and their work as if they were not individuals who can comprehend what is being said.[10]

In all of these examples, the methods of interpretation, presentation, conservation, and perpetuation take place within the framework of the European museum model and continue to be subject to that cultural filter. Within this framework, it is often preferred that native people remain static, conforming to the ideals of the late nineteenth century. The contemporary native artist is perhaps the ultimate outsider in this pattern of relationships.

Many times contemporary native art is presented in conjunction with what might be termed "cultural artifacts." Often the intent is simply to make the public aware that Indian people have not

in traditional roles. Roped off from the audience and wearing a microphone headset, Naranjo-Morse felt strongly that she herself was on public display, and expected to perform in some fashion. Her response was to remove the microphone and sit informally on a nearby bench to engage in personal dialogue. Even in this context, Naranjo-Morse sensed she was not meeting the public's expectation of what a Pueblo woman should look like and the kind of art work she should produce.[9]

The level of misinformation

vanished. The works chosen by the non-native curators are often re-creations of "traditional" pieces. These re-creations establish distance between audiences and the modern reality of native artists and what they have to say. The public appears to prefer that distance. In Minneapolis in October 1992, approximately 2,400 people came to the opening of *Visions of the People*, a gorgeous display of Plains art, at the Minneapolis Institute of Arts. But when Atlatl's *Submuloc Show/ Columbus Wohs*, a visual commentary on the Quincentenary curated by Jaune Quick-to-See Smith, opened a few weeks later, fewer than twenty museum patrons turned out.[11] Museums and the museum-going public still hold dear their images of the pure-blooded, vanishing native.

PRACTITIONERS The Repatriation Act of 1990 and the native-controlled institutionalization of Indian culture are one hope for creating a new paradigm for museum planning. There have always been mechanisms in native communities for transmitting cultural values

ARCHAEOLOGICAL CATALOGUING WORKSHOP AT AK-CHIN HIM-DAK. SPONSORED BY SE INTERTRIBAL MUSEUMS COALITION. PHOTO BY CARLA ROBERTS.

from one generation to another. In the past, these mechanisms did not conform to the cultural community standards of what constitutes a bona fide cultural organization eligible for funding and other forms of support. In 1980, there were only a handful of native cultural "institutions"—legal entities with 501(c)(3) status and the requisite boards of directors, artistic staff, and the like. Today, there are hundreds of native-controlled cultural organizations, including urban cultural centers, First Nations arts councils, professional galleries, and emerging museums. Indian people will not re-create the types of museums that have made the untimely announcement of

their demise; instead they are creating living, dynamic, community-based organisms, often modeled on the EcoMuseum concept.

This French term from the late 1960s describes a community-generated coalition designed to secure cultural preservation into the future. It looks forward rather than backward. Program decisions come from community members who are the staff and the board. Examples include the Ak-Chin Him-Dak EcoMuseum in Maricopa, Arizona, and the Zuni Museum Project, which has an EcoMuseum in the formative stages. The Zuni have chosen a site close to the entrance of the pueblo. By its location, the museum will become an introduction or a gateway through which the visitor must pass. Within the museum, visitors will become aware of behavioral issues and how to be respectful while they are within the Zuni community.[12]

Other First Nations museums have incorporated elements of the EcoMuseum concept into their planning, often without direct awareness of the model. Native communities share with EcoMuseums the concept of collective memory as the cultural wealth of the community as well as the idea that community members are the conservators of a collection that need not be housed in a museum.

The Yup'ik in southwestern Alaska are developing a cultural center in conjunction with a Council of Elders. The elders liken the organization's function to the *qasgig*, or community house, which was the place in other times where young people acquired the skills they needed in the lifeways of the Yup'ik. The operational structures and models that are being examined for the new cultural association are a hybrid of traditional social structures and contemporary business structure. The organization will meet legal criteria for arts funding, but will be uniquely Yup'ik.

First Nations Museums will always have an interesting tension between cultural values and museum standards. Native peoples believe the old ones know how to care for objects made from natural materials, but these techniques do not

PATHWAYS OF TRADITION, INSTALLATION SHOT. GEORGE GUSTAV HEYE CENTER OF THE NATIONAL MUSEUM OF THE AMERICAN INDIAN, SMITHSONIAN INSTITUTION IN NEW YORK CITY. PHOTO BY PAMELA DEWEY, NMAI.

always conform to "museum standards." The American obsession with the right of access to information does not always translate into native culture, in which information access is based on the individual's need to know. Some information is available only after initiation into specific cultural or religious societies.

When photographic prints were repatriated from the Smithsonian to Zuni, for example, a cultural resources advisory team culled the photographs to remove those that dealt with religious issues. These prints are no longer held in trust by the museum project nor are they available for public viewing. Their significance has been discussed and documented in the Zuni language with access limited to those who need to know, in accordance with Zuni custom and tradition. While the photographs probably never should have been taken at all, their existence today assists the Zuni community, and their value to community members is enhanced by the documentation in the Zuni language, which augments oral history.[13]

As First Nations museums continue their development, they are discerning the value of internal dialogue and information sharing. A group of museums in Arizona, for example, meeting since 1989 under the auspices of Atlatl and the Arizona Commission on the Arts, in 1993 formed a steering committee and adopted the working name of the Southwest Intertribal Museums Coalition. Their meetings involve dialogue, site visits to one another's museums, and hands-on training in cultural resource management.

First Nations museums are vitally concerned with repatriation and the possibility of having collections returned to their communities of origin. Through this process, the objects amassed in earlier times and interpreted from an outside perspective may finally be put to better use in creating greater cross-cultural understanding. When this has been achieved, the relationship between Native Americans and cultural institutions can, perhaps, become more productive. ✳

Notes

1. "Remains of Eskimos to be returned to Greenland," National Public Radio's Morning Edition, July 14, 1993.
2. Kenn Harper, *Give Me My Father's Body: The Life of Minik, The New York Eskimo*, (Frobisher Bay: Blacklead Books, 1986).
3. Mason Riddle, panelist, "Critical Responses to the *Submuloc Show/Columbus Wohs*." Native Arts Network, 1992. Atlatl Biennial Conference, October 1992.
4. Judith McWillie, *James Luna: Two Worlds/Two Rooms*, INTAR Gallery, New York, 1989.
5. Ira Jacknis, panelist, "Objects Remembered: The Continuing Significance of the Stewart Culin Collection," Symposium in conjunction with the exhibition *Objects of Myth and Memory*. Phoenix: The Heard Museum, January 30, 1993.
6. Diana Fane, Ira Jacknis, Culin symposium.
7. Jacknis, Culin symposium.
8. Fane, Culin symposium.
9. Personal conversation with Nora Naranjo-Morse. I appreciate Naranjo-Morse's forthright comments and her permission to share them in this article.
10. Personal conversation with a "traditional" artist with many years of experience in museum demonstrations. This artist prefers to remain anonymous.
11. Atlatl, National Service Organization for Native American Arts, takes its name from the wooden tool used to hurl a spear with greater accuracy. The atlatl is a symbol of the organization's mission: To promote the vitality of contemporary Native American art.
12. Nigel Holman, panelist, Culin symposium.
13. Holman, Culin symposium.

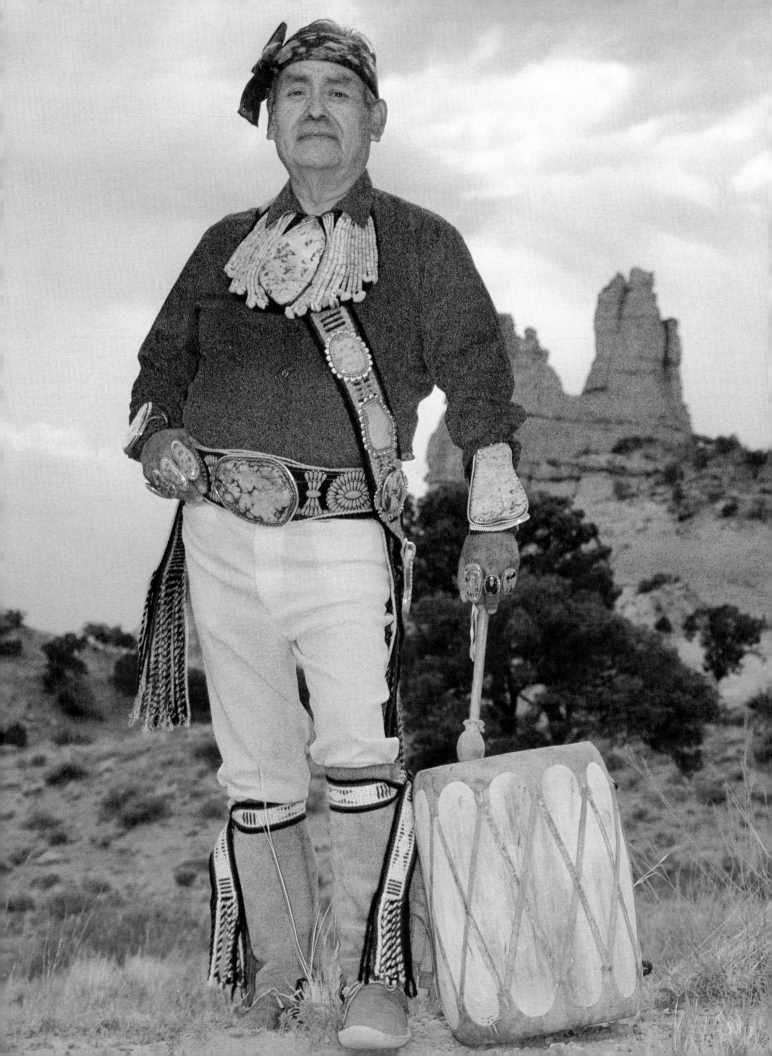

THIS PRECIOUS HERITAGE

Charlotte Heth

Native American peoples of the Americas and Hawai`i renew and reaffirm themselves on a regular basis through music, dance, ceremony, rituals, and festivals. Both music and religion are abstract and invisible, and may have secret meanings when carried out in their original contexts. Although native musical traditions may share similarities, the context in which they occur gives them individual character. For example, Northwest Coast and northern California music and dance share many resemblances, such as small steps and multipart singing, but heard indoors in the plank houses of the Kwakiutl or Tlingit they sound very different from outdoors at the open-air Brush Dance pits of the Yurok or Hupa. Even when using similar tunes and forms, different groups of singers produce different sound qualities.

Native people, the original inhabitants of these lands, identify strongly with the land, and their music reflects that reverence and appreciation. The themes of songs and chants often address the earth, the sky, sacred waters, planting and harvesting cycles, and animal spirits. Because of this closeness to the land, native

people often sing and dance in open places, their feet on the earth, in close proximity to natural water sources and away from traffic noise. The music works better this way. Native music and dance occur everywhere, however—on reservations, in cities, in rural settings, at sacred places, and at public public and joking in nature. Many native performers excel in both popular and traditional music.

After European, American, Mexican, and Canadian colonists converted some Indians to Christianity, they removed those and many other native peoples from their

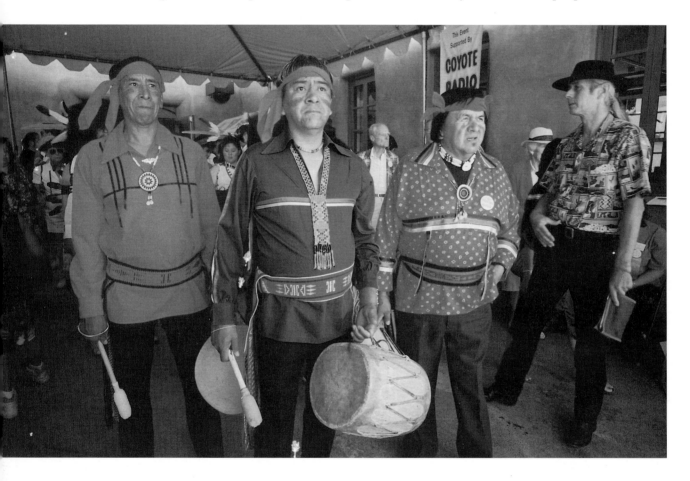

gatherings. Music and dance are parallel and interdependent. The music enables the dancers to perform, and the dancers make the music visible.

Music and dance are an integral part of life cycle events, world renewals, and ceremonial activities designed to maintain relationships with deities, supernaturals, associates, and strangers. Some events are private, sacred gatherings, restricted to initiated or birth clans, while others are

OPPOSITE PAGE 31: CHESTER MAHOOTY, ZUNI MUSICIAN AND PERFORMER. PHOTO BY JEFFREY J. FOXX, NYC.

ABOVE: DRUMMERS. PHOTO BY LARRY GUS.

homelands through warfare and other forms of coercion. Whenever the churches and colonial governments held sway, they repeatedly forbade native religious practices and ceremonies and tried to replace native

music with European music. Thereafter, singers and other religious practitioners had to hide or curtail their activities, and some of this precious heritage was lost forever.

While the United States government's ban on native religions in the late nineteenth century targeted the Sun Dance and Ghost Dance, it also affected all other religions. The Canadian government also prohibited Northwest Coast potlatches (huge native giveaway celebrations) and confiscated many beautiful sacred and ceremonial objects, such as masks, screens, drums, blankets, and headdresses, making performances difficult, if not impossible.

Today native people share their knowledge to ensure continuity of language, religion, ceremony, and customs. The leaders direct the events in native languages and follow age-old calendars and belief systems. People now make audio and video tape recordings, when appropriate, of traditional music and dance and their instructions for performance, along with stories, sacred narratives, oral histories, and ritual sayings. These efforts cap a new trend toward safeguarding and reviving older practices.

Much of the music that is best known by the public belongs to nonprivate ceremonies and social occasions, such as powwows, social dances, and staged entertainments. Other songs are used privately for medicine and curing, prayer, and other personal reasons. Many musical characteristics—length, number of repetitions, interaction of performers—arise from world view growing out of long-lasting religious and social protocols. Music, dance, religion, and ceremonial life are wholly integrated and interdependent.

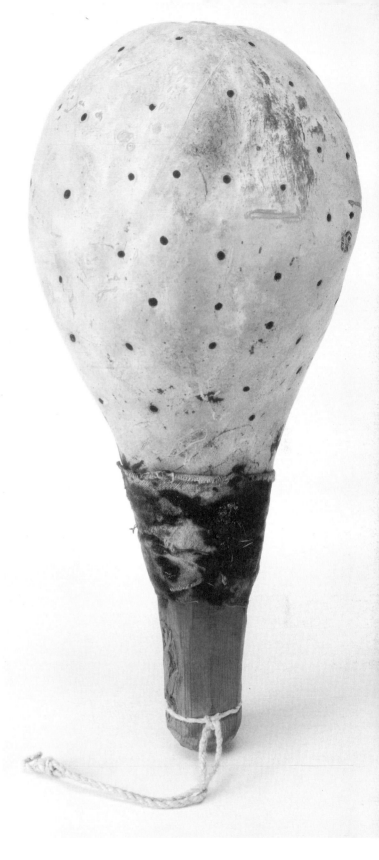

CAHUILLA PERFORATED GOURD RATTLE WITH WOODEN HANDLE, TORRES RANCHERIA, CALIF. PHOTO BY JANINE JONES, NMAI (7.2268).

ABOVE: AYMARA MUSICIANS IN BOLIVIA, 1970.
PHOTO BY JUNE NASH.

RIGHT: QUECHUA MAN IN TRADITIONAL DRESS
PLAYING FLUTE. PERU. COURTESY, NMAI (37998).

TRADITIONAL MUSIC AND MUSICAL
INSTRUMENTS In native music, the voice is
the most important instrument, with melody
and vocal style paramount. Texture (the
layering of parts to create a thick sound)
takes the place of harmony. The singers,
performing in native languages or vocables
(nontranslatable syllables), employ solos,
responsorial songs (leader and chorus taking
turns), unison chorus songs, and multipart
songs. Most singers accompany themselves
with percussion instruments.

In Hawai`i, chant, or *mele,* is
particularly important. Unaccompanied *mele
oli* are usually sung solo, while *mele hula* has
accompanying dance movements, with or

without musical instruments. Vocal style is one of the most important distinguishing characteristics of the old *mele oli,* sung for religious purposes and to recite histories and genealogies. In some of the newer styles, such as *hapa haole* songs (mixed English and Hawaiian popular songs) and songs of the *paniolo* (Hawaiian cowboys) vocal tricks, including yodeling and falsetto are common.

Common musical forms are short, repeated songs and song cycles (several different songs sung in sequence). They often have duple (2/4, 4/4) meter and pentatonic scales (five non-duplicated pitches in an octave). Melodies usually descend throughout the songs ending on the lowest or next-to-lowest pitch; songs are vocal, with rattle, drum, or other percussive accompaniment. Rare solo instruments, such as the flute and Apache fiddle, have recently been revived.

Historically, Great Lakes and Plains singers played small, shallow drums in unison, to accompany their own singing. At the end of the nineteenth century, after they adopted the large drum, singers began playing together around a single drum—now the common practice at powwows. In the southwest pueblos, men play together on large cylindrical or kettle-shaped drums, each holding his own instrument.

Unique to North America is the water drum. It is constructed from a small container, partially filled with water for tuning, covered with a moist, soft, stretched hide, and beaten by a single person with a hard stick. Eastern Indians (for example, Iroquois, Cherokee, Creek and others), the Apache and Navajo, and members of the Native American Church (a native peyote religion, widespread in North America) are its primary users.

Various rattles and scrapers add to the texture of the music. Vessel rattles are globes, cylinders, or irregularly shaped containers enclosing pebbles, fruit seeds, or other noisemakers, fixed to a handle. Strung rattles are fastened to sticks, hoops, hides, or textiles, and held by or attached to the bodies or clothing of dancers. Notched-stick rasps or scrapers, wooden box drums, bullroarers (a plaque attached to a string and whirled in a circle), flutes, whistles, musical bows, fiddles, split-stick clappers, and pairs of clapping sticks are less common.

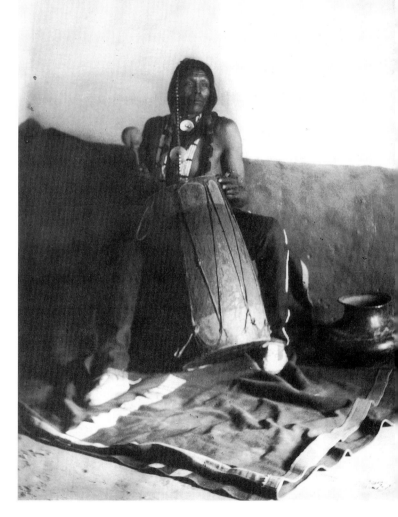

DRUMMER, SANTA CLARA, N. MEX., CA. 1910. COURTESY, NMAI (31754).

INNOVATIONS Stringed instruments, such as the Apache fiddle (made from a mescal stalk) and musical bows, found in various cultures, are early examples of innovations in Native American music beyond percussion instruments. After European contact, native people rapidly adopted stringed instruments such as guitars, fiddles, and the like, especially in Latin America, Hawai`i, and the Mexican and French-Canadian borderlands. In Eskimo (referring here to the many Arctic peoples called Yup'ik, Inupiat, and Inuit), Northern Athabascan, Plains, Pueblo, Yaqui, Papago, Metis, Ojibwe, Pima, Choctaw, and Cherokee cultures of the twentieth century, fiddle-guitar music and country dancing are widespread. In Mexico and Latin America, instrumental "band" music enhances many native events.

Early missionaries, recognizing that native people loved music, began to capitalize on that interest. Often the native people entered the missions to learn the new songs, became Christians, and started to translate and compose their own hymns. Tlingits began singing in harmony after Russian colonization, and Cherokees excel in the "Southern" harmonies of their neighbors. The harmony in both Christian and popular Hawaiian music is also based on hymn style (himeni). Now, native churches provide a place for worship, a meeting place for Christians, and a locus for singing.

PLAYING THE HARP IN ZINACANTAN, CHIAPAS, MEXICO. PHOTO BY JEFFREY J. FOXX, NYC.

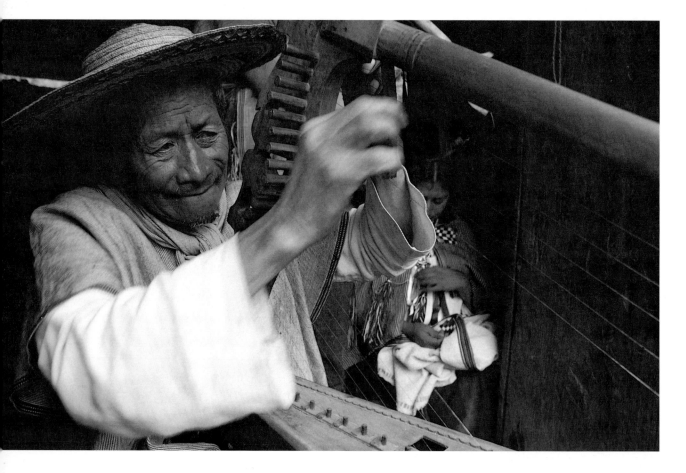

HOPIS SINGING CHRISTIAN HYMNS AT A
MENNONITE CHURCH IN ORAIBI, ARIZ. PHOTO BY
LARRY GUS.

In the 1990s, traditional singers and dancers frequently perform away from home at fairs, receptions, conferences, rallies, museum and school programs, and even the American presidential inauguration of 1993. Native choirs and bands are popular in schools. Their repertoire encompasses Western art and popular music, Christian music, and indigenous music in new choral or band arrangements. Professional musicians perform in many styles, including classical, jazz, country, folk/protest, contemporary, rock, rap, and New Age, blending tunes with mainstream rhythms, instruments, and styles. Popular dance music of the Indians of southern Arizona and northern Mexico rely heavily on European dances like polkas and schottisches with guitars, button accordions, and saxophones as the featured instruments. Native Americans, like other Americans, will sing or dance to whatever catches their fancy. Native musicians are both modern and traditional, and music pervades their lives. *

MUSICAL SYNTHESIS

INDIGENOUS VOICES PAST AND PRESENT

Elaine Bomberry

For the last three decades, native musicians have been fusing traditional music with contemporary forms, including folk, blues, pop, and more recently rock, country, reggae, and hip-hop. In North America, musicians such as Buffy Sainte-Marie, Floyd Westerman, and Paul Ortega have long incorporated folk and blues into their art, and groups such as Robby Bee & the Boyz from the Rez from Albuquerque, New Mexico, and 7th Fire Band from Ottawa, Ontario, Canada, are blending rap, reggae, and rock to create their own genre-bending music.

This synthesis began to grow strong during the 1960s, when folk and protest songs were at their peak. Buffy Sainte-Marie, Floyd

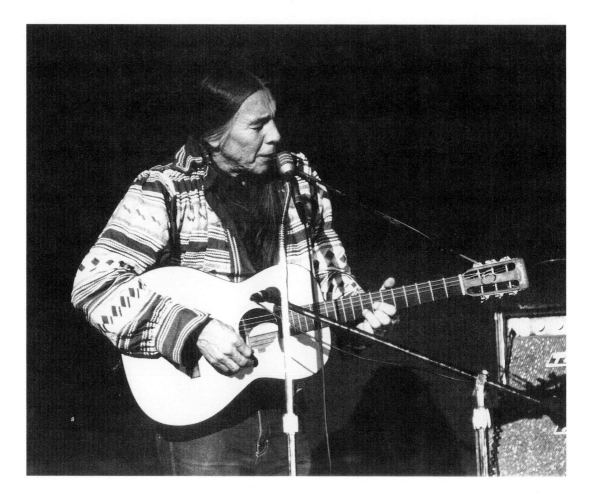

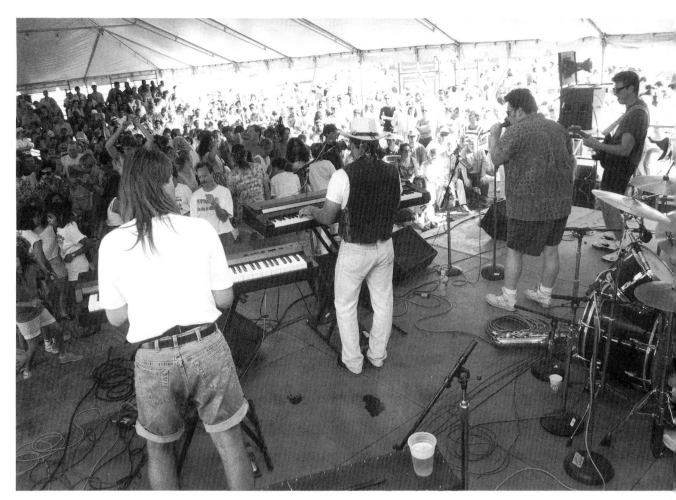

OPPOSITE: LAKOTA TROUBADOUR AND ACTOR
FLOYD WESTERMAN. PHOTO BY TIM JOHNSON.
COURTESY, TURTLE QUARTERLY.

ABOVE: THE CHANGING SOUNDSCAPE IN INDIAN
COUNTRY IS REPRESENTED BY MUSICIANS LIKE THE
ONONDAGA BAND, "WHITE BOY AND THE WAGON
BURNERS," 1992. COURTESY, SMITHSONIAN
INSTITUTION, OFFICE OF FOLKLIFE PROGRAMS,
NEG. NO. 92-7368.32.

Westerman, and Paul Ortega were among the first Native American musicians to blend native music with other forms to create songs that addressed the injustices faced by native people throughout North America. Often, the musicians themselves faced injustice. Just as Buffy Sainte-Marie was beginning to come into her own as a musician, she and other performers, including Eartha Kitt and Taj Mahal, were banned from the White House for their political positions. Nevertheless, she became the first Native American musician to land a major recording contract. Floyd Westerman, one of Sainte-Marie's contemporaries, wrote and sang some of the first native protest songs, including "Custer Died for Your Sins," "Wounded Knee," and "BIA Blues." Paul Ortega blends blues music with Native American lyrics. Ortega, who sings in Mescalero Apache and in English, says that "most Indian songs get to the heartbeat…I started to realize [that I had to] get to the heartbeat…that's where my blues came from."[1]

Music can also heal. John Trudell turned to music and poetry following the death of his wife, two daughters, and mother-in-law

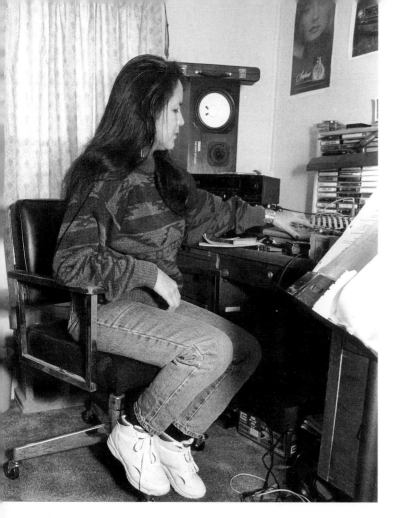

ONEIDA SINGER JOANNE SHENANDOAH IN HER STUDIO IN ONEIDA NATION TERRITORY, N.Y. JOANNE HAS PERFORMED AND RECORDED THROUGHOUT THE U.S., CANADA AND EUROPE. PHOTO BY MILLIE KNAPP. COURTESY, TURTLE QUARTERLY.

in a trailer fire. Trudell's politically conscious poetry attracted the attention of musician Jackson Browne, with whom he began to collaborate. This partnership resulted in Browne's producing Trudell's release, *Johnny Damas and Me,* a fusion of traditional and contemporary sounds. Trudell views mixing traditional native music with other styles as an act of survival. "The whole American trip is to keep the Indians in the past—to deny us a present...then we have no future. When I see...indigenous peoples experimenting with the electric sound and the traditional sounds, to me this is...a natural survival thing that comes from the people."[2]

Native American musicians have been influenced by the rise of hip-hop and rap styles. Robby Bee & the Boyz from the Rez have combined hip-hop, traditional music, and dance tracks in songs that deliver powerful messages to Native American youth. They also hope to counter stereotypical images of Native Americans through rap, which they view as an extension of the storytelling tradition. The group's lyrics are an eclectic mix, including references to Chernobyl, the Exxon Valdez oil spill, and Native American role models such as Jim Thorpe and Mary Crow Dog.

The 7th Fire Band embraces a similar amalgamation of musical styles. Their release, *The Cheque Is in the Mail,* incorporates rap, reggae, traditional Native American music, and rock with lyrics that reflect many of the down-front political and social concerns affecting Native American communities. The CD's title track observes, "A woman beaten smashed in head/Lord only knows when her children been fed/Look down the road, there's children sniffing glue/Only escape from nothing to do." Another of the band's releases, "Long Hot Summer in the Great White North," uses sampling techniques to mix with music soundbites from radio and television interviews with the major figures in the Oka Crisis of 1990, a land dispute between the Mohawks living at Kanesahtake in Quebec, Canada, and the neighboring white community of Oka. The dispute, which centered on the white community's desire to clear a pine forest and move a cemetery to build a golf course, soon escalated and factionalized the communities.

The melding of traditional native music with contemporary stylings has resulted in

indigenous music reaching a wider audience, and a growing interest on the part of non-native people in indigenous music. Joanne Shenandoah, who is Oneida, sought permission from the Confederacy Chiefs of the Oneida Territory in New York to sing and record an Oneida song that was remixed into a dance track. The result, "The Nature Dance," became a favorite at clubs in Germany. In the United States, the December 1993 issue of *Spin magazine* featured an article on Native American musicians Tom Bee and Robby Bee, a father-son team. In Canada, the Innu singing duo Kashtin sold 225,000 copies of their debut release. The two sing in their native language, which is spoken by only 10,000 people on the northern shore of the St. Lawrence River in Quebec.

Canada is among the countries leading the way in bringing indigenous music into the mainstream. Canadian *Spin* magazine has featured Inuit singer and songwriter Susan Aglukark on its cover, and Much Music, Canada's equivalent to MTV, has produced two one-hour specials on native arts and music. These programs, "Real Roots: The Native Perspective" and "Different Drums: World Indigenous Music and Arts" were aired in six countries. Canada has sponsored many music festivals showcasing native performers including Native Beat 1 and 2, the Second Annual Three Fires Music Festival, the Muddy River Music Festival, the Earth Spirit Festival, Real Rez Bluez 1 and 2, and Aboriginal Voices: The Concert Series. In 1993 ,the Canadian Academy of Recording Arts and Sciences (CARAS) accepted a proposal made by Buffy Sainte-Marie, Shingoose, and Elaine Bomberry for the creation of a category for aboriginal music in the Junos, CARAS's annual music industry awards (The United

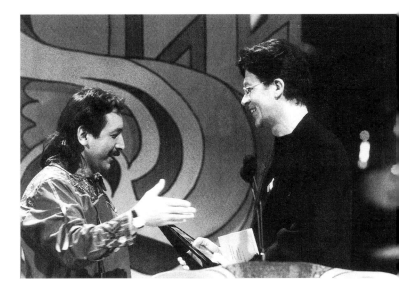

CREE MUSICIAN LAWRENCE MARTIN, LEFT, RECEIVES A CANADIAN JUNO AWARD FROM PRESENTER ROBBIE ROBERTSON, 1994. COURTESY, ELAINE BOMBERRY.

States counterpart, the National Academy of Recording Arts and Sciences, which awards the Grammys, does not have an equivalent category). In 1994, the first Juno for "Music of Aboriginal Canada" was awarded to Lawrence Martin, a musician who mixes Cree lyrics with traditional and country music.

Native people are reclaiming their voices, largely through music and the arts. More work remains to be done and the need for growth and diversity is pressing. We need to produce, market, and distribute our own music to the mainstream, and train our youth in all aspects of the music industry. Indigenous musicians and artists need to work together to increase appreciation and understanding of our musical traditions. ✳

Notes
1. Paul Ortega, "Horizons Series," National Public Radio, October 1992.
2. John Trudell, "Horizons Series," National Public Radio, October 1992.

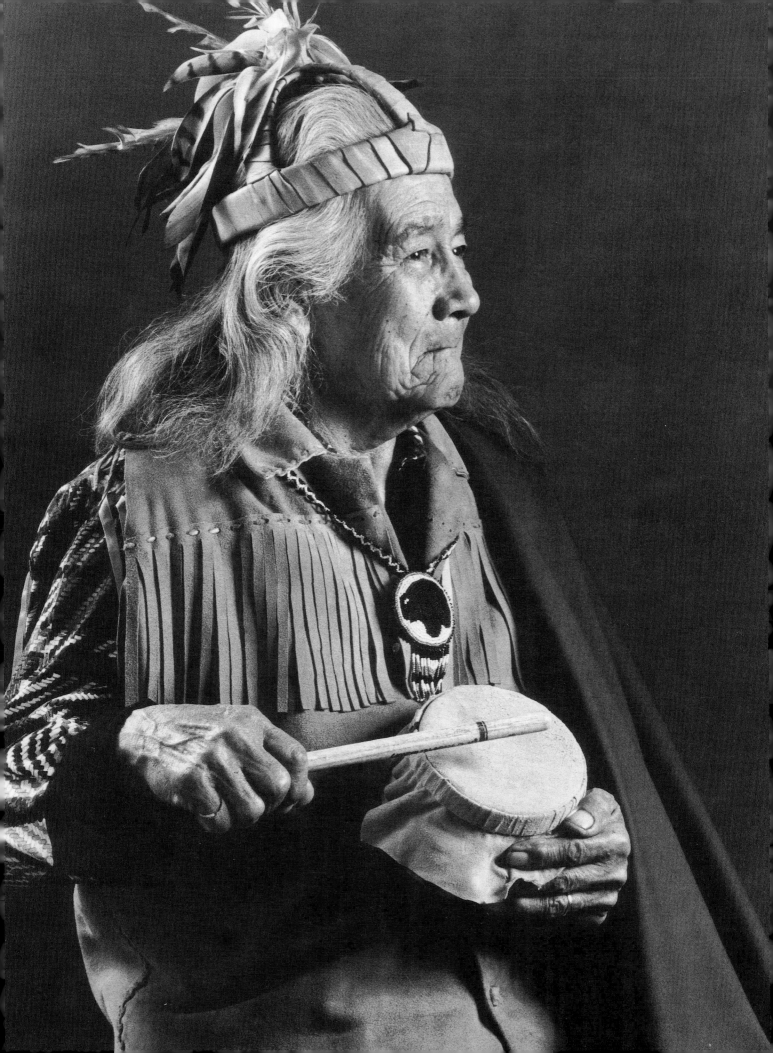

DRUMS AND TURTLE RATTLES
IROQUOIS MUSIC

John Mohawk

The Iroquois, known to the English of the seventeenth century as the Five Indian Nations and, after 1722 as the Six Nations, are composed of five member nations: Mohawk, Oneida, Onondaga, Cayuga, and Seneca. The Tuscarora Nation joined this Confederacy in 1722. They refer to themselves as Haudenosaunee—People of the Longhouse—and their aboriginal territories are located in the North American Eastern Woodlands from the watershed of the Genesee River in what is now Western New York State to the Champlain Valley in Northern New York and south to the country of the Susquehanna (or Conestoga) Indians of Pennsylvania.

Iroquois music is described as similar to that of other Indian peoples of the Eastern Woodlands, including other peoples of related languages known as Iroquoians (for example the Wyandot and Cherokee nations). In the opinion of at least one of the scholars of North American Indian music, Iroquois music more closely resembles the music of the Plains-Pueblo area than does the music of any other eastern Woodlands group.[1]

Mohawk Chief Richard Maracle of Six Nations of the Grand River, within Ontario, Canada, holds Iroquois water drum. Photo by Tim Johnson.

The music is described as constructed mainly of "…undulating melodic movement, relatively short songs (some as short as ten seconds) the use of forms which consist of several short sections with interactive and reverting relationships, relative simplicity and asymmetry in the rhythmic organization, and, perhaps the most distinctive feature, antiphonal and responsorial techniques and some rudimentary polyphony including, possibly, imitation and canon."[2]

Iroquois musicians use relatively few instruments: two sizes of water drum (one of which is used almost exclusively in a sacred ceremony), drum sticks, bark rattles, horn rattles, turtle rattles, striking stick, and gourd rattles. Flutes are also used in sacred ceremonies, but not in public performances or social dances in the traditional context.

Many of the contemporary traditional Iroquois song sets were either borrowed from or inspired by other Indians and adapted to the Iroquois style. Among such songs (actually sets of songs, which can amount to thirty or more verses) that oral tradition holds are the Corn Song, the Rabbit Dance, the Round Dance, the Eagle Dance, the Cold Dance, and the Alligator Dance. These "borrowed" songs (and dances) are evidence of the significant cultural exchange between Indian peoples in the distant and recent past.

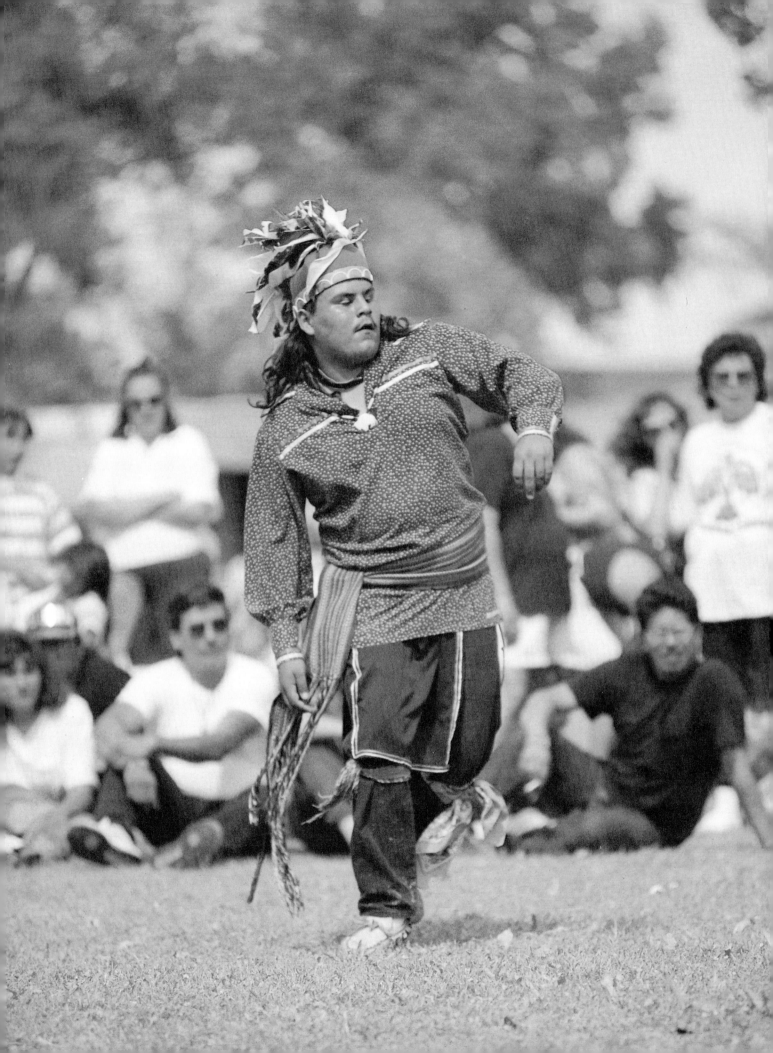

ABOVE: COW HORN RATTLES. PHOTO BY FRED NAHWOOKSY. COURTESY, ONEIDA NATION MUSEUM. LEFT: IROQUOIS DANCER. PHOTO BY JEFFREY J. FOXX, NYC.

The Round Dance, and the Rabbit Dance, for example, were acquired from Plains Indians within living memory, while the Eagle Dance appears to derive from the Calumet Dance and probably was acquired from Indians south of the Great Lakes during wars of the eighteenth century.[3]

A significant portion of Iroquois music revolves around the grand cosmology of the Iroquois and its ritual re-enactment. The Great Feather Dance (accompanied by turtle rattles), the Dream Song of the Two Uncles (the Bigheads), the Personal Thanksgiving chants (to which there is no musical accompaniment other than voice and hands), the Face Dance Songs, the Dream Song of the Creator, the Song of the Husk Faces and a host of other sacred ceremonials performed at the Midwinter Festival (at many other minor festivals) are done in association with the Great Peachstone Game. These and other songs form the foundation of the ceremonies that celebrate the creation of the world with Ceremonials of Thanksgiving, symbolized most clearly by the Great Gamble (the Great Peachstone Game). Life on earth is viewed as a product of a benevolent Creator's dream and plan, and human beings are encouraged to

give thanks for their good fortune with songs, dances and feasts. The symbols of this unfolding creation are told in a cosmology known variously as "The Myth of the Earth Grasper" or "The Iroquois Cosmology," and a second and much later oral tradition known as the "Code of Handsome Lake." (Handsome Lake was a Seneca prophet whose visions, revelations, and prophesies entered the Iroquois country in 1799.)

Ancient Iroquois traditions explained the origins of songs in legends. The songs of the Bear Dance, for example, are said to have been provided by a bear spirit, and the songs of the Pigeon Dance from pigeons.[4] Indeed, the Iroquois explanation for the inspiration of a number of songs and dances, including several of the major sacred ceremonies of the Iroquois longhouse, are found in legends, including *Change A Rib* and the long sacred ceremonies that are held at night.

Iroquois singers are often masters of a significant body of music. Ethnologist William N. Fenton thought that Allegany Seneca singer Chauncey Johnny-John's knowledge of Iroquois music approached "a thousand verses of two score ceremonies and social dances."[5] Music is one of the cultural elements that sustain a people's identity, and traditional Iroquois believe that as long as they continue to have their language, dances, and songs, they continue to be Iroquois. ✳

Notes
1. Bruno Nettl, *North American Indian Musical Styles* (Philadelphia: American Folklore Society, 1954): 36.
2. Nettl: 33.
3. William Fenton, *Songs From the Iroquois Longhouse: Program Notes From an Album of American Indian Music from the Eastern Woodlands* (Washington: Smithsonian Institution, 1942): 2.
4. Jeremiah Curtin and J.N.B. Hewitt, eds., "Seneca Fiction, Legends, and Myths," in *Thirty-Second Annual Report of the Bureau of American Ethnology* (Washington: Govt. Printing Office, 1918): 658-666.
5. Fenton: 5.

ARCHITECTURE AS A WAY OF LIFE

Duane Blue Spruce with Richard Hill and Fred Nahwooksy

We are deeply influenced by the spaces in which we live, work, and go to school. Buildings have a character of their own and that character affects the ways we learn and interact. For Native American communities, architectural design was the primary form of the expression. Basic architectural design decisions, such as

building orientation, configuration, or selection of building materials were typically driven by cultural beliefs. Native buildings were designed to foster the beliefs and traditions of the community. All native design, whether in clothing, ceramics, ritual objects or architecture, provides a sense of place and well-being and brings a feeling of unity within the community and continuity across the generations. The aesthetics of native architecture reflect the very identity of the people and serve as a visual reminder of community values.

Changes in Indian homes and community facilities over the last two centuries have altered Indian relationships to the land and to their families. More important, these changes have had a negative impact on the native sense of place. In the past, Indian homes seemed to grow out of and blend into the environment, while also

serving as family, ritual, and community centers. Since the imposition of other forms of housing, many Indians have been forced into homes that create a sense of poverty, dislocation, and cultural decay. Only recently, with the emergence of Indian architects and new federal attitudes, has that process begun to reverse to the benefit of the Indian family.

TRIBAL MUSEUMS LAUNCH A NEW ERA OF ARCHITECTURE

Throughout the last two decades a new style of architecture has marked a return to cultural relevance. Ironically, it was the construction of tribal museums in the 1970s that forced the issue of symbolic architecture

to the forefront. Since community cultural facilities had to visually represent community values, building designs became a metaphor for the world view of the people, and recalled traditional architectural features.

The first tribal museum to gain attention for its architecture was the Indian Pueblo Cultural Center in Albuquerque, New Mexico. The design of the center was inspired by Pueblo Bonito— one of many structures located in the ancient site of the Anazasi community at Chaco Canyon. Like Pueblo Bonito, the center is a curved multistoried structure facing toward and embracing an open plaza. From above, the building looks like a rainbow.

Inside, the center houses museum exhibitions, a conference center, restaurant, craftshop, and curatorial offices. Today, the center serves as both a major tourist facility and a center for the pueblo governance.

This structure was followed by other tribal museums such as the Seneca-Iroquois National Museum in Salamanca, New York, which has sacred wampum belt designs incorporated into the exterior brickwork; the Makah Museum in Neah Bay, Washington, which recalls the cedar longhouses of the Northwest Coast peoples; the Yakama Cultural Center in Washington State, which uses the design of their traditional

mat-covered lodges as the central design theme of the museum; and the Native American Center for the Living Arts in Niagara Falls, New York which is designed in the shape of a turtle, the Iroquois symbol of the earth. In these cases, form follows the native tradition of a relationship to nature that is transformed into a symbol that is understood by all tribal members. Since then, more

IMPORTANT EVENTS AND SACRED ICONS WERE OFTEN DEPICTED ON THE BUFFALO HIDE OF THE EXTERIOR TIPI COVER. NATIONAL ANTHROPOLOGICAL ARCHIVES, SMITHSONIAN INSTITUTION, NEG. NO. 1471-A-1.

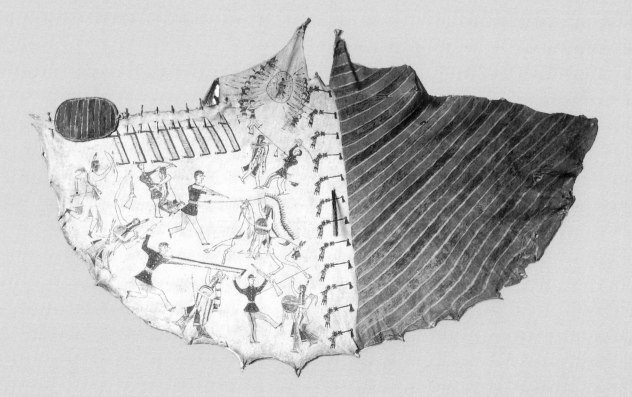

and more native communities have incorporated tribal symbolism into their architectural designs in order to make the building an artistic statement of shared values.

CHANGES IN THE INDIAN HOME

To better understand how architecture can serve a cultural need in native housing, we need to examine the underlying attributes of Indian architecture of the past. Native religions and world views are often categorized as "earth-based." While it is very evident in the rituals, oral histories, and contemporary arts of Indians, it was less evident in the style of homes and community buildings on most reservations around the country. Symbolic architecture, or even culturally relevant architecture, could not be seen in Indian Country.

How was the most significant visual evidence of Indian thinking removed from the daily lives of Indians? The introduction of the single family log cabin, the development of the frame house, and the involvement of the federal government in Indian housing and tribal facilities, resulted in huge changes. For most Indian communities, that change has

been irreversible. Yet Arapaho Indian architect Dennis Sun Rhodes began to explore what he calls "Amerindian architecture" specifically designed to meet unique Native American space needs, with a focus on cultural identity symbolism, and architectural heritage icons from the historic art of the respective tribes. In his design of tribal museums, community facilities, and Indian schools, Sun Rhodes has brought forth a new style of architecture where the building itself is a symbol, as in the Native American Center for the Living Arts.

Since much of the government approach to satisfying its responsibility to Indians has been predicated upon a "basic needs" approach, Indian cultural concerns were often ignored. The solutions offered by the government were based upon

THE FEDERALLY FUNDED CONVENTIONAL HOUSE OFTEN DID NOT FIT INTO THE LANDSCAPE LIKE THE OLDER INDIAN DESIGNED HOMES. THIS 1961 SCENE AT FT. APACHE AGENCY SHOWS THE CONTRAST WITH THE OLDER APACHE HOUSE ON THE LEFT. NATIONAL ANTHROPOLOGICAL ARCHIVES, SMITHSONIAN INSTITUTION, NEG. NO. 55,143.

suburban models and sheer economics, not upon cultural relevance or the promotion of a native world view. Frame houses appeared in small clusters all across the country, since these mini suburbs were efficient to build and practical to wire for phone and electrical service. These developments often contradicted traditional settlement patterns of building orientation and extended family relationships.

Recently, the Department of Housing and Urban Development (HUD), has been rethinking its own approach to Indian housing. Under the leadership of Don Nessi, HUD, along with the National Endowment for the Arts, sponsored a series of design workshops during which Indian architects and engineers sought local Native input into rethinking homes for Indians. Using design charettes, teams of professional designers in cooperation with local artists, tribal planners and traditionalists experimented with reincorporating cultural values into home design.

As a result of these workshops a new organization, called the American Indian Council of Architects and Engineers (AICAE) was formed. Its mission is to replace suburban planning models with architecture more relevant to Indian lifestyles. While making inroads into many areas of community and commercial facilities, the HUD requirements have made it difficult to stray from the suburban norm in Indian housing.

The Indian architects identified several aspects to consider in Indian architectural design, including the use of historical attributes of the traditional architecture of the community, cultural components of design reflecting community or clan identifiers, sensitively applying symbolism from historic art traditions, understanding land use and social organization so as not to violate spiritual traditions, site planning to minimize environmental impact on the land, vegetation, and other natural resources, use of open exterior spaces to promote community interaction, and culturally-relevant planning to help the native family take ownership of and pride in their communities.

The principals of AICAE have formed the Native American Design Partnership, comprising American Indian and Alaskan native-owned architectural and engineering practices in order to compete for larger architectural and engineering projects. The Partnership includes leading native professionals such as Charles Archambault (Gros Ventre), Fred Cooper (Salish/ Shoalwater Bay), Gilbert Honanie Jr., (Hopi), David Sloan (Navajo), and Lou Weller (Caddo/Kaw). Together, they have collaborated with Polshek Metcalf Tobey and Partners of New York City to design the new Cultural Resources Center for NMAI, to be opened in 1997 in Suitland, Maryland.

Their purpose was to create a building using Indian design principles that is integrated into the landscape, provides a welcoming environment for Indian scholars, professionals, and researchers, and creates a proper home for the one million objects, 100,000 archival photos and the research, library, and community-services staffs of NMAI. In order to accomplish this the architects and the Native American Design Collaborative held a design charette in Santa Fe, New Mexico, attended by fifty native artists.

The participants envisioned a structure with three floors of open space, a radial roof, and a public flow into deeper levels to allow access to the collections. The words of Pueblo Indian architect Rina Swentzell embody the concepts expressed in formative consultations with the native community:

We are part of an organic world in which interrelationships at all levels are honored…. We embrace the cycles of our organic world…. Our reciprocal networks of hospitality connect families, tribes, and nations…. We are sovereign, adaptive, and thriving communities of people.[1]

ARCHITECTURE AND THE NATIONAL MUSEUM OF THE AMERICAN INDIAN The search for a culturally relevant design that represents the essence of the native societies of the western hemisphere, has been a major challenge for the National Museum of the American Indian. To be located on the last available space on the National Mall, between the National Air and Space Museum and the Capitol Building, the new museum will be seen as a monument to the native cultures of the past and a testament to the enduring cultures of the present. After an extensive search, the Smithsonian selected the architectural firm of Geddes, Brecher, Qualls, and Cunningham of Philadelphia in association with Douglas Cardinal Architect, Ltd., of Ottawa, Ontario, Canada, to design the museum.

The inclusion of Cardinal (Blackfoot) as the principal designer, is key to the Smithsonian's hope for a unique architecture that represents native peoples while serving the educational needs of the millions of people who will visit the National Museum of the American Indian. Cardinal designed the Canadian Museum of Civilization in Hull, Ontario, and has recently completed the master plan for the Institute of American Indian Arts campus in Santa Fe, New Mexico.

Assisting Cardinal will be Donna House (Navajo/Oneida), a landscape architect and botanist; Ramona Sakiestewa (Hopi), noted weaver and interior designer; and native artists Susie Bevins (Inupiaq Eskimo), Peter Jemison (Seneca), Jaune Quick-to-See-Smith (Flathead), and Lorgio Vaca (Guarayo from Bolivia).

While the small triangular site on the mall sits vacant, one can only imagine what the museum will look like. Based upon extensive consultations with native communities, some of the architectural features of that new museum are clear:

CANADIAN MUSEUM OF CIVILIZATION. PHOTO BY PIERRE SOULARD.

there must be a seamless transition from the outside to the inside as a way of honoring the earth, and the sacred elements of sky and water and the space must also feel like "native space," not like a typical museum. Cardinal believes that architectural design is a "spiritual act." That may be just the attitude needed to arrive at a design that will meet educational needs in the nation's capital and still be relevant for distant native communities. The turn of the century will bring us that new design as the new museum opens in 2001. ✳

1. *Way of the People*, National Museum of the American Indian Architectural Program Document.

A QUICKENING PACE
Native American Media 1828 to 1994

Richard LaCourse

The joke goes like this: What did Indian peoples call this country before the arrival of the Europeans? Ours. Prior to contact, North America was a quiltwork of contiguous, territorial, indigenous cultures stretching north to south, east to west, whose languages and practices were as diverse as the continent. From the Eskimo communities in the Arctic to the mound cities in the midwest, the Iroquois Confederacy in the northeast to the Seminole villages in Florida, and the ancient pueblo city-states in the southwest, native societies survived for millennia because they had developed enduring social organizations and successful subsistence and trade cultures.

The processes of debate and public consent in traditional tribal societies in North America were essential parts of self-government prior to the colonial and national eras in the United States. The concept of the tribe and its cohesive bonds, the nature of the distribution and exercise of authority, and the processes of public consent were institutional factors in tribal societies. These societies' survival depended on agreed-upon means of government, management of territory, hunt, harvest, and fishing areas, preservation of foodstuffs, and the set-aside of surplus

goods for trade. Beneath this concept of "nation," of course, were the sociological and political realities of each particular people, each with its own pattern of ancestral governance and history. Government was the understructure of continuing group survival. These native societies had traditional means of communicating over distance and within their communities, including forums for discussing diverse ideas, and for reaching consent and consensus among divergent groups, bands, and clans with competing interests.

COLONIZATION AND PRINT MEDIA Colonization of North America by Europeans from the East and by Russians from the West irrevocably

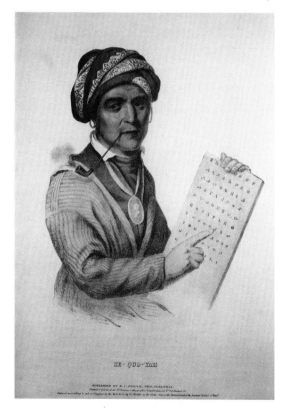

SE-QUO-YAH

PUBLISHED BY E. C. BIDDLE, PHILADELPHIA.

SEQUOYAH. COPY OF McKENNEY AND HALL LITHOGRAPH. COURTESY, NMAI (30929).

OPPOSITE PAGE 53: MARK McEWEN, HATTIE KAUFFMAN, KERMIT, AND HARRY SMITH OF CBS THIS MORNING. COURTESY, CBS THIS MORNING.

changed the natural developmental trajectories of native societies. Among these changes was the birth of the native press in North America in 1828. The development of a native press was the result of three profound revolutions within native communities: the transformation from oral cultures to print cultures, the adaptation of the technology and philosophy of the printing press to tribal interests, and the employment of the press for collective Indian interests.

The gradual transformation from oral to print cultures was the consequence of efforts to educate and evangelize native peoples, first in the east and later in the west, through the use of the English and French languages in the east, and Spanish and Russian in the west. On the eastern seaboard in the early 1800s, native people who could read and write English were the first to gain entry into, and receptivity from, the white press and the world of printed books. A companion phenomenon, beginning in the 1820s, was the emergence of alphabet systems and syllabaries for tribal languages, which were used in Native American publishing.

Adaptation of the printing press to Native American interests emerged as literate Indians became familiar with the press and its role in non-Indian communities— particularly its role in supporting the forced emigration of tribal people from their homelands to accommodate non-Indian settlers and squatters. If newspapers could be used as agents for white settler interests, they could also be used to represent those of Indian people. In addition, newspapers could be read and understood by neighboring readers and people living great distances from Indian lands, and could establish a public voice for tribal interests and causes

amid the cacophony of public debate about the future of Indians in North America.

Unlike their non-Indian neighbors, native people had collective interests rather than individual economic and political rights at the heart of their concerns. In the 1800s, when the native press was born, those interests included the retention of hereditary ancestral tribal territories and intact native environments, the preservation of cultural, social, and religious systems, and the secure distancing of native communities from the multiple intrusions of white culture.

TRIBAL CENTURY Indian journalism was born in the late 1820s among the Cherokee of Georgia, amid intense political pressure by white federal and state governments for the Five Civilized Tribes to move to Oklahoma Territory and abandon their Southeast homelands to the rising tide of white settlers. The Georgia state government wanted the 14,000 members of the Cherokee Nation removed from Georgia to Oklahoma, leaving the fertile land to white immigrants.

The creation of an eighty-six-character Cherokee alphabet became a key instrument in the defense of the Cherokee people. Sequoyah, a Cherokee silversmith, puzzled over the American alphabet. Within a decade, he had developed a writing system for the Cherokee language that was adopted by the Cherokee Nation. In 1827, the Cherokee Nation encumbered funds to begin publication of its own newspaper. Elias Boudinot, a mixed-blood tribal member, was named editor. A printing press with punches and casings in the Cherokee and English alphabets was obtained. On February 21, 1828, the first edition of the *Cherokee Phoenix* appeared in Cherokee and English in New Echota, Georgia.

A REPRODUCED COPY OF AN 1828 EDITION OF THE *CHEROKEE PHOENIX*, PUBLISHED IN NEW ECHOTA, GA., SHOWS AN INTERESTING EDITORIAL BLEND THAT INCLUDES CHEROKEE LAWS, CANNIBALISM IN NEW ZEALAND, REPORTS OF GOVERNMENT HEARINGS, QUOTES OF SOCRATES AND BIBLICAL SCRIPTURES, AND POETRY.

The push for the removal of the Cherokee from Georgia continued. The issue of whether to remain or emigrate divided the Cherokee, stretching the nation to the breaking point. In 1838, the Georgia troops moved in, killing large numbers of Cherokee people and driving thousands along the Trail

of Tears to Oklahoma Territory. The *Cherokee Phoenix* printing presses were disassembled and buried. One year later, Boudinot was killed by his own people, because he espoused the emigrationist philosophy.

The utility of an Indian press was recognized by native people in the Oklahoma Territory. *The Cherokee Advocate* was launched in 1844 with the motto Our Rights, Our

CHARLES TRIMBLE, OGLALA SIOUX, WAS PRINCIPAL FOUNDER OF THE AMERICAN INDIAN PRESS ASSOCIATION IN 1969. COURTESY, C. TRIMBLE.

Country, Our Race, and Indian newspapers proliferated across the territory as the Chickasaw, Choctaw, and Creek people developed alphabets and obtained printing presses and funding. Newspapers were produced on tribal printing presses, and contained reports on official tribal business and new laws, legal notices, advertisements, notices of property sales, schedules, editorials, and columns. In the 1880s, Indian

editors of Oklahoma Territory formed the first Indian editors' association.

The development of Indian newspapers generally moved from east to west, following the establishment of Indian reservations and the creation of federal and missionary schools for young Indians on those reservations, which were followed by a system of regional schools. The federal government's Indian boarding schools spread print literacy and familiarity with the newspapers of white America across the western United States. By the turn of the century, more than 250 native newspapers had appeared from Florida to the Alaska Territory. Indian newspapers of this time reflected growing fissures in the old tribal societies and divisions of people into conservatives or progressives, Christians or traditionalists, educated or noneducated. Some newspapers reflected only segments of community life, and many of the papers reprinted material from other tribal newspapers, marking the beginning of a dialogue on issues.

Numerous tribes adopted constitutions. In 1852, the Choctaw Nation constitution had specific provisions for a free press. It stated: "That the printing press shall be free to every person, and no law shall ever be made to restrain the rights thereof. The free communication of opinions is one of the inviolable rights of man, and every citizen may freely speak, write and print on any subject, being responsible for the abuse of that liberty."

INTERTRIBAL CENTURY The twentieth century may be characterized as the intertribal century of Indian journalism. In 1911, on the eve of World War I, a literate Indian political group emerged from the reservations to form

Looking back at those times, I see us as having been fearful of heresy and unwilling to question anything "Indian." I see ourselves as having been somewhat xenophobic in the fear of termination and abrogation of treaties. And we were appropriately angry, as the times seem to have called for, and that anger sometimes clouded our objectivity and reason.

In that group we saw each other in the light of respect and kinship. We were very sensitive to one another in the Indian press, even to the point of avoiding anything that would cause unfair competition among newspapers. For example, there was discussion of perhaps pooling resources to publish a national Indian newspaper, that idea was rejected in favor of providing a news service to help improve the individual community newspapers across Indian Country. Our concern was that a national paper would destroy the local papers. We did consider a concept of a boilerplate national paper with regional inserts, which *Indian Country Today* now seems to be doing.

Organizations like NAPA and ICA suffer from the fact that they are made up of creative, idealistic, and individualistic people. The organization is perhaps also torn between an Indian world of tradition and a world of high technology. Which leads me to say a few words about the conflict we might find in ourselves in performing our mission.

In the ICA proposal for funds to develop fund-raising tools and methods for the stations, Ray Cook says, "When you operate in non-traditional territory you have to approach operations in a non-traditional manner, using innovative, groundbreaking means."

He is right in that statement. But I would say that you may also find that you have to challenge what some will say is "tradition" or "Indianness." Samuel Johnson wrote, "Patriotism is the last refuge of a scoundrel." It is safe to say that sometimes traditionalism is the last refuge of a scoundrel as well.

I recall in one of our early public meetings of the AIPA, a young activist who was accompanied by several other young men and looking for a good fight, stood up and accused AIPA of forcing our Indian people into assimilation and acculturation. According to his reasoning, we were doing this by publishing in the English language using the symbols of the alphabet. Things were at a tense standstill until, fortunately, in the audience a very large AIM leader named Harvey Wells stood up and broke the ice with the declaration, "English is the lingua franca of all intertribal Indian affairs, now let's get on with our discussion."

I was thankful for Harvey Wells' intervention, and subsequently had to look up the meaning of the term "lingua franca." But that young activist was using an ostensible defense of tradition for his own misguided mischief. Indianness and tradition are important and must be respected, but there are some Indian people who will use them as an excuse for failure or as an ever-convenient cop-out to scuttle something they can't control.

We should adhere to the sacred and treasured values and resources of our Indian heritage and cultures. But we should not allow ourselves to be suspended somewhere in the past—freeze-framed, as it were, in a scene from *Dances With Wolves*. ✳

Presentation by Charles E. Trimble, President, Red Willow Institute, to the Indigenous Communications Association, Clearwater, Florida. January 30, 1994.

the Society of American Indians (SAI) in Washington, D.C.. From 1912 until 1923, SAI published the *SAI Quarterly Journal,* and later the *American Indian Magazine.* These publications portrayed American Indians as a race rather than as a large number of independent, indigenous peoples. Dissent within SAI, however, led to the creation of an independent crusading paper, *Wassaja,* written and published by Carlos Montezuma

MORE NATIVE COMMUNITIES ARE GETTING INVOLVED IN TELECOMMUNICATIONS. PHOTO BY FRANK TYRO AND ANNETTE BROWN. COURTESY, SALISH KOOTENAI COLLEGE.

(Apache). Other spinoff publications appeared, including ones in Oklahoma and in Kansas, where the first Indian prep school published the newspaper *Indian Outlook.*

During the Great Depression, Indian Commissioner John Collier launched efforts to reestablish tribal political power. As part of these efforts, the Bureau of Indian Affairs (BIA) published Indian materials and assisted tribes in producing their own publications. During this period, many Indian people began to migrate to small towns and cities, looking

for employment. The first urban Indian publications appeared in the Southwest and Midwest. In the 1950s, the federal policy of relocation moved large numbers of Native Americans from reservations to cities, and Indian publishing spread among the newly formed Indian centers, spawning more newspapers and bulletins.

The War on Poverty of the 1960s under President Lyndon Johnson saw a share of antipoverty funds from the Office of Economic Opportunity devoted to new Indian publications, both on reservations and in cities. Since that time, Indian publications have ebbed and flowed. In 1994, there are 464 newspapers and forty-seven magazines being published by Indian people on reservations and in the cities in the United States.

NATIVE ELECTRONIC MEDIA The first Indian involvement with radio communications occurred in the 1930s, across the vast spaces of the Native Alaska Territory. BIA appropriations provided radio equipment to the scattered native villages, and the radio connections were born in the far north. In the "Lower Forty-eight" in the 1950s, first the Navajos, then the Pueblos in New Mexico began day-long broadcasts of Indian news and entertainment in native languages. This broadcasting technique spread to many states under the rubric of public service time. It was not until the 1970s that Indian tribes began to construct or purchase their own radio stations. Four of the first five Indian-owned stations were in the Southwest.

Indian access to television came in the late 1960s and early 1970s. BIA schools in Albuquerque and Santa Fe, New Mexico, and Haskell Indian Junior College in Lawrence, Kansas, began to offer video training. The

first Indian television broadcasters went to work for commercial stations, and others began weekly half-hour public service shows in both English and Native American languages. The first Native American television reporters—and some anchors—began to appear in western cities in the 1970s including Tanna Beebe (Cowlitz) and Hattie Kauffman (Nez Perce), in Seattle; Sammy Tonekei White (Kiowa), in Oklahoma City, Oklahoma; Tom Beaver (Creek) in Minneapolis, Minnesota; Chester Yazzie (Navajo), in Albuquerque, New Mexico; and Roy Track (Sioux) in Phoenix, Arizona.

Independent commercial native television production companies were also born in the early 1970s. KBOL-TV, the first Indian-owned television station in the United States, began broadcasting on November 1, 1984, from Dull Knife Memorial College on the Northern Cheyenne Reservation in southeastern Montana, under the management of Ron Holt (Nez Perce). The station's first programming included a news magazine, children's programming, Native American film and feature programming from a variety of television film libraries, educational materials, sports, and newscasts for the Northern Cheyenne and Crow Reservations in its viewing area.

ASSOCIATIONS In 1970, native America witnessed the first national organization of native journalists, named the American Indian Press Association (AIPA). AIPA was formed in Fort Collins, Colorado, under the impetus of Charles E. Trimble, an Oglala Sioux educator and journalist. Trimble, with a cadre of Indian editors from several states, wrote a constitution and by-laws for AIPA, and in 1971 opened an administrative office in Denver, Colorado, and staffed a weekly print news service in Washington, D.C., featuring commercial news service to newspaper and radio subscribers. The AIPA News Service provided on-the-spot coverage of Indian activities and events, constituting an unprecedented effort. The AIPA held annual native journalist conventions from 1971 to 1975, and conducted a summer journalism training institute in Washington, D.C. AIPA also launched the monthly publication *Medium Rare,* the organization's internal bulletin that emphasized in its coverage journalism ethics, developments in the communications field, First Amendment problems surfacing among its membership across the country, and free press rights as expressed under the Indian Civil Rights Act of 1968, which was enacted by Congress to guarantee freedom of the press on all Indian lands in the United States. In 1972, AIPA began a relationship with the Alberta Native Communications Society (ANCS) of Edmonton, Alberta. Problems in funding and legal problems with the Internal Revenue Service prompted AIPA's reluctant closure in the fall of 1975.

The Native American Public Broadcasting Consortium (NAPBC) was incorporated in Lincoln, Nebraska, in the spring of 1976, to meet the needs of public television stations by pooling and exchanging video programming by, for, and about American Indians. Frank Blythe, a Sioux-Eastern Cherokee radio and television operations director, became executive director of the organization. NAPBC set out to catalog existing Indian programming and materials, to develop a distribution system for these materials, to produce and encourage production of high quality programming

about contemporary Indian life, to train Indians in television, and to serve as native liaison with public television broadcasting stations. Toward these aims, NAPBC also conducts annual communications conferences for both print and electronic journalists.

The Native American Press Association (NAPA) was formed in 1984, under the impetus of editor and journalist Tim Giago (Oglala Sioux), to assume the duties and services of the defunct AIPA. The organization established annual native media conventions, organized liaisons with other minority journalist associations, the American Society of Newspaper Editors, and the American Newspaper Publishers Association, and revived publication of *Medium Rare* as a quarterly, emphasizing journalism training for native high school and college students. In 1990, NAPA was renamed the Native American Journalists' Association (NAJA).

The first daily nationally syndicated radio news program for Native Americans was launched on January 5, 1987, when Oklahoma Creek broadcaster Gary Fife began syndication of "National Native News" (NNN) over the Alaska Public Radio network. The program comprises ten-minute daily news broadcasts, which are transmitted by satellite. NNN is still broadcasting, and has been the prime spur for increasing professionalization of reservation news broadcasting and programming through the use of materials from member native stations.

The Indigenous Communications Association (ICA) was organized in 1991 by fifteen native radio stations in the United States, under executive director Ray Cook (Akwesasne Mohawk). One of ICA's main goals is to have Congress mandate the Corporation for Public Broadcasting (CPB) to invest money in minority and rural radio initiatives. ICA aims to bring radio services into every native community in the United States by the year 2013. The organization maintains corporate offices in Grants, New Mexico, and a developmental office in Hogansburg, New York.

The newest Native American media child is the American Indian Radio on Satellite (AIROS) network, which NAPBC and ICA jointly brought into being. AIROS began transmitting in January 1994 in Lincoln, Nebraska, under the management of Susan Braine, a veteran northern Cheyenne broadcaster. The goal of AIROS is to develop a national satellite system to distribute programming for native radio stations. Its mandate also includes completion of technical interconnections necessary to distribute AIROS programming to Native American communities, stations, and general audiences, and the development and distribution of radio programs that address the political, social, artistic, and spiritual concerns of Native American communities in the United States.

In the long perspective, native peoples entered the newspaper industry 139 years after the first white newspaper was published in Massachusetts in 1689. Indians entered commercial radio forty-eight years after its birth in 1922, and the field of television about twenty-five years after the advent of commercial television. Native Americans began utilizing the communication satellite system only seventeen years after its 1960 launch. The pace of Indian media development is fast approaching that of the nation at large. ✻

NATIVE COMMUNITY RADIO
Its Function and Future

Ray Cook and Joseph Orozco

Native-owned and operated radio is a relatively new industry. Its "golden age" has not yet developed. Of the 545 federally recognized tribes in the United States, only twenty-five native communities own and operate radio stations. Radio came to native communities a little more than twenty years ago. Most native communities started their stations in the late seventies or early eighties.

All native communities began their stations for similar reasons, primarily to serve the unique needs of their people. The native stations are used to preserve the essence of native culture. This may involve restoring a fading language or correcting the ill effects caused by non-native misconceptions. Sometimes, the stations are virtual lifelines of communication for native people in remote locations.

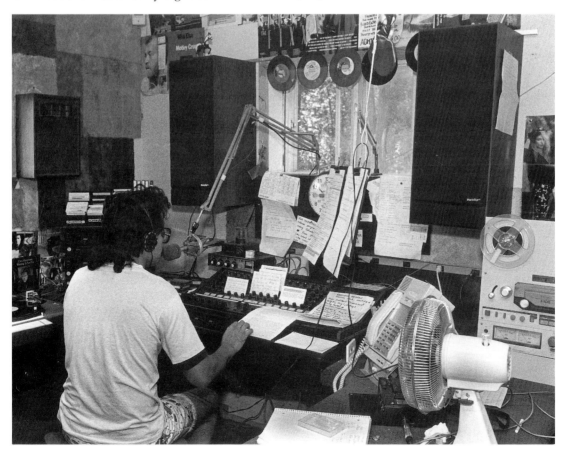

Throughout the years, different waves of employees have given life to native radio stations. Viewed solely as a tool, radio is nothing more than electronic equipment comprising switches, wires, and a tower. The essence of radio, however, is people. It is people who own the license to broadcast, and who mold the useful purpose of a native radio station. It is people who work the equipment and who give native radio personality. When we step back to view the nation's landscape, we see twenty-five radiating Native American radio station signals with similar purposes and personalities. The obvious quest is to unite these twenty-five similar services and create a web of electronic media information.

The Indigenous Communications Association (ICA) is helping individual stations identify their new role in the national scene. ICA and other media allies have created the American Indian Radio On Satellite (AIROS), a satellite system that will transmit programs from all native communities to the world. Participants in AIROS (pronounced arrows) need to be trained thoroughly to actualize their roles in radio. Native communities and their governing councils understand radio's potential, and are investing in making national native communications a reality.

The development process of the mainstream American media and entertainment industries can be available to the native world. Early daytime radio programs became early daytime television programs. These media have in turn evolved into multimedia applications. Native media is going through a similar evolution, but in a condensed time period. Our advantage is that we have watched and experienced much of what the non-native media has done. New media technology is available to us. It is time to evaluate our current media knowledge and invest in the appropriate training needed to develop the proper professional skills.

When our tribal governing bodies acknowledge radio as an industrial cornerstone, educational funding will be targeted to communications fields. When people see there is a viable future in broadcast communications and electronic media, they will direct their children to learn skills necessary for building careers in these areas. When people learn communications skills to a point where they can experiment with different techniques and media applications, the "golden age of native radio" will begin.

The role of native radio is to continue providing media access for our people. Through use and hands-on training, we can thoroughly mine all the potential of this industry. In the future, native radio will evolve into native telecommunications networks. With this advancement, native people will be fully integrated into global communications. ✳

PREVIOUS PAGE: ALEX JACOBS BROADCASTING AT CKON, MOHAWK NATION AT AKWESASNE (ST. REGIS RESERVATION). INDIAN RADIO STATIONS OFTEN BEGIN AS PIRATE ENTERPRISES, ELBOWING ROOM FOR THEMSELVES IN THE AIRWAVES. THIS OFTEN LEADS TO FORMAL AUDIENCE DEVELOPMENT, BUSINESS DEVELOPMENT, AND THEN FORMAL LICENSING. MANY STATIONS RECEIVE MOST OF THEIR INCOME FROM ACTIVITIES LIKE RADIO BINGO. INDIAN RADIO ALSO PLAYS A SIGNIFICANT ROLE IN CULTURAL PRESERVATION BY DEVELOPING PROGRAMMING IN NATIVE LANGUAGES. PHOTO BY TIM JOHNSON. COURTESY, TURTLE QUARTERLY.

NATIVE LANGUAGE SURVIVAL
THE CONTEXT OF RADIO AND TELEVISION

Gary Farmer

Every time a shocking or provocative event occurs in our society, television provides the means for the world to have something in common. It gives us a language and a shared understanding of an event and enough information to formulate ideas or theories, which keep us fascinated. And it entertains us. Television appears to provide a semblance of truth, but it also transmits a warped sense of reality. It is the modern assimilator, replacing the old methods of residential schools, churches, and governments, which were once the primary agents of socialization among indigenous people. Television has infiltrated practically every native household from the farthest reaches of the Northwest Territories through the tip of South America, and indigenous communities are bombarded by information that does not reflect their reality or their needs, their language or their culture.

How can a native community, urban or rural, ever hope to hold its own amid this onslaught of information and images? I have been taught that native languages are the true study of nature. Based on centuries of observation, these languages reflect an understanding of creation, the earth, and how human beings are to survive in the world. Following years of neglect and moral

dissuasion, aboriginal languages are struggling to survive. Today, mass media and the corporate mentality that produces television programming are overrunning many established cultural patterns. For example, television and other mass media make it extremely difficult to maintain languages spoken fluently by small native communities.

These issues of cultural survival must be addressed. Our indigenous languages are vital to our continued existence as distinct peoples with distinct linguistic formulas. Through our

Navajo broadcast student Lynette Ganadonegro playing country music at KABR, Alamo, N. Mex. Photo by Colleen Keane.

languages, we maintain our cultural uniqueness and perpetuate our understanding of the way the natural world stays in balance.

Anything that takes tribal people away from who they are culturally tends to result in high numbers of suicides, drug abuse, incarceration, diabetes, alcoholism, and all the social dysfunction that follows. Indigenous peoples have experienced an erosion of their cultural bases and a loss of control over their lives. Non-native government policy has determined virtually every aspect of their existence. Now, native people are taking back their destiny, and are determining their own future. Radio is an important tool for reestablishing control of our cultures.

It is necessary for Native Americans to undertake our own style of broadcasting, based on our own distinct cultures. How can we effectively exist in today's world without our own media, particularly radio stations, broadcasting our songs and our languages? Every native community in North America should have a radio transmitter, antennae, and satellite downlink capabilities. In a perfect world, teams of communication specialists would produce entertaining, informative radio programming that addressed the needs and aspirations of Indian people. For those who were interested, intensive training in every aspect of radio production would be available in all native communities.

Native language programming is the most important aspect of our network. It has to be developed and initiated by the community members, or supported in areas where a specific language is alive and strong. Music produced by native performers should be broadcast regularly. For every concern in a native community, there is a creative solution in radio broadcasting.

Community-based radio operations can be profitable. These revenues should stay in the community and should be spent on developing programming, upgrading production facilities, and creating lasting employment. Eventually, these operations might develop into other cultural industries, becoming a valuable contribution to the fabric of the contemporary native community.

Imagine native people two hundred years ago. Creativity was not something carried out by a particular sector of the community. Everyone expressed themselves through song and dance. Certain people had certain gifts—a good storyteller, for example—but everyone expressed themselves in a creative way. Today, native peoples' gifts of sharing and understanding could help socialize us to a simpler way of life and could help heal our people. We could share our gifts more easily if radio stations were established in every native environment—reserves, reservations, Indian centers, cultural centers—anywhere where there's an audience interested in listening. These stations would be owned by the community and responsive to its needs.

For the past twenty years, indigenous communities around the world have begun to take control of the media most directly related to them. This is not an easy task. Native communities face a great deal of bureaucracy from the regulatory boards, whose policies tend to favor private broadcasters. But the fight is well worth the effort. The positive change a publicly owned radio station can make in an Indian community is astounding. I've made a point to watch the growth like an astronomer watches the stars. One day, all the indigenous broadcasters around the world will come together—one day soon. ✳

ELECTRONIC MORTAR
NATIVE MULTIMEDIA COMMUNICATIONS

Lawrence SpottedBird

With the rapid development of new multimedia technologies involving satellites, computers, information networks, and radio and television broadcasting, Native Americans around the country are recognizing that the survival of their languages and cultures hinges on the ability to "keep up" with modern technology. New Native American organizations are springing up to address this phenomenon. Older, established Native American organizations are redirecting their focus toward building on-ramps to the information superhighway. Native Americans will not be techno-peasants left hitchhiking on the side with cyberblankets in hand. The development of an information infrastructure for tribal America is an important priority. As sovereign nations of indigenous peoples, we can unite for the primary purpose of preserving our languages and cultures. Tribes must connect with each other by using the information infrastructure as "electronic mortar" for building our future.

In 1991, the American Indian Higher Education Consortium (AIHEC), at the request of the Senate Committee on Indian Affairs, initiated a plan that would explore how the twenty-nine-member consortium of

tribal community colleges could more effectively achieve their mission through the use of telecommunications technologies. The results of this study show how the long-distance learning television network provides a way for remote colleges to expand their course offerings, produce culturally specific telecourses, enhance existing courses, and provide in-service training for college staff, ongoing meeting

"VIDEO NAS ALDEAS," FROM DEMOCRACY IN COMMUNICATIONS. COURTESY, CENTRO DE TRABALHO INDIGENISTA.

opportunities, and access to Internet resources. As a starting point, AIHEC has developed an electronic bulletin board system that gives the tribal colleges and selected individuals access to consortium information and a message system. Similarly, Americans for Indian Opportunity (AIO) in Bernalillo, New Mexico, has established INDIANnet, an Indian-owned and operated civic computer network dedicated to developing free public access to

NATIVE RADIO DISC JOCKEY IN MEXICO. PHOTO BY JEFFREY J. FOXX, NYC.

electronic information and communication services for Native Americans. AIO works with tribes to avoid electronic colonialism and to empower tribes and all native peoples to be active participants in the information age.

Cultural institutions are recognizing the importance of telecommunications access to cultural survival. The philosophy of the National Museum of the American Indian (NMAI) on technology is described in several facility planning documents, and comprises four goals. NMAI's first goal affirms the need

for all of its proposed museum facilities to be technologically "interconnected and fully supported." The full extent of applied technology is stated in the second goal: "NMAI should become a node and clearinghouse in the flow of information among international Native communities." Telecommunications at the museum must be multimedia applications, providing rapid communication across great distances to remote native communities. The communications infrastructure must be as advanced as practically and economically possible, and as nonproprietary as possible, to accommodate existing technology and future applications. The third goal, which focuses on the Cultural Resources Center in Suitland, Maryland, states that, "offering the 'Electronic Museum' to remote sites is the greatest potential for linkage. The museum has to be built for tomorrow and not for today."

Telecommunications will provide the museum a means for reaching another major goal: communicating cultural programs to the United States' population in general, and to remote Native American communities in particular, the "fourth museum." The substance of this communication may be pre-recorded video and audio, or live broadcasts depicting tribal activities. Communication and information sources in Native American communities, such as radio and television stations and schools connected by Wide Area Networks (WAN) or the Internet, will also interact with staff or events at the museum.

The Native American Public Broadcasting Consortium (NAPBC) began operation in 1977 with funding from the Corporation for Public Broadcasting. The primary mission of NAPBC is to produce and encourage the production and successful use of quality public telecommunications

programs by and about Native Americans, for both Native American and general audiences. The NAPBC is currently the largest exclusive distributor of Native American programs in the United States. In 1993, NAPBC and the Indigenous Communications Association (ICA) worked together to begin the development of the American Indian Radio On Satellite (AIROS) network. AIROS will ultimately link the twenty-five native-controlled radio stations via satellite. These remotely located radio stations will be able to use the AIROS network to share programming, produce new programming, and develop programming in native languages. This practical use of native languages would serve to enhance native language education and help preserve languages.

According to a leading linguist, Ives Goddard of the Smithsonian Institution's National Museum of Natural History, as many as ninety percent of Native American languages may no longer be spoken by the end of the next century. To prevent this grim prediction from coming true, NAPBC has proposed a plan for the education and preservation of languages that could ultimately impact all Indian nations. Working with the United Keetoowah Band of Cherokee language expert Dr. Jim May of California State University in Chico, California, NAPBC is developing a cultural language tool kit. The tool kit would be a fully integrated multimedia program using CD-ROM technology. Initially, the kit will use the Cherokee language, in which Dr. May has completed extensive research. Once the program is fully developed, other native languages can be incorporated into the basic package. CD-ROM technology could be used to develop native language programs that create the much needed practical usage that enhances preservation of tribal languages.

NAPBC is entering into other telecommunications areas. Working in partnership with AIO, and potentially with NMAI, NAPBC is proposing a plan to make the Indian tribes in the continental United States and Alaska part of the national information infrastructure. With corporate partners U.S. West and Apple Computers, NAPBC will design a model to show how equitable access to communications networks can be achieved. Other potential partners in the project include the Alaska Public Radio Network, Native Communications Group, National Center for the Production of Native Images, Bureau of Indian Affairs, and the Environmental Protection Agency. The demonstration project will examine ten tribal sites in the United States.

Once connection to the national information infrastructure is established, tribes will have electronic access to every desk in Washington via the Internet. Communication will enable federal agencies to consult with Native Americans, and respond quickly to tribal needs and concerns, as mandated by a recent presidential order to United States government agencies. The federal government and tribal governments will be able to communicate directly, allowing needs and resources to be matched more efficiently.

Native Americans have survived for tens of thousands of years, overcoming tremendous odds. Multimedia communications, our new tool for survival, can ensure the continuing strength of our cultural bonds. *

THE WAY SOUTH

LATIN AMERICAN INDIGENOUS ENCOUNTERS

José Barreiro

He squats on his haunches, grimacing as he stoops into a shrug, the turtle of Creation growing in a hump on his back. He is Deminán, ancient Taino ancestor, and one of the finest works held by the National Museum of the American Indian (NMAI). This invaluable, thin-walled, baked clay piece depicting the genesis—only one of many rare items from the Smithsonian's extensive Caribbean collection—is a compelling image. In the Taino creation story, Deminán, with the assistance of his three brothers, gives birth to Turtle, at once the beginning of the people and of the islands of the Caribbean.

If genesis describes the new museum's entrance into the world of Latin American indigenous peoples, then the Caribbean provides its natural point of entry. The Taino and the Arawak, who survive in several communities on the islands, on the mainland and in the diaspora, were not only the first people to meet Columbus; their ancestors were the beginning of the migrations of indigenous Americans—hemispheric journeys that spanned millennia, as people traversed from north to south, past the Amazon, flowing back up to the Orinoco River and, by canoe, to the islands.

Related to the Tup'i Guarani and other rain forest, mountain and coastal peoples, from the Chaco to the Andes, the indigenous cultures circled by the Taino ancestors' migratory loop contain a grand diversity. The southern American hemisphere, with a native population of some forty million, is home to more than five hundred cultures and languages—kinship nations aboriginal to the Americas, now living in a variety of relationships to their national societies and to the natural world.

The native peoples south of the Rio Grande are well represented in the gigantic collection of the NMAI. More than a quarter million objects, artifacts and burial remains, twenty-six percent of the NMAI collection, are from Latin America. The Caribbean (Taino) collection is the most rare and extensive, representing six percent of the total, but there are as well substantial materials from Meso and South America, including five percent each from Mexico and from Central America, and eleven percent from the various regions of South America.

Given the growth in communications between north and south as well as the NMAI's mandate to serve all cultures represented in its collections, the extension of its work into the Caribbean, Mexico, Central, and South America is among its most

TAINO CULTURE HERO, DEMINÁN, CA. 1492. BAKED CLAY EFFIGY JAR REPRESENTING MALE FIGURE. COURTESY, NMAI (31414).

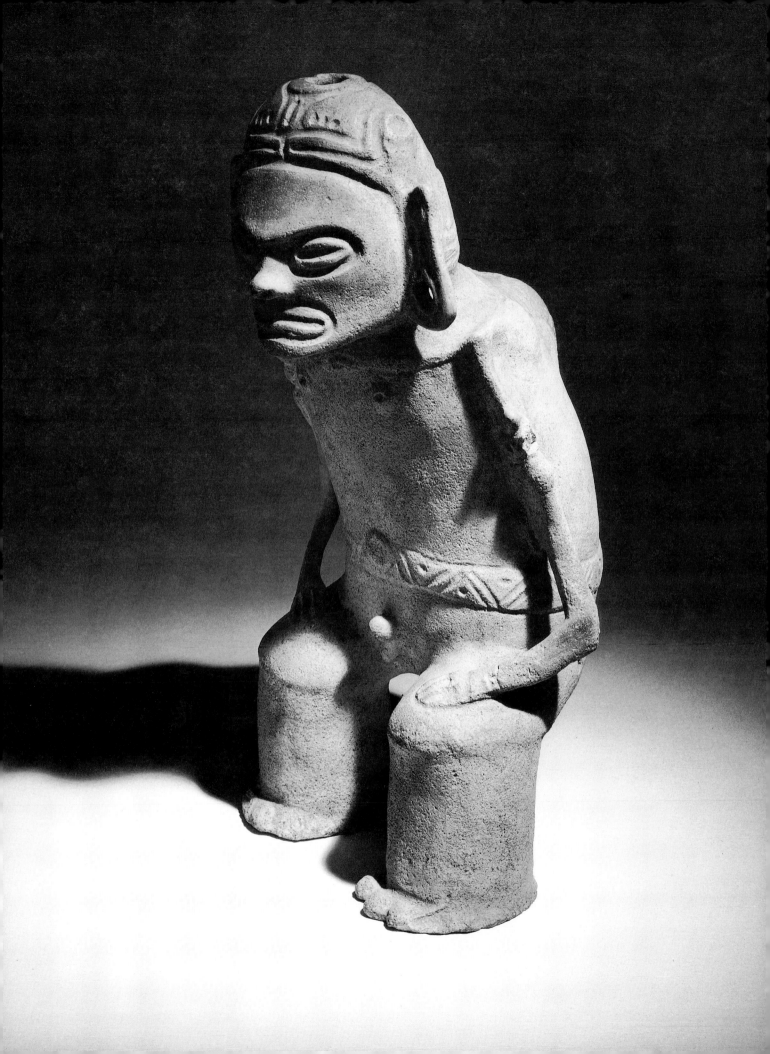

important and potentially difficult endeavors. The complexity of the issues of cultural and intellectual property, repatriation, and self-interpretation multiplies as relations and negotiations across national boundaries encounter language and cultural barriers. Meeting the challenge of the way south will require a sophisticated consultation process and new and creative approaches for the NMAI. The communications networks developed by native peoples in the past decade flow primarily along political lines. Cultural expression, the arts, and the potential for exchanges with native individuals, communities and institutions will demand a strategy of expansive, concentric circles, careful attention to a great variety of cultural and political climates and clear intent.

The vast range of culture and art represented in the Latin American indigenous experience not only shapes the native communities themselves, but often frames the cultures and national identities of the countries formed on their aboriginal lands. The national symbol of Mexico thus depicts an Indian legend, the struggle of the eagle and the serpent. Cuba, Haiti, Panama, Nicaragua, Paraguay, Uruguay, and Chile—among others—are named with words originating in Indian languages. Many of the foods, identities, musical instruments, and national feasts of Latin American countries are rooted in the indigenous cultures. From the architectural grandeur of Peru's Machu Pichu to the featherwork intricacies of the Brazilian Amazon and north to the jade and stone, clay and woven pieces of the Mesoamerican Maya and Aztec, and the productions of their many surrounding peoples, the indigenous world of Latin America still resounds, still depicts itself.

ZAPOTEC WOODEN MASK, OAXACA, MEXICO. PHOTO BY PAM DEWEY. COURTESY NMAI (20.1615).

The term "Latin America" is itself suspect, borrowed from the roots of the European migration. Thus, in recent decades, the ancient names return: Tewantinsuyo, Mayalan, Kuna Yala, Tenochtitlan, Borinken. In recent years, too, a written native literature has begun to reemerge, accompanied, as in the north, by the revitalization of the visual arts. If language carries culture, the expressive arts visualize and symbolize it.

Geographical remoteness, abject poverty, and intense repression have hardened the journey of Caribbean, Central and South American native peoples. The military policies that characterized the years of Manifest Destiny in nineteenth century North America have been present in the south throughout the twentieth century, and are still a factor for the indigenous peoples in some areas below the Rio Grande. Yet, as with their northern relatives, an enormous resiliency— physical, cultural and spiritual—dictated a survival of Latin American Indians that is nothing less than miraculous.

Since the late 1960s, community activism has grown in response to the dismal

ABOVE: PRESENT-DAY MAYA FARMERS PLANTING SEEDS USING TRADITIONAL DIGGING STICKS. PHOTO BY JEFFREY J. FOXX, NYC.

RIGHT: OCCUCERO INDIANS PLANTING CORN IN CHIAPAS, MEXICO, CA. 1900. COURTESY, NMAI (36624).

conditions facing native peoples in Central and South America. Despair turned to social protest, and often participation in political movements and socio-cultural activities has led participants to the traditional elders. Elders' councils and organizations of many remote communities have begun to seek each other out. This cultural revitalization phenomenon has regrounded the new native generations in a pride of their aboriginal culture and identity. Current Indian activism is noted particularly for its traditional cultural aspirations, of which a central factor, beyond the retention

and reclaiming of ancestral lands, is the projection of a politically and artistically self-determined identity.

Communication among and within native communities spread rapidly in the 1970s, which was a brief period of relative peace and prosperity. This was a "decade of enlightenment" for Indians in Central and South America and the Caribbean. The Maya of Guatemala, for example, made many partnerships during the 1970s, particularly following the earthquake of 1976, when the opportunity for international assistance was greatly enhanced. In the

same period, the Kuna in Panama were undergoing their own phase of revitalization, staking out new projects over their ancestral rain forests, and in Nicaragua, the Miskito and Sumo formed their first regional Indian

indigenous cultures.

In South America, remote areas have become increasingly accessible and native people from different regions and countries have found it possible to meet. Such interaction has occurred

the hope of garnering greater recognition of indigenous peoples. This process, begun in 1977 at the United Nations in Geneva, Switzerland, has culminated in the current "United Nations Decade of Indigenous People." As Phillip Deere, Muscogee-Creek medicine man, told the international indigenous audience at that seminal conference in Geneva: "Wherever they are, I want my Indian people to be heard. No matter how small a group they might be, each of them has the right to be who they are."

Native peoples in the Americas exhibit both cultural diversity and philosophical consistency. The transcending principles that guide the native cultures bear a remarkable resemblance to one another. These principles, often represented in spiritual ceremony, include respect for place of origin and for the long-term impact of actions taken in the present, as well as the expressed importance attached to the glue of kinship and community.

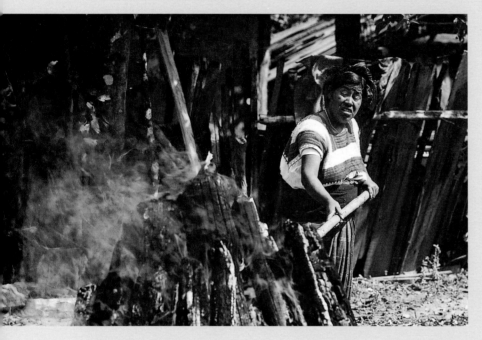

FIRING POTTERY IN STATE OF CHIAPAS, MEXICO. PHOTO BY JEFFREY J. FOXX, NYC.

elders' council, made up of thirteen major districts. In Costa Rica, Honduras, and even in El Salvador, native peoples' outreach projects multiplied. In Mexico, particularly since the events at Chiapas in early 1994, there has been widespread political identification with the

between the Quechua and Aymara across three different countries, with the Mapuche over the Andes between Chile and Argentina and among the confederations of tribal nations inhabiting the dense and highly demarcated Amazon, where the cultural context of a vast region has been remapped. Significantly, increasing numbers of representatives of native communities have journeyed to international meetings in

Among the points of commonality, identity in the land and the preservation of the natural world are foremost. Land (and preferably territory) provides the foundation for all

other human activities. Social, cultural, economic, political, and spiritual factors are rooted in land and ecosystem. Indigenous peoples have great attachment to original land bases. There is always concern for, if not always practical achievement of the continuation of indigenous inhabitation of the ancestral territory, as well as concern about environment and ecology of the home lands. As the expression of these concerns grows, both politically and culturally, relations among native peoples of the Americas will increasingly entwine. The NMAI, with its concept of the community itself as the "Fourth Museum," and its potential for creating networks, could add a significant dimension to this trend.

The NMAI cannot be expected to resolve or even involve itself in contentious political issues, but it can stimulate the expression of native culture and greatly enhance the range and depth of its understanding in curating, in training programs, in interpretation, and in the use of collections to enhance self-understanding and to combat stereotypes. Consider, for example, the excitement of a classroom of Zuni students communicating directly, via computer, with Maya students in Guatemala. Consider the potential for the many fledgling cultural centers and community-run museums to exchange materials for exhibitions with the foremost research institution in the world. Says Dave Warren, a Pueblo Latin Americanist, "Imagine Indians in Colombia and the Arctic, the Amazon and the northeastern woodlands sharing hemispheric events in real time, by the day, by the minute. Imagine native people all over the hemisphere having access to all of the Smithsonian's collection without leaving their home countries, without even leaving their communities."

There are major differences, of course. In Latin America, ninety percent of Indians live in rural areas. They constitute, in some cases, a majority population. There is the question of who is the appropriate party with whom to work. How will the NMAI support local indigenous concerns relative to national governmental entities? When an object is repatriated, who will own it, who will hold it— the particular ethnia from whence it came, or the national government that now represents them? Is it possible to conceive of regions ecologically or culturally, instead of, or in addition to, politically? How does one categorize aboriginal regions? What is archaeological and what is ethnographic? What about the recent migrations— the thousands of Maya now in southern Florida, for example? How will the NMAI acknowledge the issues of identity, of *mestizaje* (mixed race), of representation, without becoming a protagonist, without exacerbating the conditions on the ground? These are difficult questions, but not necessarily insurmountable.

In the first several years since its creation by federal statute, the NMAI has canvassed North American Indian opinion by holding consultations throughout the communities and by gathering native leaders and thinkers in Washington, DC, and New York. Expanding this process to the southern peoples, denying nothing but rather layering the many concerns and creating space for respectful exchange, offers a workable method for the new museum as it readies itself for the journey south. ✳

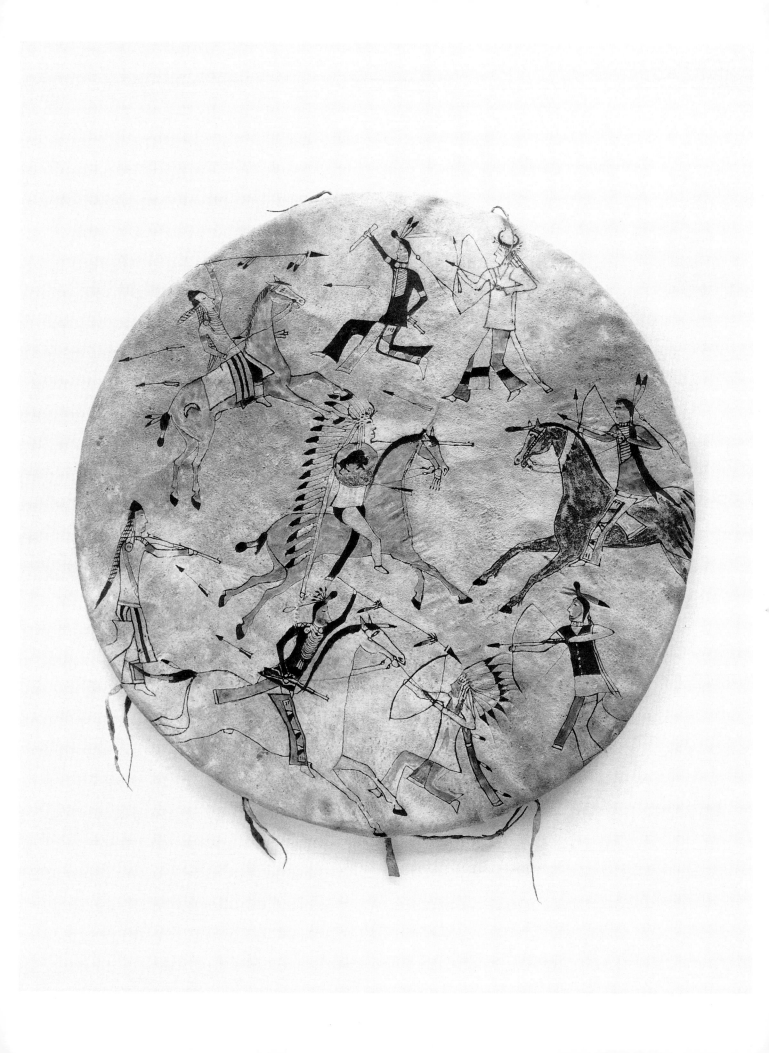

THE OLD AND THE NEW
DIFFERENT FORMS OF THE SAME MESSAGE

Richard Hill

Both Indians who call themselves "traditional artists" and scholars sometimes call into question the validity of art by native artists who have adopted Euro-American artistic traditions. Such questioning suggests that there are separate camps of "traditional" and "contemporary" forms of expression and uses technique and imagery to establish false notions of what Indian art should be. Do Indians still use the thinking and aesthetic traditions of their ancestors in creating expressions about Indian realities? Is there an underlying tradition of creativity that manifests itself in different forms from generation to generation? How is Indian art of today the same as historic art?

Finding the answers to these questions involves looking into the origins of the Indian creative process in order to better understand the continuities. The differences are more obvious—changes in materials, new techniques of craftsmanship, and the introduction of new imagery. While these changes are usually considered a break from tradition, I suggest that there is a deeper tradition

ABOVE: NARRATIVE AND SYMBOLIC PAINTING IS A NATIVE AMERICAN TRADITION. AS CIRCUMSTANCES CHANGED, PAINTING ALSO CHANGED. AMONG THE PLAINS INDIANS, PICTOGRAPHIC IMAGES WERE USED TO SHOW WARRIOR EXPLOITS, DOCUMENT EVENTS AND CAPTURE THE SPIRITUAL ESSENCE OF LIFE ON THE PLAINS. INDIVIDUAL DESIGNS OFTEN WERE ASSOCIATED WITH PARTICULAR PEOPLE OR FAMILIES. OTHER DESIGNS CAME THROUGH VISIONS AND DREAMS. THE ARTIST HAD TO INTERPRET PROFOUND SIGNIFICANCE INTO LINE, SHAPE AND COLOR. THESE BLACKFEET ARTISTS FROM 1921 ARE USING BONE PAINT BRUSHES, AS DID THEIR ANCESTORS. COURTESY, CANADIAN MUSEUM OF CIVILIZATION (52840).

OPPOSITE PAGE 75: DAKOTA DANCE SHIELD. THIS PAINTED HIDE COVER OF A SHIELD DEPICTS A BATTLE SCENE BETWEEN THE DAKOTA AND THE CROW. IN THE CENTER A WARRIOR CARRIES A SIMILAR SHIELD, BUT WITH THE DESIGN OF A BUFFALO, PROBABLY A SPIRIT GUIDE TO PROTECT HIM IN BATTLE. THE FIGURES ARE EXPERTLY ARRANGED WITHIN THE CIRCULAR FORM, KEEPING THE EYE MOVING AROUND THE CENTRAL FIGURE, AND YET KEEPING A STRONG SENSE OF VISUAL BALANCE. COURTESY, NMAI (22294).

at work, a tradition of storytelling and creativity that has always allowed art to change, even before contact with other art traditions. The search for the connections between contemporary art and historic art involves investigating the sacred origins of art.

SACRED ORIGINS OF ART Looking at the most ancient objects in the collection of the National Museum of the American Indian (NMAI) and comparing their imagery and style to the sacred stories that are still told, provides an idea of the origins of image-making from an Indian point of view. Within the native philosophical context, culture must be seen as a problem-solving mechanism that applies certain values and principles to any situation. The artist transforms materials into a cogent statement of those values and principles.

In the past, images of spirit forces appeared frequently. Clay pipes had animal effigies looking at the smoker of the pipe. Shell gorgets had circular symbols with the four directions engraved in their surface. Design motifs and symbols gave the community the sense of a common origin and a common destiny.

The NMAI collections contain examples of Seneca hair combs, for example, that tell stories—people and animals in a state of frozen animation as though performing for the wearer. Among them are seventeenth-century combs with images of white men, horses, flint locks, and three-cornered hats. By carving a never-before-seen horse instead of a bear or a turtle, the artists were recording what was happening in their times. The older hair combs also recorded stories from their own times. The stories changed, but the art captured the moment.

The Kiowa Five, the first native painters to gain national attention, included Stephen Mopope. His work recalled the days of freedom and fighting on the Plains and served as an inspirational model for generations to come. A portfolio of his and the other Kiowas' work, interesting because it developed at the School of Art at the University of Oklahoma, was produced in Paris to rave reviews. Painting in this style became an accepted form of Indian art. Buffalo Hunter. Steven Mopope. ca. 1930. Courtesy, Native American Center for the Living Arts.

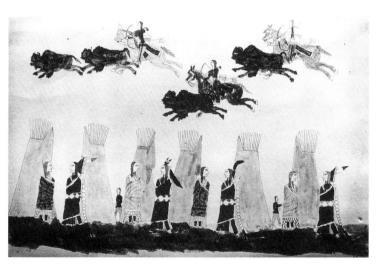

From the turn of the century to the 1930s, paper and colored pencils replaced hides and pigment paints, although the imagery remained the same. Referred to as ledger art, because the paintings were often done in military ledger books, these works set the stage for the emergence of easel art. Courtesy, National Anthropological Archives, Smithsonian Institution, Neg. No. 363-B-1.

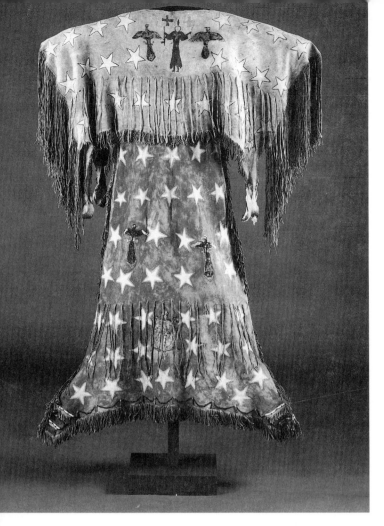

WOMAN'S DRESS FOR GHOST DANCE, CA. 1890.
LEATHER, PIGMENT, FUR, GLASS BEADS, IRON
ORNAMENTS, SINEW, COTTON THREAD, HEIGHT
155.6 CM. COURTESY, INDIANAPOLIS MUSEUM OF
ART, NEG. NO. 750801-306.

My own father, Stanley Hill, Sr., has revived the tradition of antler carving among the Iroquois. Instead of using steel files obtained in trade from the Dutch, he uses electric Dremel tools, obtained through trade with Sears. At first, my dad did not want to carve hair combs because he felt that their style and imagery belonged to someone else. He had to find his style. Eventually, he found a close connection to those ancestors through long years of carving moose antler and contemplating what the old-timers must have thought about. Today, he carves hair combs to show a companionship with the thinking of the old-timers. In this way, he is not replicating the past through his art; he is creating a symbiotic expression of his ties to the ideas behind the older hair combs. Since my father grew up as a farmer, very much like his ancestors, food plants, trees, and animals have a special meaning to him. His art is not a shallow reflection of the past. It shows that he has come to the same understanding about the value of corn, the power of the eagle, and the endurance of the turtle as did those who did not think in English.

The creative process is the same for contemporary artists. It is a different world today, so it is only natural that the art should be different—not better or worse, just different. The art of today has to talk of different things to be valid for its times. At the same time, some of the old stories are still relevant, and they will be retold. Art, therefore, is another form of storytelling by which each succeeding generation adds its experiences to the collective consciousness. I still wait to see the Iroquois hair comb depicting the Arab terrorist blowing up the skyscraper built by Mohawk ironworkers, or of the Pope apologizing to Catholic Mohawks for the conduct of the Jesuits, as proof of my theory. The good thing about art is, you never know what you will see next.

A BRIEF HISTORY During the boarding school days, the campaign by the federal government and most Christian churches to save the individual by destroying Indian culture also attempted to divorce Indian art from its native roots. Teachers tried to remake Indian children through the use of "domestic arts" for Indian girls and "industrial arts" for Indian boys. Traditional Indian arts were routinely discouraged, as were native languages, rituals, and ties to reservation or

community life. When this approach failed, art was transformed once again. This time, Indian aspects were brought back into the classroom as an incentive to have Indians stay in school and use art as a way to make a living. Indian schools began to teach art as a form of economic development, allowing and even promoting the use of native imagery, which previously had been discouraged.

The early narrative painters among the Indians carried that marriage a step further to

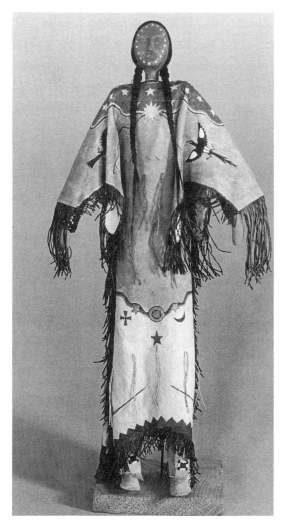

CONTEMPORARY DOLL. RHONDA HOLY BEAR, LAKOTA. FOR PLAINS INDIAN ARTISTS, GHOST DANCE IMAGERY IS ALIVE WITH MEANING. SHE DOES NOT SIMPLY REPLICATE THE IMAGERY, BUT UNDERSTANDS ITS MEANING AND RE-CRAFTS IT FROM WITHIN. PHOTO BY RICHARD HILL.

produce a whole new form of expression—easel painting. Fueled by anthropological zeal, Indians were commissioned to paint ceremonial scenes or to recall former lifestyles through their visual art. Indian painters began to manifest the oral traditions of their people.

The emergence of Indian artists as tourist props coincided with the movement to create a museum culture about Indians, resulting in stereotypes. Indians were expected to paint a certain way. In the last century of imagemaking, art has become a commodity of exchange—the transmission of information into non-Indian hands, and the transmission of money into Indian hands.

The function of easel painting is different from the other forms of expression currently employed by Indians. Romanticized notions about life as an Indian, scenes from a distant past, and clichéd images of buffalos, warriors, horses, eagles, and spirits serve for many as a form of cultural therapy, connecting the artist to a distant cultural consciousness. Most of the leading contemporary Indian artists, however, have grown to have a deeper respect for the cultural foundations of their home community and many have returned to reestablish communal ties that, in turn, reinvigorate their art.

By the same token, some are both visual artists and "traditionalists." They make art about their beliefs. They exist both as art world luminaries and as religious practitioners. They become the modern interpreters of ancient thought, providing both ritualized expression of that communal interpretation and a visual expression of their individual point of view.

Contemporary arts now include painting, sculpture, photography, printmaking, theater, literature, film- and video-making, performance,

and installation. They also include jewelry making, clothing, beadwork, ceramics, textiles, and quiltmaking. All forms of expression are valid. All points of view are Indian.

FUNCTION OF ART Indian art should not be measured by an anthropological ruler. This means that all forms of expression—from powwow crafts to performance art—should be seen in relationship to their own changing social, cultural, and economic landscapes. We need to see how art functions to meet Indian needs, beyond the marketplace or the institutional collection, and to see how art helps Indians remain Indians.

Art, meaning objects made by hand to manifest the world view of the people, is the only real evidence we have from the past of the beliefs and practices of the people. This is why archaeologists have sought out these objects as if they were road maps of the past, showing village migrations, changes in cultural patterns, and acculturation through contact with Europeans. Beyond science and history, though, these objects also contain a spiritual essence that still resonates.

In 1632, French Jesuit, Father Gabriel Sagard traveled among the Huron Indians and wrote, "They are fond of painting, and practice it with considerable skill, considering they have no rules of art." Sagard could not see the Indian rules, and instead judged their art by his own. It is futile, however, to try to fit the works created by the indigenous people of this hemisphere into the definitions that were made for Europe. Instead, we need to accept that the work is self-validating, that it defines itself. This is possible when we look at it for what it is, rather than for what it is not.

This does not mean that the works made by Indians cannot be appreciated across cultures or should not be viewed as fine art. Rather, there is a need to better appreciate function, intention, and creativity over stylistic convention:

Are non-Indians therefore banned forever from understanding the beauty and the meaning of Native American art? No. Yet, too often the art objects of a holistic society are seen as static, isolated, physical entities. So perceived, they become mere cryptic specimens—dusty pots on shelves, curious dancing garments forever separated from the dancer and the dance. Native American art is an integrative social phenomenon, a complex creative collage of song, dance, ceremony, myth, prayer, and vision. The visible "art object" is a small part of this cultural experience.[1]

No single definition captures the Indian understanding of art, which varies from region to region, tribe to tribe, artist to artist, and generation to generation. An understanding of a definition emerges from the following variety of voices.

Gary Witherspoon:

Navajo art thus expresses Navajo experiences, and Navajo experiences are mediated by the concepts of and orientations to the world found in Navajo language and culture. All experiences are directed towards the ideals of *hozho,* and *hozho* is the intellectual, moral, biological, emotional, and aesthetic experience of beauty. A Navajo experiences beauty most poignantly in creating it and expressing it, not observing it or preserving it. The experience of beauty is dynamic; it flows to one and from one; it is found not in things, but in relationships among things. Beauty is not to be conserved but continuously renewed in oneself and expressed in one's daily life and activities. To contribute to and be a part of this universal hozho is both man's special blessing and his ultimate destiny.[2]

Loretta Todd, Canadian Metis filmmaker:

But what of our own theories of art, our own philosophies of life, our own purposes for redemption? By reducing our cultural expression to simply the question of modernism or post-modernism, art or anthropology, or whether we are contemporary or traditional, we are placed on the edges of the dominant culture, while the dominant culture determines whether we are allowed to enter into its realm of art.

When we assert our own meanings and philosophies of representation we render the divisions irrelevant, and maintain our aboriginal right to name ourselves. However, when we articulate the dichotomy of the traditional versus the contemporary, we are referencing the center, acknowledging the authority of the ethnographer, the anthropologist, the art historian, the cultural critic, the art collector. We have to play "catch up" to the academic and other institutions of art. And we set up an opposition within our communities that keeps us in our position of "other." We are caught in the grasp of neocolonialism, in the gaze of the connoisseur or consumer, forever trapped in a process that divides and conquers.[3]

Alfred Young Man, a Cree artist and professor at the University of Lethbridge:

North American Indian artists, on the other hand, have literally reinvented their cultures many times over with no loss of continuity with earlier native cultures and consequently, they have had, and do have, an untold influence on the way the "outside" world perceives them. They have reconstructed their societies as true artists must, as technicians who were, and continue to be, involved in the actual creative process from within.[4]

Mary Lou Fox Radulovich, Director of Ojibwe Cultural Foundation on Manitoulin Island, Ontario:

EARL EDER, LAKOTA, CAPTURES THE SPIRIT OF THE OLDER WORKS AS HE INTERPRETS THE POWER OF THE THUNDERBIRD. COURTESY, INSTITUTE OF AMERICAN INDIAN ARTS MUSEUM.

EARL BISS, CROW, WENT INTO THE MEANING OF THE PLAINS INDIAN SHIELD, SEARCHING PAST THE STYLISTIC CONVENTION AND PAST THE PHYSICAL IDENTIFIERS. HIS WORK, AS SEEN IN THIS LARGE CIRCULAR CANVAS FROM THE 1960S, SOUGHT TO TAKE VIEWERS UPON THE VISION QUEST AS SEEKERS OF KNOWLEDGE. COURTESY, INSTITUTE OF AMERICAN INDIAN ARTS MUSEUM.

Indian people have no word for art. Art is part of life, like hunting, fishing, growing food, marrying and having children. This is an art in the broadest sense... an object of daily usefulness, to be admired, respected, appreciated and used, the expression thereby nurturing the needs of both body and soul, thereby giving meaning to everything.[5]

Fred Benjamin, a Mille Lacs Ojibwe elder:

The way the Indian people, long ago, made their songs was by looking at what the Great Spirit gave them to understand in their minds... to make songs out of what they saw. Like the leaves when the wind blows they're shaking; they make a little noise. That's how they got the idea to put bells on their legs. And sometimes you see a fowl, like an eagle, an owl, a chickenhawk. The Indian people looked at them, the way they'd swing their wings,

how they'd go down and up. That's how they'd make the pitch of their songs.... And everything they'd see; when they looked at the sky, the clouds, they'd make songs out of those. And they'd make words out of the clouds that they saw. And they'd think that there's kind of a holy spirit going around, and that's how they'd make their songs.[6]

Inuit sculptor, Paulosie Kasadulak:

It is not only to make money that we carve. Nor do we carve make-believe things. What we show in our carving is the life we have lived in the past right up to today. We show the truth... we carve Inuit figures because in that way we can show ourselves to the world as we were in the past and are now.... There is nothing marvelous about it. It is there for everyone to see. It is just the truth.[7]

CONCLUSION Handmade objects still have an important role in the contemporary life of the native people of this hemisphere. Personal and community rituals of thanksgiving and healing continue, and are often dependent upon such objects. Social and religious dances continue to be important forms of expression, requiring each generation to make clothing that manifests its tribal identity. Indian households still contain handmade objects of cultural identity, as if to offset the complexities of modern life. The objects in the collection of the National Museum of the American Indian continue to be important inspirations to Indians of today.

Amos Owen, a Dakota elder, at a conference on repatriation held several years ago, spoke about talking with the dead Indians whose bodies were held by a museum. He described the pain they suffered, separated from those things that were buried with them to help them on their journey to the spirit world. He used the sacred pipe to communicate with them. Owen, who recently passed into the spirit world himself, helps us to remember that art objects may have a deeper meaning than visual pleasure:

I watched the old Sioux men carve and learned from them.... The quarry is sacred ground. I make my offerings before I go.... Back at my home, I say a prayer with the stone.... It's a good feeling to know the spirits are with me.... The Sioux have always carved. In earlier times, a holy woman gave us the pipe, with instructions as to how we should live...the pipe has meaning to our people today.... The pipe provides guidance, shows us a way of life.... When we travel, we place the pipe on the dashboard of our car, and they watch over us.... It's a presence. I know it's there.[8] ✳

Notes
1. Ed Wade, Carol Haralson, Rennard Strickland, *As In A Vision—Masterworks of American Indian Art* (Tulsa: University of Oklahoma Press, 1983).
2. Gary Witherspoon, *Language and Art in the Navajo Universe* (Ann Arbor:z University of Michigan Press, 1977).
3. Loretta Todd (Metis), "What more do they want?" In *Indigena: Contemporary Native Perspectives*, Gerald McMaster and Lee-Ann Martin, eds. (Vancouver: Douglas & MacIntyre, 1992).
4. Alfred Young Man, Plains Cree, "The Metaphysics of North American Indian Art" in McMaster and Martin.
5. Mary Lou Fox Radulovich, Director, Ojibwe Cultural Foundation, "Quillwork" (Toronto: Ontario Crafts Council, 1984).
6. Fred Benjamin, quoted in *Circle of Life: Cultural Community in Ojibwe Crafts* (Duluth: St. Louis Historical Society, Chisholm Museum and Duluth Art Institute, 1984).
7. Paulosie Kasadluak, from an essay in "Inoucdjouac–Port Harrison," (Winnipeg: Winnipeg Art Gallery, 1976).
8. Jane Katz, ed., *This Song Remembers—Self Portraits of Native Americans in the Arts* (New York: Houghton Mifflin Co., 1980).

CONTINUITY AND CHANGE IN NATIVE ARTS

Fred Nahwooksy

Each year in mid-August, a mass migration of art collectors, gallery owners, Native American artists, and curious tourists journey to Santa Fe, New Mexico, to go to Indian Market. Beneath colorful canopies, in row after row of vendor booths, Native American artists sell all manner of contemporary and traditional arts and crafts.[1] Against this backdrop, numerous gallery openings, receptions, and other art-related events punctuate a week of sales. Thousands of art enthusiasts are finding ever-increasing opportunities to sell and purchase Native American art. The shows, sales, and participation in cultural events have led to some innovations in artistic development, but they have also raised some issues that need to be understood if we are to appreciate the arts and artists, and the traditions they carry forward.[2] Native American traditional arts reflect cultural values. Culture is understood as an ongoing dynamic process that shows continuity of form, use, and practice. As Hopi scholar

Emory Sekaquaptewa has said, "language...rituals, customs, and other forms of usage, continue to call up memories of the past that give meaning to the present and future."[3]

HISTORY The federal government has influenced the development of Native American arts in both positive and negative ways. In the last century, it amassed huge collections of information and objects from native peoples—under the erroneous belief that native cultures would be assimilated into white American society. In this century, it has supported native art through important legislative mandates and executive agencies.[4] Relatively new organizations, such as the Smithsonian's National Museum of the American Indian and the Keepers of the Treasures, will have a long-term role in preserving traditional arts and practices of Native Americans.

Federal government funding is only one factor among many that influence culture and the arts. Resources, materials, tools, economics, cultural function, time, and empowerment all influence the continuity and change in traditional arts and material culture.[5] Historically, objects were made to

SANTA FE INDIAN MARKET IN 1993. PHOTO BY MURRAE HAYNES. COURTESY, SOUTHWESTERN ASSOCIATION FOR INDIAN ARTS.

serve a specific purpose in native societies. Some objects were made purely for self-adornment, and valued on the basis of factors such as materials, personal preference, love, and power. Decoration became a means for identification, statement of status, record of activities and visions, and an opportunity for creating beauty. These individual expressions often became accepted as a community's expressive culture forms.

Established standards of quality and design changed as materials and innovation, construction methods, and popular culture changed. Euro-American culture has had a continuing impact on traditional arts through the introduction of materials and tools (beads, cloth, needles, thread, silver, domesticated

THIS HUNKPAPA SIOUX SHIELD REFLECTS THE VISION AND POWER, OR "MEDICINE," OF ITS OWNER. PHOTO BY JANINE JONES. COURTESY, NMAI (21.3663).

sheep), cash economy and trade systems that Europeans instituted in the Americas and Hawai`i, and a personal ownership mentality that leads to the gathering and collecting of property. To their credit, native artists and object makers have retained cultural values in design, construction methods, and materials, and symbols, even when their crafts have been made solely for sale to benefactors and tourists.

Decorative arts, such as beaded fancies and colorful diamond-shaped yarn God's eyes, although they seem to have no meaningful purpose in defining group culture, claim a form or practice that serves as an element of group identity, even if only in a pan-Indian sense. In this age of global communication, North American native peoples identify with other indigenous peoples, such as Latin Americans, or Native Hawaiian traditionalists, for instance. Our common histories and experiences impact and broaden our sense of "Indianness." Art has frequently played a significant role in the struggles of many native peoples to regain control of their destinies.[6]

IMPACT OF TOURISM ON TRADITIONAL ARTS
Tourism has played a role in helping some traditional art forms to survive and prosper. Regarding the survival of pottery making among the Gay Head Wampanoag Indians of Martha's Vineyard, Eleanor Wachs says, "if tourists had not bought the pottery in years past, the tradition might have been lost altogether."[7]

This point is borne out again in an article by Edith McKinzie:

> many sacrifices of language and traditional expressions were made to accommodate commercialization of Hawaiian themes and music. On the one hand, such changes

brought sacrifices at the expense of the Hawaiian traditions. On the other hand, the changes occurred as a process and have evoked an appreciation of Hawaiian culture by the people of Hawai`i. This will insure the survival of the Hawaiian culture despite the foreign influences in the islands.[8]

In the early 1900s, esteemed Tewa potters Maria and Julian Martinez (from San Ildefonso Pueblo, New Mexico) successfully rediscovered the process for producing highly polished black pottery. Their prior work as traditional craftspeople for the pueblo included producing functional pieces for home use and ceremonial purposes.[9] From their experiments and perseverance, a major tourist/collector market developed for San Ildefonso and, arguably, for native peoples of the entire southwestern United States.

The issues of cultural tourism include the reassertion of Indian control of land access, culture, and the development of their futures. As native control of tourism grows, traditional art forms take on roles beyond the functional and the ceremonial. As objects of tourist/collector commerce, however, traditional art forms have retained their cultural associations and values. The quality of the craft determines its value.

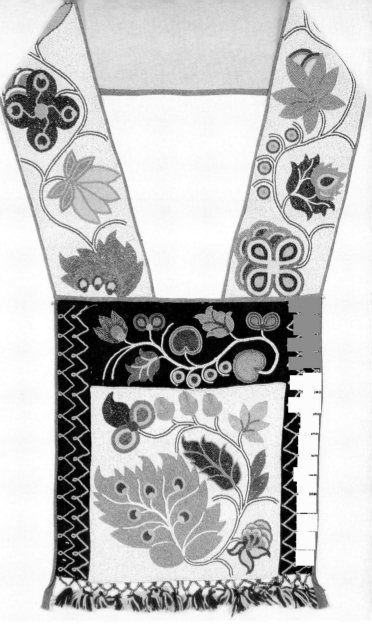

BEADED VELVET POUCH, SHOULDER BANDOLIER TYPE. CHIPPEWA, FROM WISCONSIN. PHOTO BY JANINE JONES. COURTESY, NMAI (23.2965).

QUALITY Quality is assessed in the overall first impressions—weight, symmetry, intricacy, durability, color, complexity, functionality, and adherence to an established form. These measures tend to hold as basic starting points when applied to traditional arts, but we also allow for new applications of traditional processes—beaded baseball caps, for example, using sewing machines to sew ribbonwork, and crafts made with drill presses and other power tools. After all, at what point does a form become traditional? Just as culture is a dynamic process, so is the development of traditions, as elements of culture. It is only now that we have all the means necessary to record and document development, and to facilitate increased production using modern tools and materials. This should not devalue new traditions as they arise.

EMPOWERMENT There is a backlash from native people against the attitudes of many museum professionals, art historians, curators, and collectors who define traditions within narrow academic parameters.[10] I asked a native friend to define Indian art. Because she is highly educated, I expected her to go off on several tangents to explain the possibilities as presented by a range of scholars. But she said, 'If it's art made by an Indian, it's Indian art. End of story.' Her response is an example of the ownership that native people are exerting over their cultural patrimony, including the arts. They are unwilling to be defined by anthropologists and others as subjects of academic study. Indian people offer explanations on Indian terms and present culture directly from tradition bearers, so that it cannot be misinterpreted by outside scholars. This is a strategy for eliminating stereotypes, validating the beliefs and practices of native groups, and retaining intellectual property rights to cultural patrimony.

TRADITIONAL AND CONTEMPORARY ART In native cultures, traditional and contemporary art play very different roles. Contemporary arts are individual expressions appreciated on a primary level as objects of beauty that engender emotion through visual excitement, while traditional arts are forms that continue to play a role in the maintenance of culture. Traditions are learned forms passed from one generation to another within the community. Contemporary forms are learned in more formal settings like school or through individual trial and error. Definitions like this are not always as clean as we might like, but they are useful for discussion.

Both traditional and contemporary arts involve creative freedom. Makers of traditional art do not mechanically produce objects for domestic and ritual use, any more than a dancer dances a prescribed set of steps without deviation. The creative and individual aspects of the work, and how it retains its traditional character, help to define quality. Although the art of quilting, for example, was introduced by missionaries, Native Americans have endowed it with their own meanings, purposes, and designs. Native Hawaiian quilters, for example, developed a unique approach to design that is grounded in their practices of making clothes from *kapa* barkcloth.[11] Through similar processes, Lakota people have made the star quilt design famous on the northern plains.[12]

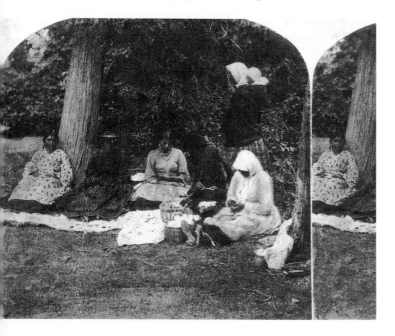

IROQUOIS WOMEN SEW AND SELL THEIR BEADWORK TO TOURISTS VISITING NIAGARA FALLS, N.Y., AS SEEN IN THIS VERY EARLY STEREO-VIEW CARD. SUCH BEADWORK BECAME A PRINCIPAL SOURCE OF INCOME AND PRIDE FOR THESE WOMEN. THE IROQUOIS WERE GIVEN THE RIGHT TO SELL THEIR CRAFTS AT THE FALL'S EDGE DUE TO THE SERVICE THEIR MEN PROVIDED DURING THE WAR OF 1812. PHOTO BY DOLORES ELLIOT.

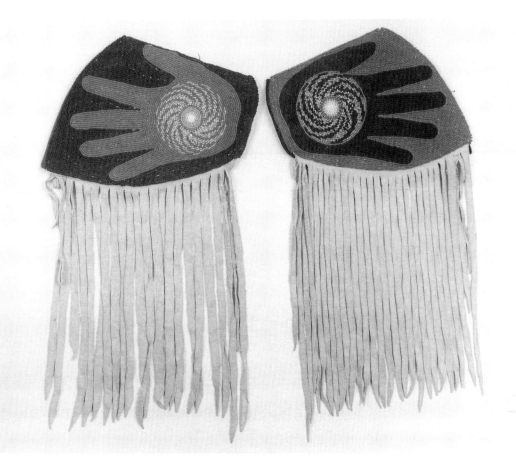

EXPRESSIVE CULTURE Many art traditions continue today and are being developed to a high degree of quality. The Haudenosaunee (Iroquois) longhouse ceremonies require drums and turtle shell rattles.[13] These musical instruments are made by people in the community. The Comanche people in the 1870s developed religious objects that function in the peyote ceremony.[14] Beadwork art on fans, rattles, and staffs (or wands) used in the peyote ceremony has extended beyond religious uses, and is also important in secular settings, like powwows. As the peyote religion has migrated to other groups in North America, so has the development of the peyote stitch, or gourd stitch style of beadwork.

The Osage people of Oklahoma are known for their exceptionally fine ribbonwork. Symmetry, color, and intricacy define quality ribbonwork. Beyond visual

BEADED CUFFS BY MARCUS AMERMAN, CHOCTAW. WITH THE INTRODUCTION OF GLASS BEADS, AN ENTIRELY NEW STYLE OF ART BEGAN. NEW COLORS, NEW TECHNIQUES AND NEW IMAGERY BEGAN TO APPEAR ON NATIVE CLOTHING ALL ACROSS THE COUNTRY. THESE CUFFS, IN CONTRASTING RED AND BLACK BEADS, DRAW INSPIRATION FROM THE MOUNDBUILDER CULTURES THAT PRECEDED THE CHOCTAW IN THE SOUTHEAST. THE UPTURNED HAND WITH THE SUN SPIRAL IS AN ANCIENT SYMBOL THAT IS GIVEN NEW LIFE IN THESE CONTEMPORARY CUFFS. PHOTO BY LARRY MCNEIL. COURTESY, INSTITUTE OF AMERICAN INDIAN ARTS MUSEUM.

appeal, however, clothes that are decorated with ribbonwork maintain an important place in the In-lons-ka Society dances of the Osage people. Ribbonwork patterns of the Osage, Ponca, Pottawatomi, and Winnebago people include both geometric and floral designs that honor their woodlands ties to the Great Lakes region of Wisconsin, Minnesota, and the eastern Dakotas. Georgeanne Robinson, for example, has set a level of craftsmanship that ensure that the ribbonwork tradition would continue to be a viable part of Osage culture.

SUMMARY Iroquois people have articulated what many other native peoples feel is the purpose for everything they do in life. They say life is lived for the Seventh Generation, for those who are yet to come. This belief is reflected in native respect for the earth, retention and development of culture, and

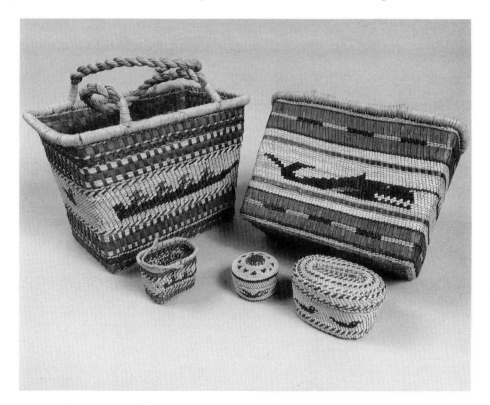

THE NOOTKA BASKETS AND THE CHIPPEWA BANDOLIER BAG REFLECT QUALITY. NOOTKA BASKETS. COURTESY, INDIAN ART CENTRE, OTTAWA, ONTARIO. BANDOLIER BAG. PHOTO BY JANINE JONES, NMAI. (23.2965)

has become the standard for quality for ribbonwork among her Osage people. As one of the first recipients of the National Heritage Fellowship Award from the National Endowment for the Arts, she has passed her knowledge to members of her family to

adaptation to changing technology, and is grounded in group history, traditions, and practices. After multiple attempts by governments to destroy native culture and cultural practices, many Native Americans are regaining full control of their communities and their futures. Under these circumstances, traditional arts will prosper as an added dimension of group identity. *

Notes

1. For purposes of this article, I am using traditional as defined by Charlotte Heth in *Native American Dance* (Washington, D.C.: National Museum of the American Indian, Smithsonian Institution 1992). She says, "'Traditional,' as used by many Indian people and scholars, can be an overarching term with varying meanings. Sometimes it refers to the oldest norms: languages, religions, artistic forms, everyday customs, and individual behavior. At other times it refers to modern practices based on those norms. Again it may refer to categories…that draw most closely on ancient, established practices. 'Traditional' will also refer to practices, methods, materials, and values that are passed from one generation to another so that there is unbroken continuity. Traditions are learned within the informal settings of home and community, and in association with family and group members." I use "traditional art," and "craft(s)" interchangeably throughout. In European thinking, "craft" took on a pejorative meaning during the Renaissance and has been applied to any handwork, or process, that served utilitarian or ritual purpose. "Traditional art" has been used as a response to the pejorative use of "craft" in an effort to show equal value with terms like "fine art" and "contemporary art." I use "craft" without any connotation about the intellectual superiority of art over craft. See Edward Lucie-Smith, *The Story of Craft: The Craftsman's Role in Society* (Ithaca: Cornell University Press, 1981).

2. There is an interesting discussion on innovation in Indian art in *Creativity is Our Tradition* (Santa Fe, N. Mex.: Institute of American Indian and Alaska Native Culture and Arts Development, 1992).

3. Emory Sekaquaptewa, *The Hopi Dictionary, 1991 Festival of American Folklife Program Book* (Washington, D.C.: Smithsonian Institution, Office of Folklife Programs, 1991).

4. These include the establishment of the National Endowment for the Arts and the National Endowment for the Humanities (1965), the opening of the Institute of American Indian Arts in 1962, and the Indian Arts and Crafts Act of 1990. See Robert Fay Schrader, *The Indian Arts & Crafts Board: An Aspect of New Deal Indian Policy* (Albuquerque: University of New Mexico Press, 1983); Joy L. Gritton, "The Institute of American Indian Arts: A Convergence of Ideologies," *Shared Visions* exhibition catalog. (Phoenix, A.Z.: The Heard Museum, 1991).

5. Ethnomusicologist Tom Vennum ran a program in 1989 that addressed the issue of access to resources. See the *1989 Festival of American Folklife Program Book*. Office of Folklife Programs (Washington, DC: Smithsonian Institution, 1989).

6. See *Akwe:kon Journal*, Volume XI, Number 2, (Summer 1994) for a series of essays about the issues that surround the lifelong struggle in Chiapas. Folklorist Olivia Cadaval addressed the issues of development in a program that she curated for the 1994 Festival of American Folklife. See the *1994 Festival of American Folklife Program Book*. Office of Folklife Programs (Washington, DC: Smithsonian Institution, 1994).

7. Eleanor Wachs, "Traditional Crafts and Tourism on Cape Cod and the Islands," *1988 Festival of American Folklife Program Book* (Washington, DC: Smithsonian Institution, Office of Folklife Programs, 1988).

8. See Edith McKinzie, *Hawaiian Performing Arts Traditions, Folklife Hawai`i Program Book* (Honolulu, HI: The State Foundation on Culture and the Arts, 1990).

9. Susan Peterson, Maria Martinez: *Five Generations of Potters* (Washington, DC: Smithsonian Institution, Renwick Gallery, National Museum of American Art, 1978).

10. Susan Dixon's article, "The Essential Spirit" addresses this issue. She says, "Because art-making has traditionally been integrated into Native cultures, the concept of quality relies less upon fixed rules established by an academy as upon the effectiveness of the work of art within the culture." *Unbroken Circles—Traditional Arts of Contemporary Woodland Peoples, Northeast Indian Quarterly* (Ithaca, N.Y.: Cornell University, Akwe:kon Press, 1990).

11. See Lynn Martin's article in this issue regarding Native Hawaiian traditional arts. Also, see *Folklife Hawai'i* (Honolulu: The State Foundation on Culture and the Arts, 1990).

12. See Margaret Wood and Marsha MacDowell's article in this issue for more information about Native American quilting.

13. The Haudenosaunee or Iroquois Confederacy includes the Mohawk, Oneida, Onondaga, Cayuga, Seneca, and Tuscarora Nations. Although they are centered in New York State, there are also Haudenosaunee people in Canada, Wisconsin, and Oklahoma. The Haudenosaunee longhouse is not only a physical structure in each community, but is also the manifestation of traditional worldview and ceremonies for the Iroquois.

14. Ernest Wallace and E. Adamson Hoebel, *The Comanches: Lords of the South Plains* (Norman: University of Oklahoma Press, 1952): 32.

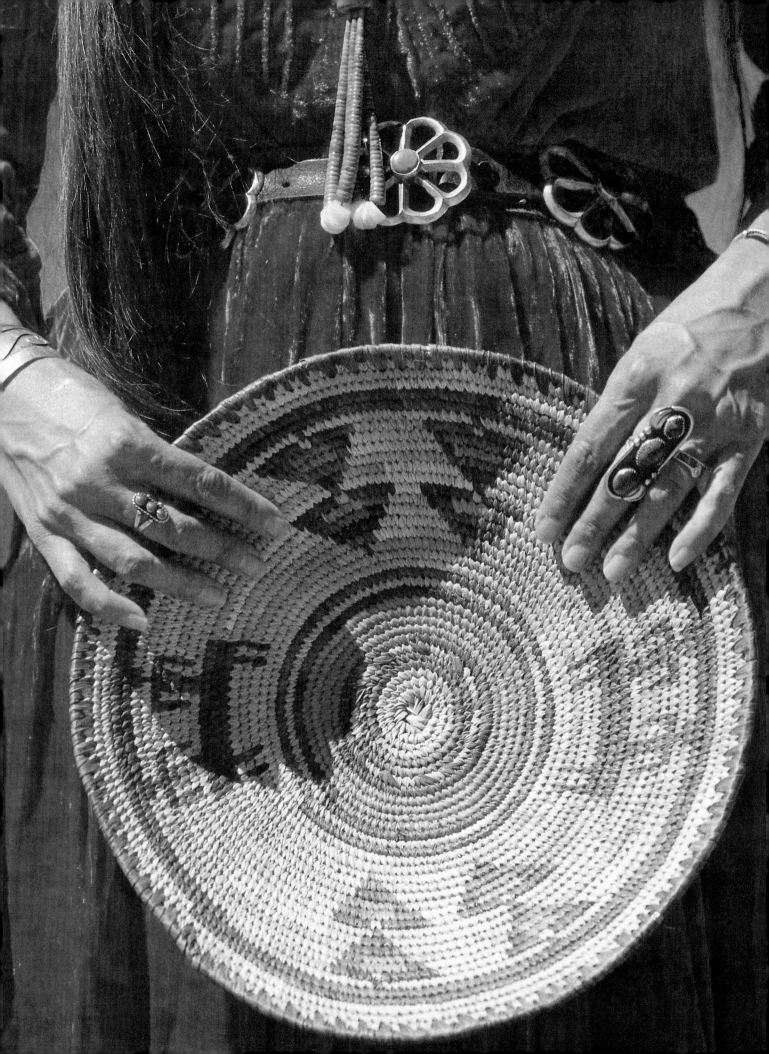

STRATEGIC ADAPTATIONS
NATIVE AESTHETICS THROUGH TIME AND SPACE

Simon Brascoupé

What meaning does a two-hundred-year-old basket have to contemporary Native Americans? Like ancient books and texts, Native American art can be interpreted by knowledgeable readers. Art communicates meaning and information over time. Its message can be profound, sacred, and elusive. Baskets, clothing, shelter, tools, and sacred objects were adorned with images that transmitted values and meaning through many generations.

ABOVE: BLACK ASH SPLINT AND SWEETGRASS BASKET BY MARY ADAMS, MOHAWK. PHOTO BY EMIL GHINGER.

LEFT: NAVAJO COILED BASKET. PHOTO BY JEFFREY J. FOXX, NYC.

While Native American languages had no word for art, contemporary Native Americans define art broadly. Art, understood as a communicator of meaning, has always been a part of all things created and honored by Native Americans.

The Columbus Quincentennial inspired Native Americans to look again at their traditional arts for the ancient knowledge and teachings they contain. Today Native American artists integrate, synthesize, and interpret traditional knowledge and artistic expression. This process of discovery and rediscovery bridges the gap between the past and the present. Contemporary artists make ancient voices speak by rediscovering and reintegrating traditional art and symbols. Through our elders' teachings we have become concerned about languages, values and culture. We are now learning how to read our ancient arts. Baskets, beads, and feathers are making another transformation from their role as income generator to spiritual and moral voices.

Basketmaking is a valuable example. The master basket-maker's task entails the harmonization of body, mind, and spirit. For some, collecting the raw materials for the

basket includes giving an invocation and an offering of tobacco. The raw materials are considered gifts to be conserved, respected, and harvested in a prescribed manner. The saying of special prayers and giving of offerings at collection points can transform a basket into a medicine basket. The underlying structures of some baskets represent the four sacred directions. Materials such as sweet grass give some baskets special healing qualities. Each basket can be read as an allegory for the universe, creation, and knowledge.

Traditional knowledge teaches that everything has meaning. Colonization obfuscates meaning. Continuity within colonization depends on the innovation, invention and creative energy of artists who encoded art with spiritual and cultural meaning. Images, symbols, and designs were meant to pass on truth to future generations. Today readers of these symbols, with the help of elders, reawaken culture by decoding the hidden meanings and allowing the ancient voices to speak.

The arts have been regarded primarily as a source of income since the late eighteenth century when other economic opportunities were severely restricted. Baskets produced for sale or trade during the reservation period when Native Americans had few other sources of income, kept food on the table and culture in our hearts. Even during the darkest hours of oppression, certain aspects of native culture, including basketmaking, were tolerated because of their commercial value.

Native American arts have changed throughout the past five hundred years to

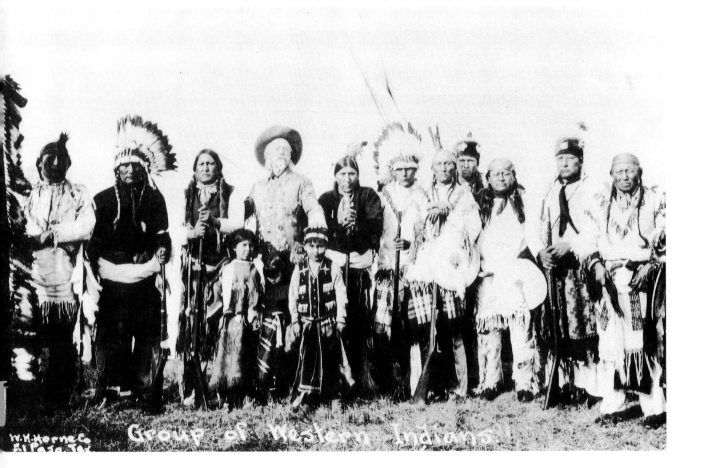

Group of Western Indians

reflect the social and political conditions in which they flourished. Dress, for example, became a metaphor for change in Indian material conditions. As conditions deteriorated, dress decoration became an act of resistance. During the reservation period the government's assimilation policy was geared toward "civilizing" Native Americans and encouraged them to wear European dress to symbolize "progress." In response to this, Indians used decorative techniques to reflect their own aesthetic sensibilities.

Because the arts have both public and private meanings, art is a forum for dialogue, communication, and conflict. Art is not neutral or as silent as some people think. In Canada from 1880 to 1951, it was illegal to participate in a potlatch or Sun Dance, but Indians were allowed to perform dances and music in public. When Indian culture was being denigrated and repressed, Indians were performing in Wild West shows and powwows. While apparently done solely for the entertainment of the non-Indian audience, such events fulfilled the even more important task of maintaining the continuity of culture right under the noses of the people who were oppressing them.

The commercialization of native culture through Wild West shows, souvenirs, crafts, and performances has been viewed as exploitative, but such opportunities provided needed income and became an act of resistance during a time when Native American culture was under its greatest threat. The Wild West show was a negotiated space where Indian and white worlds met. Within this neutral and agreed-upon site, Indians acknowledged their own solidarity and diversity. This understanding continues

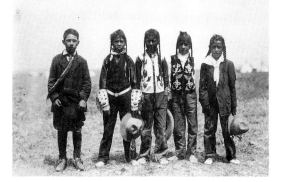

TOP: WOMAN'S SHIRT DECORATED WITH SILVER BUTTONS AND 12 SILVER BROOCHES MADE FROM LATIN AMERICAN COINS, OKLAHOMA. PHOTO BY PAM DEWEY, NMAI. (2.1021)

ABOVE: IN THIS PHOTOGRAPH WE SEE THE TRANSITION BETWEEN NATIVE DRESS AND PERSONAL ADORNMENT TO MORE CONTEMPORARY STYLES INTRODUCED BY EURO-AMERICANS. (NMAI N21900)

OPPOSITE: BUFFALO BILL CODY, CENTER, TURNED THE CONFLICT ON THE PLAINS INTO A FORM OF ENTERTAINMENT THAT STILL INFLUENCES HOLLYWOOD MOVIES ABOUT INDIANS. (NMAI N22828)

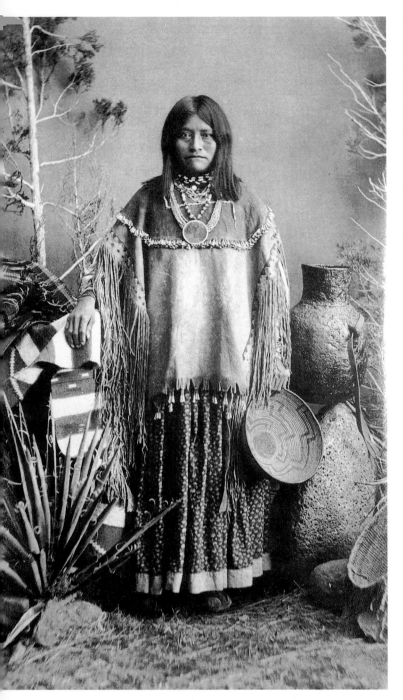

ABOVE: BASKETRY, WEAVING AND JEWELRY CAME TO BE IDENTIFIED WITH SOUTHWESTERN INDIANS. OFTEN THE ARTS OF MANY TRIBES WERE THROWN TOGETHER IN THE PHOTOGRAPHER'S STUDIO. COURTESY, NMAI (35992).

today in the space of the powwow, where Native Americans can express and reinforce their identity. Within the powwow space Native Americans redefine the romanticized Hollywood image of Indians and regain control over their portrayal.

A similar process takes place in visual art, novels, and other art forms that contain both public and private aspects and are accepted forms of expression. Visual artists who paint in two-dimensional space rather than on traditional materials, or storytellers who use the novel or poetry rather than oral forms, are not rejecting tradition but strategically adopting a form that is mutually accepted within native and white societies. By working within the privileged arts, Native Americans not only ensure cultural continuity, but fight for credibility for Native American culture, knowledge, and peoples.

The arts play a crucial role in the decolonization process which reappropriates voice and control of identity and self. While Native Americans fight for self-determination, the arts play an important function in cultural continuity. Following long periods of incursion and dependence, native cultures are now in a renaissance. Assessments of contemporary Native American art show that the artistic productions of today stands up to those of any previous era. Native American voices are being heard through their own artists, curators, and museums. If these are indicators of social health, then our artists are saying we are at the threshold of a Golden Era. *

SOULS OF THE ANCESTORS
DEFENDING CULTURAL PROPERTY

Victoria Bomberry

A delegation from the community of Coroma, Bolivia, entered a large United States Customs warehouse in San Francisco, California, in 1989. They had journeyed more than six thousand miles from a remote altiplano region of Bolivia to identify their sacred textiles, which had been illegally taken by art dealers and collectors. Stacked before them were the sacred textiles that they had traveled so far to recover. Tears of joy ran down their cheeks as they came face to face with the souls of their ancestors after such a long separation. The atmosphere of the cold, distant government warehouse was transformed to an intimate community reunion as Doña Salustiana de Torrez embraced each textile from Coroma.

As a master weaver, Doña Salustiana was able to identify the textiles by the patternings unique to Coroma, the most common of which are bold stripes of rich russets and deep shades of blue. Beyond the knowledge of technique, however, was the force of the weavings that lived within her. Caressing the finely woven cloth, she "read" the stories contained in the textiles. With intense clarity she recalled rituals in which the sacred textiles played an important role. Each mark and pattern liberated the memory and continued the story and history of Coroma as the people talked excitedly among themselves.

The sacred textiles are more than the memories, songs, stories, and histories they recount. They are the embodiment of the souls of the ancestors who founded the ten *ayllus* of Coroma. Pio Cruz, a member of the delegation, explained that the *ayllu* system is a lineage-based social group. Each one of the *ayllus* has possession of a *q'epi* containing the sacred weavings. Of these weavings, each *awayo*, each *ajxu*, each *unku*, each *llaqota* has a particular name that corresponds to the name of a founding person of the *ayllu*. These founding grandfathers and grandmothers are the living power that reaches back to the beginning of life and continues to hold the people together. Through the weavings the people know who they are. Each thread vibrates between the spiritual realm and the everyday lived experience of the community. The theft of the weavings produced a crisis that threatened to destroy the identity of the community and the basic tenets of the indigenous philosophical system. It was an act of violence in the guise of art collecting and preservation.

During their visit, the Coroma delegation requested a meeting with Native Americans in California, a meeting that intensified an ongoing interaction between the people of the north and south who are working on similar issues. People came from the central valley and the northern California coast to take part in the meeting. For the past twenty years, a movement dedicated to cultural and spiritual revitalization has been building in California, and the two delegations found they shared many of the same concerns. Clarence Atwell, tribal chairman and religious leader from Santa Rosa Rancheria, expressed his worry that the souls of the ancestors were alone in California. Joe Carrillo from Tule River remarked, "If in any small way we can contribute to this spiritual process that's happening, then it is good to do. For our people to travel to Bolivia [when the weavings return] is not just a meeting between people, but a coming together of the spirits from our tribes." In an act of friendship and solidarity, an exchange of rituals introduced the ancestors of Coroma to the spirits of the land so they might be comforted during their stay in California. Moreover, the Coromeños and the representatives from California pledged to support one another in repatriation efforts and the right to practice their religions freely.

On September 24, 1992, forty-eight sacred textiles were returned to the community in a ceremony in Washington, D.C. A delegation from California followed the weavings to Coroma in December to give thanks for their safe return and to continue the effort to locate and repatriate other missing textiles. Because of their victory, the community of Coroma has become synonymous with the defense of cultural property.

Since the 1970s, textiles have been disappearing from communities throughout the Andes at an alarming rate, surfacing on the international art market as icons of "lost cultures," often selling for thousands of dollars. The success of the people of Coroma marks the first time that indigenous people have gained the repatriation of stolen cultural property on an international level and had the property returned to the local community rather than to the state as national patrimony. The return of the sacred weavings to the community of Coroma reaffirms the ongoing, dynamic nature of indigenous culture, and offers insights into how an international campaign can succeed. ✳

For a more complete account of this issue, see Victoria Bomberry's article, "Text and Context: Organizing the Return of the Sacred Textiles to the Community of Coroma, Bolivia" *Akwe:kon Journal,* Vol. 9, No. 4 (Winter 1993): 2-11.

THE AYMARA COMMUNITY OF COROMA, WHICH RECOVERED ITS SACRED TEXTILES. PHOTO BY VICTORIA BOMBERRY.

A LEGACY OF EXCELLENCE
HAWAIIAN CRAFTS

Lynn Martin

Many authorities agree that the Hawaiian islands were first inhabited by Polynesian peoples who journeyed to Hawai`i from the Marquesas in the fifth century, and from Tahiti in the tenth century. Using a sophisticated knowledge of ocean currents, swell patterns, and the stars, they sailed on double-hulled wooden canoes carrying the resources necessary to start life in a new land—food, plants, a few small animals, and the ancient skills and wisdom of their ancestors. Until 1778 when the British seafarer and explorer James Cook arrived in the Hawaiian Islands, the Hawaiian people lived in virtual isolation from other cultural influences. Building upon their Polynesian heritage, they developed a complex culture making use of the natural resources in the lush and varied environment of Hawai`i.

KARAKAKOA Bay. OWHYEE.

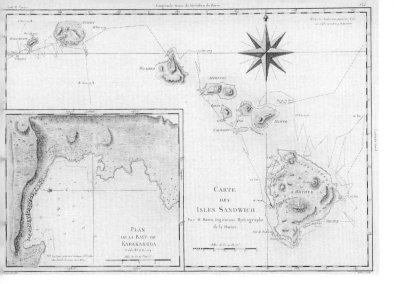

Early Hawaiian society was based upon a four-tiered class system. The *ali'i* (chiefs) ruled with the sanction of *kahuna* (priests) who maintained the relationship between people and the gods. The society was supported by the farming and fishing activities of *maka'ainana* (commoners), and a small group of *kaua* (slaves) tended to the more menial tasks of the society.

A LEGACY OF EXCELLENCE As with many cultures, Native Hawaiians showed great ingenuity in developing crafts that supported daily survival. With no metals, minerals, or high-fire clay deposits available, they fashioned containers from wood and gourds, and made tools from bone, stone, and wood. They pounded bast fiber of the piper mythisticum (paper mulberry) plant for a cloth-like material known as *kapa,* and decorated it with dyes extracted from seeds, bark, and roots.

Hawaiians invested their crafts with beauty and grace. The most exquisite crafts—including shoulder-and full-length capes signifying rank and prestige—were made as tribute for the *ali'i.* For these capes they used the tiny red, yellow, and black feathers of native forest birds, embellishing them with bold geometric designs. At the time, they rivaled the finest velvets of Western culture. The Hawaiians made personal adornments such as lei for the head, neck, wrists, and ankles, from a variety of materials. Temporary lei were made from flowers and leaves, while more permanent ones were made from bone, human hair, wood, feathers, and shells. Hawaiian artists were particularly accomplished in the manufacturing techniques and decorative patterns used to produce *kapa,* which was the most sophisticated in the Pacific. Their feathered capes and lei were by far the most advanced type of featherwork in the region.

WESTERN CONTACT The voyages of Captain James Cook opened the way for a steady stream of Europeans and Euro-Americans into Hawai`i. By the mid 1800s, the port towns of Honolulu and Lahaina had become way stations for traders, whalers, adventurers, and missionaries. Although most travelers stopped only briefly, some stayed in the islands. These first Westerners brought to Hawai`i their vastly different languages, customs, beliefs, life-styles, as

well as the products and tools of their culture. All of these had a dramatic impact on Native Hawaiian culture.

Western imports dramatically influenced Hawaiian crafts. In some cases Western items and methods replaced those of native design. In others, Hawaiians embraced elements of Western design or form and blended them with their original craft traditions. Sometimes, completely new traditions emerged. Throughout this period and into contemporary times, however, the underlying aesthetic of Hawaiian crafts has remained constant. Large design schemes supported by intricate patterning, an interest in both symmetry and asymmetry in design schemes, and an emphasis on finely executed craftsmanship all continue to be important elements of Hawaiian design. Some of the most dramatic examples of change and innovation in crafts can be seen in lei making, woodcarving, quilting, and *lauhala* plaiting.

LEI MAKING Perhaps the most enduring and adaptable craft tradition in Hawai`i is that of the lei, a tradition of making and wearing garlands. Modern lei are fashioned from a variety of materials, including flowers, leaves, shells, seeds, and feathers. Since ancient times lei have been made from the lush Hawaiian flora. A variety of techniques, including *haku* (plaiting materials in a braid), *wili* (using a strand of fiber to wrap materials onto a central base), and *ku'i* (stringing materials onto a strand of fiber) were used to make lei. Lei made from fresh materials were and still are given as a sign of respect and

affection, and are made and worn by chanters and dancers of the hula. With a fresh lei, the concern is not that it lasts a long time but that the materials used in the lei are at their peak when it is given and first worn. The ephemeral nature of the lei is part of its beauty—its colors, textures, and fragrance are for the momentary enjoyment of the person wearing the lei and the people viewing it.

Fashioning lei from more permanent material is a tradition that dates back to ancient Hawai`i, when lei made from bone, wood, feathers, and shells were made for

MILILANI ALLEN WEARING VARIETIES OF FRESH LEI. PHOTO BY LYNN MARTIN.

special people and occasions. Many of these lei are still made, though not necessarily for specific people or events. The most prized of the permanent lei are those made from feathers and shells. Feathers used to create the ancient-style round lei that are worn around the neck are no longer taken from indigenous birds, many of which are extinct or endangered. Instead they are fashioned from the feathers of introduced birds such as peacock, pheasant, or guinea hen. Sometimes imported duck or goose feathers are used. Shell lei are made from tiny, subtly-colored shells that wash up only on the shores of Ni'ihau and southern Kaua'i. These lei are valued for their exquisite delicacy and beauty, and are sold in fine jewelry stores. Older ones are treasured as heirlooms.

WOODCARVING In ancient Hawai`i, large and small images of gods were carved from wood, as were nonreligious items such as

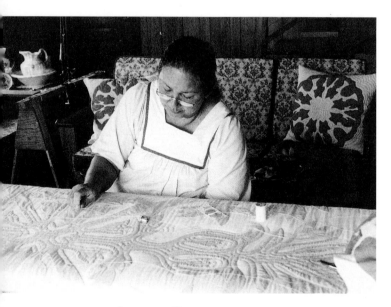

JUNEDALE QUINORIES QUILTING A TRADITIONAL PATTERN AT HER HOME ON THE BIG ISLAND OF HAWAI'I. PHOTO BY LYNN MARTIN, HAWAI'I STATE FOUNDATION ON CULTURE AND THE ARTS.

serving platters and calabashes. The men who carved the deities had to master religious and spiritual protocol before carving, to ensure that their work was carried out with the proper ritual and that the images were invested with spiritual power. They, like the carvers of wooden canoes, held an elevated status in the community and were regarded as a priestly class. When the Hawaiian religion was challenged and eventually overthrown in the early 1800s, traditional wood-carvers lost the principal context for their artistry. Contemporary wood-carvers strive to create images based upon traditional religious subjects. With this spiritual foundation they integrate their personal creativity and artistry, resulting in bold images that are traditional in inspiration and contemporary in execution.

QUILTING In pre-contact Hawai'i, clothing and bedding were used to protect the body and fend off the occasional chilly weather. Clothing was minimal—yards of *kapa* wound around the waist for women, a loincloth for men, and a shoulder cape for both. People usually slept on a mat plaited from the dried leaves of the pandus tree (*lauhala*) and covered themselves in *kapa-moe* (sleeping *kapa*), sheetlike layers of *kapa* stitched together at the top edge, often featuring large stencilled geometric designs.

When New England missionaries came to Hawai`i they brought their styles of dress and encouraged the Hawaiian women to learn to sew. Sewing schools were set up at churches where women made clothing and later turned their skills to quiltmaking. Rather than adopting the New England patchwork style of quilting, Hawaiian women freely exercised their creativity, building upon their

design heritage, which they combined with Western quilting techniques. Born from this combination was the distinctive tradition of the Hawaiian quilt, which characteristically features a single overall symmetrical design motif in one color appliquéd onto a single-color base. The motif of Hawaiian quilts is often based on floral or leaf designs ,and the pattern is cut much like a paper snowflake. Radiating out from the *piko* (navel) of this pattern are rows of quilted stitching, approximately one inch apart.

LAUHALA PLAITING In pre-contact Hawai`i, the dried leaves, stems, and vines of various plants were plaited to fashion a wide array of baskets, headgear, floor mats, roofing, and cordage. The greatest ingenuity and time were invested in twined baskets made from *'ie'ie,* the aerial roots of a high mountain vine. Subtle monochromatic patterns were created by varying the direction of the twist in the twining technique. Intricate monochromatic patterning also predominated in plaiting sleeping mats from *makaloa* stems, an endemic sedge grass of Hawai`i. These mats, the largest of which might reach twenty square feet, were made from strips of fiber measuring as narrow as one-sixteenth of an inch across and could take many months to complete. The finest and most coveted *makaloa* mats were produced on the island of Ni'ihau, now a small privately-owned island off the southern coast of Kaua'i. *Lauhala,* a highly durable and versatile fiber produced from the dried leaves of the pandanus tree, was also used to fashion work baskets and floor mats. These baskets and mats contained little ornamentation and were plaited in a much bolder style, using fiber widths averaging one-half to one inch.

After the introduction of Western tools and materials in the early 1800s, many traditional plaited items were no longer used. Thus, by the late 1800s the production of *'ie'ie* baskets and *makaloa* mats virtually ceased. Pandus baskets and floor mats continued to be made, but production was limited mostly to rural areas. The skills and artistry of weavers, however, were not abandoned but were redirected to the making of hats. The newly imported headgear introduced by the Western community inspired Hawaiian weavers to create hats in a variety of styles, ranging from practical work hats to fashionable hats for special occasions. Today, *lauhala* hats are made by a small but dedicated group of weavers. Many of these weavers are originally from the district of Kona on the Island of Hawai`i, where from the 1930s to the 1950s hatmaking was a vital cottage industry.

Through the years hat styles have varied greatly. Subtle, monochromatic chevrons, similar to those used on old *makaloa* mats, embellish finer hats. Another style of patterning called *anoni,* which emerged in the Kona District, features patterns created by using two natural tones of *lauhala,* a dark brown and a lighter cream or tan. A flower or feather lei is usually added as a final adornment on any *lauhala* hat.

Although changes brought by contact with the West precipitated the loss of many skills and art forms, Hawaiians have preserved the integrity of their cultures. By blending Western forms, materials, and techniques with their own, Hawaiians have given the world new art forms and new traditions. This ability to adapt and transform will provide Hawaiian artists with the strength to carry their traditional crafts into the future. ✳

THE KUNA MOLA
A WOMEN'S ART

Mari Lyn Salvador

The Kuna peoples of Panama are best known for their molas, the colorful and richly decorated appliqué blouses made by Kuna women. Kuna cultural identity, however, comprises a remarkably wide range of distinctive visual and verbal modes of expression, all informed by a dynamic and sophisticated system of aesthetic values. In the visual domain, the Kuna make use of intricately woven baskets and hammocks, as well as hand-carved wooden stools, utensils and calabashes, as a part of daily life. Authority staffs, painted doors and portraits are associated with Kuna politics in the village gathering house. Carved anthropomorphic figures and ceramic braziers are used in healing rituals. Bird bone necklaces, cane flutes, and calabash rattles are associated with rites of passage. In the verbal domain, eloquent political oratory and captivating narrative chants are performed in the village gathering house. Rites of passage, healing chants, and lullabies offer opportunities to demonstrate verbal mastery and musical ability while teaching shared values. Art and artistry permeate and enrich all aspects of Kuna life, creating an overarching means of distinguishing individual achievement and the expressive spirit of the Kuna people.

THE KUNA AND THEIR ENVIRONMENT The Kuna live in Kuna Yala (formerly known as the Comarca de San Blas), a reserve belonging to the Kuna according to legislation of the Panamanian government. It includes the San Blas islands and the nearby mainland rain forest. Most of the Kuna live on approximately 35 of the 365 small islands located in this 170-mile-long chain that lies just a few miles off the Caribbean coast of Panama and stretches from east of the Canal Zone almost to the Colombian border. They have lived there since the 1850s when they left the mainland for the more hospitable environment of the islands—escaping the insects, illness, vampire bats, and other discomforts of rain forest living. This migration also enabled them to increase coastal trade in items such as coconuts and tortoise shell.

The Kuna have had extensive contact with Europeans and other outsiders for more than four hundred years. The Spanish were active in areas now known as Panama and Colombia following their arrival in the early sixteenth century and maintained an adversarial relationship with the Kuna. Hostilities continued until 1787 when the Spanish and Kuna signed the Treaty of Ascension and the Spanish withdrew. A

century and a half later, in 1926, the Kuna rebelled against local Panamanian authorities and established a semiautonomous territory. The Kuna propensity toward independence continues today.

While deeply concerned with the preservation of traditional ways of life, the Kuna actively incorporate influences from the outside world. Missionaries, anthropologists, Peace Corps volunteers, and more recently shiploads of tourists have brought a wide range of material goods and ideas to Kuna Yala. For the Kuna themselves, travel outside the archipelago and long stays in urban centers such as Panama City have become common for many families. As a result of these influences, items such as elevators, scissors, needles, and thread have been included in their mythology. Helicopters, Santa Claus, Mickey Mouse and JFK have appeared as themes in molas. Nevertheless, these outside elements are integrated in very "Kuna" ways.

KUNA EXPRESSIVE CULTURE Through ethno-aesthetic analysis of Kuna arts, it has become clear that the Kuna value talent, learning, competence, productivity, and eclecticism. Further, there are stunning similarities in the structural principles that guide the verbal and performance arts as well as the visual arts. Filled space, subtle asymmetry, embellishment, parallelism, and repetition with subtle variation are the basic standards for artistic criticism of mola design—standards that have also been documented for Kuna speech, chants, lullabies and flute music. These aesthetic principles appear to be consistent in all spheres of Kuna expressive culture.

Basic to the Kuna's ideology is the concept of *kurkin*. The ability to excel in artistic

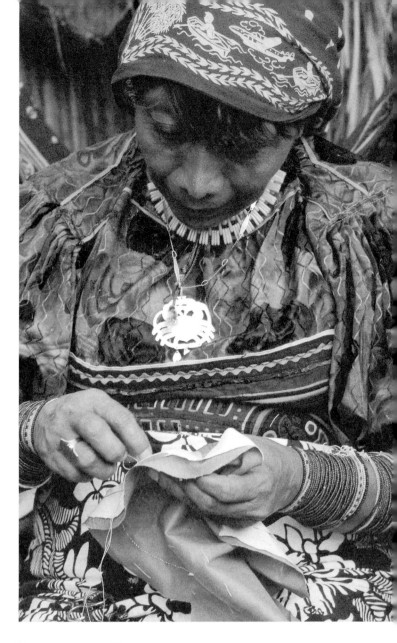

MAKING MOLAS, A KUNA WOMEN'S ART, KUNA YALA, PANAMA. PHOTO BY MARI LYN SALVADOR.

endeavors such as public speaking, dancing, healing, making molas, is attributed to having *kurkin*— intelligence, natural aptitude, ability, or talent. Kuna believe that *kurkin* is distributed in varying degrees to all people by Mu, the mythological grandmother. One can have *kurkin* for any skill—hunting, learning a foreign language, eloquence, or making beautiful molas. *Kurkin* can be improved by the use of various medicines. Women who wish to

enhance *kurkin* for making molas, for example, will soak plant leaves with interesting geometric designs in water. They then bathe their eyes in this water to improve their ability to see and create pleasing forms in their own work. Women also soak and mold this kind of leaf into rounded shapes to be dried and burned. They place their hands in the rising smoke to improve their *kurkin* for cutting the fabric for molas.

Generally speaking, the primary mode of artistic expression for women is visual,

ways of Kuna life. Women also give speeches in the Mola Cooperative and the village gathering house when the subject is of interest to them. Likewise, men create important visual arts, such as carved wooden figures, authority canes, baskets, decorated canoes, and painted doors for gathering houses.

WOMEN'S ARTS Kuna women are noted for their distinct style of dress. Family wealth is often expressed through the women's dress and jewelry, and beautiful women bring

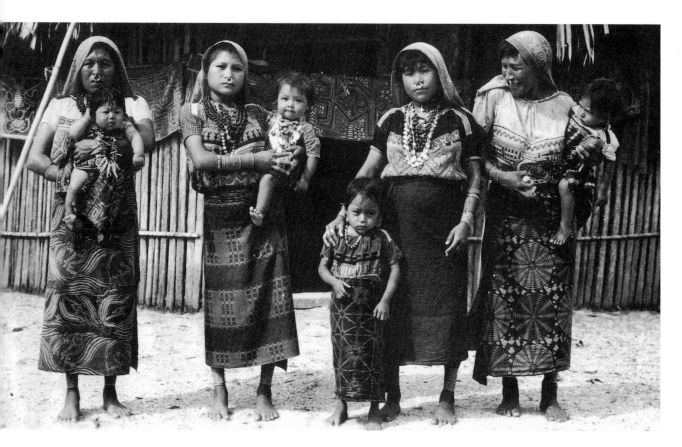

such as mola making, while for men it is verbal, such as chanting and speaking in the gathering house and during public rituals. This is not always the case, however. Women also engage in verbal arts. Lullabies sung to children by their mothers, sisters, or other female relatives provide children with their earliest exposure to language, song and the

A GROUP OF KUNA WOMEN AND CHILDREN FROM THE SAN BLAS ISLANDS, PANAMA, ARE SEEN IN TRADITIONAL DRESS. COURTESY, NMAI (25444).

prestige to the whole family. Style of dress is an important avenue for personal expression, with emphasis placed on the careful combination of molas with specific scarves and skirts. The most integral part of Kuna women's dress is the mola. Although outside of Kuna Yala mola panels have come to be thought of as appliqué wall hangings or pillow cases, they are actually the front and back panels of a blouse.

Although the origins of Kuna dress and mola making have been integrated into Kuna mythology, mola making, is, in fact, a relatively recent process. Towards the end of the nineteenth century, Kuna women began to experiment with a new practice, the transfer of body painting designs to fabric. Initially, these designs were painted onto an underskirt (picha). When printed trade cloth was introduced, the women used it as a wraparound skirt over the underskirt, which they no longer painted. These designs were subsequently sewn onto the borders of blouses which required the acquisition of needles, thread, scissors, and fabric—all elements from outside Kuna culture. By the early 1900s, as more brightly colored cloth became available, women cut geometric designs out of the top layer of the border, folded the edges under and sewed them to the layer below. Soon the blouse itself was made shorter and the mola portion was increased, until only a small yoke and the sleeves were left without embellishment. Early molas were large, loose fitting blouses with simple designs done with broad elements. Over the years, Kuna women have refined the process and developed several thousand designs and more and more innovative and difficult ways of executing them. Mola making in the twentieth century has developed in the direction of increased complexity, refined designs, smaller and smaller elements and an increasingly sophisticated system of aesthetic judgment.

Mola making is a frequent topic of conversation among women. In fact, in Mola Cooperative meetings, the manner in which molas and related business matters are discussed has taken on a level of importance comparable to that of political oratory in the gathering house. Keen judgments are made and a highly refined system of qualitative criteria has been developed. In addition to those mentioned previously, these criteria include skillful manipulation of the technical process, proper visual organization, visibility of design, use of correct colors, and interesting subject matter.

Generally speaking, Kuna women make molas for their own use, and sell them after they tire of the blouse. Since the 1960s, however, the making of molas has taken on a new level of importance in Kuna society. Groups—such as the Mola Cooperative which was started with the assistance of Peace Corps workers—have begun making molas and mola objects specifically for sale. Molas have become popular items for purchase among tourists, and are an increasingly important source of income. Moreover, the influence of the international market and the interest of tourists has in turn influenced the development of mola forms and motifs—there are now mola stuffed animals, bags, and pillows. Although the form of molas has continued to change as a result of outside influence, the cooperatives have maintained the same rigorous standards of quality. ✳

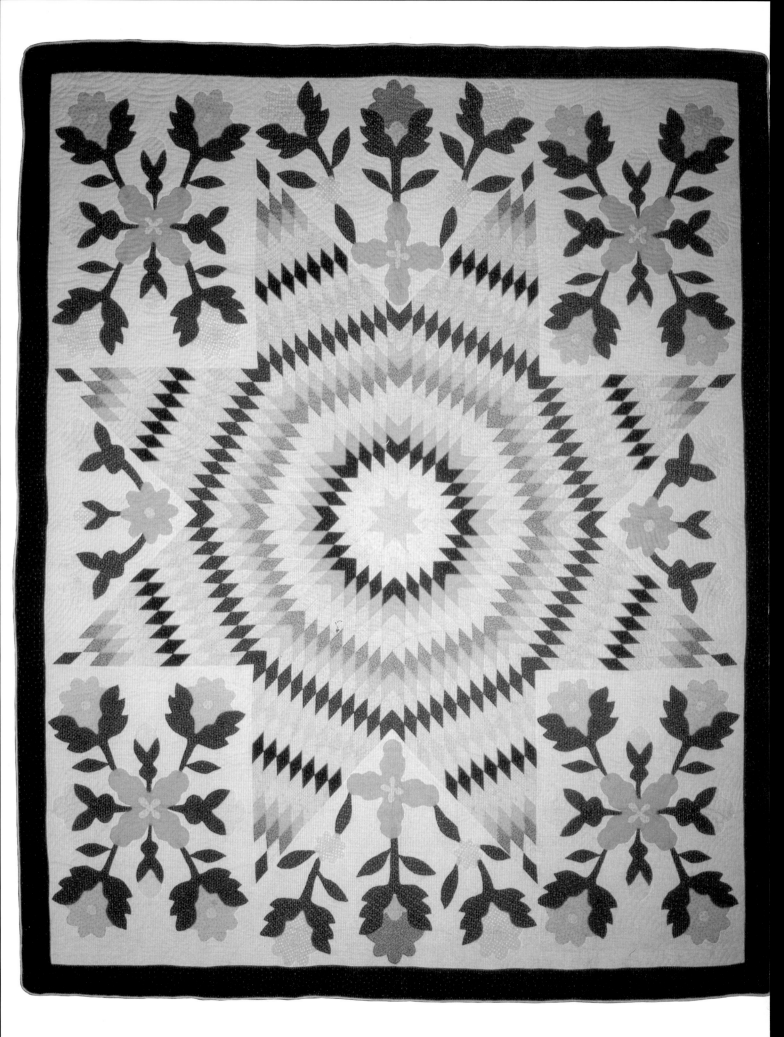

SEWING IT TOGETHER
NATIVE AMERICAN AND HAWAIIAN QUILTING
TRADITIONS

Marsha MacDowell and Margaret Wood

Of the various North American Indian art forms that resulted from contact with Euro-American missionaries and settlers, perhaps the least well known is quiltmaking. Throughout the entire post-contact period, native quilters in the Hawaiian Islands and on the North American continent have used colors and designs distinctly their own to make quilts which function in ways both similar to other cultural groups as well as in ways that have specific tribal or pan-Indian meanings. Quilts are used in native communities, as in other cultural settings, simply to serve as warm bedcovers, as items to be sold at fundraisers, and as gifts for special occasions.

Quiltmaking was first introduced to many tribes in the 1880s by government and religious agencies. Quilting and other domestic skills were learned in women's church groups, or were taught to adults by government workers and to young girls in the home economics classes at federal and parochial boarding schools. When large numbers of native women were moved onto reservations in the late nineteenth century,

STAR OF BETHLEHEM, MARGARET DAVID, CA. 1920. 195 X 233 CM. COURTESY MICHIGAN STATE UNIVERSITY MUSEUM.

they began to adapt their sewing skills from traditional materials to Euro-American trade goods and textiles. In the early 1900s, when frame houses became common, the quilt became an important household item. For Plains Indians, quilts functioned not only as bedcovers but also as wallhangings which were carryovers from the days of dew curtains that hung inside tipis to serve as moisture barriers, wind breaks and insulators. Elders newly settled in frame houses hung quilts as doors and as window covers.

Currently, quilts have gained a prominent place in powwow gatherings around the country. Sometimes quilts are raffled at powwows to help raise funds to pay expenses. Often a quilt is opened and carried around the edges of the dance area so spectators can toss in money to help pay expenses. Quilts are often used in gift-giving activities during powwows, elders gatherings and other tribal-based events. In some areas of the country, quilt judging categories have become standard fare at tribal art shows and quilt shows have become part of some powwows. As quilts gain in popularity, quilting techniques are being used by contemporary textile artists to express individual creativity and ethnic and racial identity.

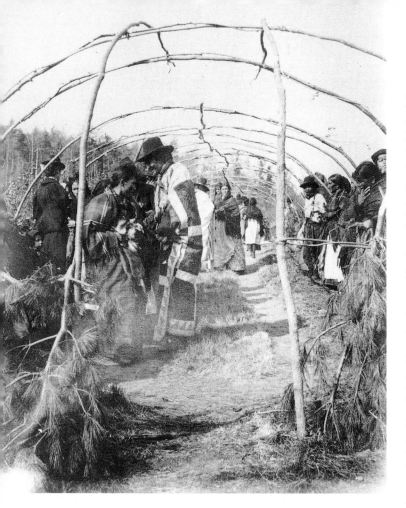

MAN WRAPPED IN QUILT, MIDEWEWIN CEREMONY, LAC COURT OREILLES, WISCONSIN. CA. 1899. PHOTO BY A.E. JENKS. COURTESY, NATIONAL ANTHROPOLOGICAL ARCHIVES, SMITHSONIAN INSTITUTION, NEG. NO. 476-A20.

There may be a cultural basis for the widespread adoption of quilting among native peoples. The social nature of the production of quilts mirrored the social and cooperative work patterns of the preparation and decoration of hides and other tasks. Quilts were functional and could be produced inexpensively. Everyday quilts were made from old clothes, flour sacks, even empty tobacco bags. They were simple patchwork patterns and were usually tied or tacked together. New fabric was reserved for gift quilts or ones to be used for ceremonial occasions. Special quilts were almost always hand quilted.

PLAINS AND GREAT LAKES REGIONS The star pattern, frequently used among the Plains Indians, closely resembles traditional Plains decorative tradition. An important and striking traditional motif known as the Morning Star pattern was painted, quilled, or beaded on hide robes, clothing, shields, and other items. The Morning Star, which appears in the east in early April, represents the direction from which spirits of the dead travel to earth and thus signifies a continuing link between the living and the dead. This medallion design consists of diamonds in progressively larger circles. The star pattern used by Sioux quiltmakers is virtually identical to the Star of Bethlehem or Lone Star pattern which dates back to the eighteenth century and was used in the United States and England. Plains women may have borrowed and adapted the Anglo-American Star of Bethlehem design or invented the pieced star based on the Morning Star motif.

Among the Plains tribal groups, the star quilt has become an object of considerable social and ceremonial importance. At contemporary funerals, star quilts are draped over caskets and or hung in back of them. Often one of the displayed quilts is wrapped around the corpse before burial. Star quilts are considered essential gifts in helping newly married couples set up housekeeping. A crib-size star quilt is a common gift for a newborn child.

Quilts have been used as gifts in naming ceremonies and as an outer wrapping to warm individuals on vision quests. Among the Oglala, a star quilt may be made from the cloth used in Yuwipi ceremonies and then used as a medicinal covering to help heal someone suffering from respiratory illness. The Oglala also commonly wrap a star quilt

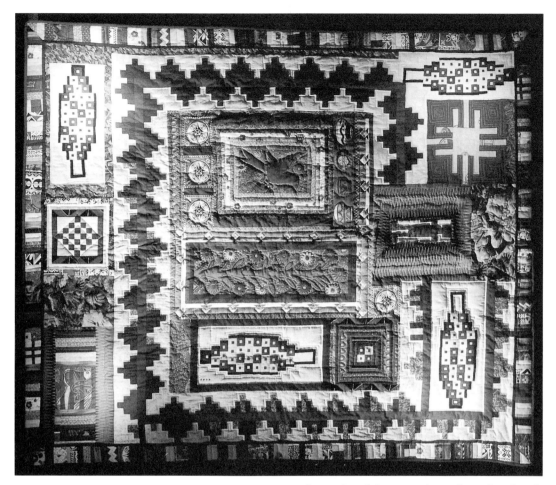

RUSTY MAIZE, MARGARET WOOD. COTTON AND SHELL QUILT, 205x172 CM. QUILT DISCOVERY DAY, PHOENIX, ARIZ, 1994. PHOTO BY BILL McLEMORE. COURTESY, NMAI.

and matching pillows around a new tombstone until it is unveiled.

Quilters from the Great Lakes tribes also use the star pattern, enhanced in the four corners by typical regional floral appliqué. Others have adapted designs from traditional quillwork boxes. In this region, quilting is documented to have been well established by the 1920s to the 1930s, among the Potawatomi, Ottawa, and Ojibwe tribes, which speak similar dialects of the Algonquin language. The mission churches introduced quiltmaking techniques to the Great Lakes tribal women, who relate stories of church groups creating quilts for poor families and raffling or selling quilts at church bazaars. Away from the church, Indian women made quilts that they used for barter, sold for cash to tourists and local stores, and used to pay for services rendered.

OKLAHOMA SEMINOLE Quiltmaking among the Seminole reflects their past. In the 1830s, some Seminoles were removed from their Florida homeland and sent to Indian Territory, later called Oklahoma. Being displaced culturally and geographically, they quickly assimilated; most lived with vestiges of Seminole culture and language interwoven with a rural American existence, which included quiltmaking.

It has become a part of funeral practice among Oklahoma Seminoles to place a quilt, a new one if possible, over the casket in the grave. The quilt protects the casket and muffles the sound of the soil hitting the casket.

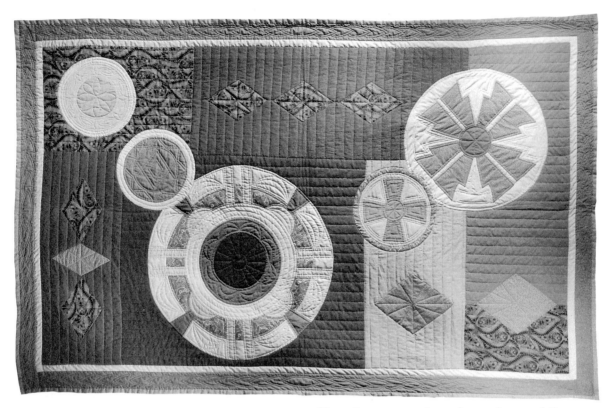

BASKET QUILT, DIANE O'LEARY. DISCOVERY DAY, PHOENIX, ARIZ, 1994. PHOTO BY BILL McLEMORE, NMAI.

PIMA-MARICOPA AND NAVAJO Most of the women in the Pima Maricopa Indian community of Scottsdale, Arizona, learned quilting skills through women's club gatherings, government home extension classes and church groups. Similarly, quiltmaking was introduced to the Navajo community primarily by missionaries and was taught through church groups.

HAWAIIAN QUILTS Hawaiian quilts differ significantly from mainland American quilts, perhaps because of two factors. First, the Hawaiians were already skilled at the art of making large sheets of *kapa* cloth from the mulberry plant, which they decorated with intricate original designs. Secondly, the loose muumuus the missionaries taught the

Hawaiian women to make, and coaxed them to wear, were made in such a way that there were no scraps left over for quilts.

The Hawaiians devised a method of what might be called "whole cloth appliqué" quilting. In this method, a large piece of light-colored fabric, often a purchased bed sheet, serves as the base. An almost equally large brightly colored piece of fabric is folded and cut in the same manner as one cuts out a paper snowflake. The cut appliqué piece is opened, spread over the base, basted, and the edges sewn using a whipping stitch. The appliqué patterns are almost always floral designs adapted from native plants. By far, the most common quilting pattern is one that outlines the appliqué design and repeats the pattern at spaced intervals. This echo quilting technique is often called Hawaiian quilting.

CONTEMPORARY QUILTERS "Contemporary" is used here to mean quilters producing pieces in modern times using other than traditional

quilt patterns, materials, and techniques known to the local community. All handmade quilts are in a sense original pieces of art because each, whether a traditional or an original design, is adapted or modified to please the designer. Fabric, color, and quilting pattern choices further lend ownership to the individual who can say, "I did it this way because it pleases me."

Among Indian as well as non-Indian quilters, there are some who draw inspiration only from existing patterns and there are those who create original designs. Some are artists who move outside their regular medium of painting or other art forms to experiment in quilts. Other quilters choose to adapt Navajo rug patterns, Plains tribal beadwork patterns, or basket designs into fabric. Some want to record personal histories and tribal stories. Most contemporary quilt designers draw upon their own tribal identities as well as general and specific design motifs and techniques from various other tribes. There is a trend to blend tribal motifs as quilters of mixed blood create art that incorporates both or all of their own tribal identities. As native quilters become more aware of the quilt traditions of other cultural groups, blending and borrowing of tribal motifs will take place.

CONCLUSION Recently, there has been more attention to the quilting tradition than ever before. Quilts are being used as decorative elements in graphic designs for such items as the cover of the best-selling book *Lame Deer: Seeker of Visions* and the flyer for the Northern Plains Indian Art Show. Hidatsa Mandan quilters have participated in the Smithsonian Festival of American Folklife, Clifton Choctaw quilters in the Louisiana Folklife Festival, Seminole quilters in the Florida Folklife Festival, and Ottawa and Ojibwe quilters at the Festival of Michigan Folklife. Native quilters have participated in the Traditional Arts Apprenticeship Program run by several states' arts programs. A native Hawaiian quiltmaker, Melaii Kalama, was honored in 1985 as a recipient of the prestigious National Heritage Fellowship.

Individual quilts made by Native American textile artists have been included in recent exhibitions such as *Lost and Found Traditions: Native American Art 1965-1985* (organized by the American Federation of the Arts) and *Michigan Quilts: 150 Years of the Textile Traditions* (organized by Michigan State University Museum, 1987). Quilts have also been the subject of an entire exhibition entitled *Native Needlework: Contemporary Indian Textiles from North Dakota* (organized by the North Dakota Council on the Arts, 1988). In the mid-seventies, Florence A. Pulford, a white American, started promoting, exhibiting, and selling her collection of Plains Indian Morning Star quilts. Her work has contributed significantly to the visibility of these quilts.

As more information about and exposure to American Indian quilts and quilters occurs, these artists will receive the public and scholarly recognition they deserve. The tradition of quilting will be recognized as a cultural expression clearly connected to native communities, and designers of contemporary art quilts will be more fully acknowledged within the quilt and art communities. ✳

INDIAN ARTS AND CRAFTS ACT: POINT

Dennis Fox

Imagine the uproar if a car manufactured overseas and falsely presented to the public as American-made were offered for sale at cut-rate prices in the United States—and began to outsell the domestic models. Controversy over the cost to the American economy would put the deceptive manufacturer out of business, as soon as the scheme was discovered.

Yet this scenario is played out time and again as American Indian-made products are undercut by less expensive offshore production pieces. This happens despite laws in place to stop it. The Indian Arts and Crafts Act of 1990 states that artists who claim to be American Indian and represent themselves as such and thus gain monetary compensation for "authentic" American Indian art must be recognized as American Indian.

This measure alone will greatly reduce the competition from fakes on the marketplace and preserve the diverse cultures of the American Indian nations—on Indian terms. It will also, as intended by Congress, assist American Indians in gaining a foothold in a market estimated in the hundreds of millions of dollars annually. That market currently operates in their name and image (a false image to be sure), but with little tangible benefit to them.

With implementing guidelines in place, we have an answer to the most pertinent question: "How do I tell what is actually American Indian-made?" Under the guidelines, the answer could be as simple as, "Look for the Indian Arts and Crafts Association logo," a tribal identification logo, or an American Indian arts organizations logo, much in the way brand loyalists look for a company trademark when shopping. In this case the insignia would say nothing about quality or commercial appeal and nothing about brand loyalty. It would not function as a seal of artistic approval. It would simply declare an object American Indian-made, nothing more.

Giving regulatory teeth to the 1990 law would also "count coup" against the ludicrous stereotyping Indian people continue to endure. Stereotypical images are perpetuated in the art objects of people who have no idea of American Indian diversity or of what it means to be Indian.

Cultural preservation and renewal must be the province of recognized American Indians, and this means reclaiming the culture once and for all from a nostalgic image of Indians as a stagnant relic of the past and a stumbling block to the nation's westward expansion. The injunction to "go west, young man" is no longer tenable, westward expansion has stopped at the ocean, the frontier has disappeared—yet the first Americans are still expected to live in tipis, wear feathers, and ride horses bareback. They are still considered a stumbling block to progress.

Countering this moribund image is one important way to reclaim the living culture of American Indians; and in the last analysis, only legitimate American Indians can do this, for only they possess the on-

the-ground experience that can act as an antidote to rampant misinformation and romantic clichés.

When fully operational, the Indian Arts and Crafts Act would indeed expand that marketplace by setting precedent for non-Indian businesses claiming links with Indian communities. Anyone capitalizing on a claim of authenticity for American Indian production connected to the arts—be it authorship, intellectual property, historic artifacts or innovations on traditional tribal practice—will have to substantiate their claim or risk infringement of copyright. American Indian

groups and communities are the sole repositories of their own authenticity; to relinquish the use of it is not to relinquish a right of ownership.

Finally, implementation guidelines would protect the Indian Arts and Crafts Act from loopholes opened by international agreements. Guidelines must be in place to ensure that importers cannot sidestep provisions of the act through careful wording in compliance with a selective definition of indigenous peoples. Such loopholes, if allowed to remain in the law, will simply shift the routing of fake items from offshore to north or south of United States

borders as suppliers import their putative indigenous products under a less restrictive definition.

Meanwhile, artists who happen to be American Indian, but who are not recognized by the Act for whatever reason, will not be hindered. They can identify as artists involved with an artistic movement or an aesthetic community, or in some other way describe their accomplishments. The intent of the Act is simply that those who have identified as American Indian for years must now prove that they are American Indian or relinquish that claim. ✳

INDIAN ARTS AND CRAFTS ACT: COUNTERPOINT

Kay WalkingStick

At the turn of the century my grandfather, Simon Ridge WalkingStick, a lawyer in Tahlequah, Oklahoma, was hired as a Cherokee interpreter for the implementation of the Curtis Act, which parceled out "Indian Territory" to those individual tribe members who would allow themselves to be numbered and registered. The land that remained after this

parceling was then given or sold to white homesteaders and businesses, Indian Territory was no more, and Oklahoma became a state. My grandfather took the job because he saw the inevitability of statehood and wanted to get his tribe the fairest shake possible. He wanted to ensure that those registrants who spoke only Cherokee knew exactly what

they were signing.

Many Cherokees, however, didn't sign. Some lived outside Indian Territory and felt they had nothing to gain by making the trip to Tahlequah. Others mistrusted white people—the Trail of Tears was only sixty years in the past. These people were often traditionalists who wanted to retain the old ways. Their tribal lands and their

way of life were being taken from them. Furthermore, numbering and registering them was a humiliating process, and its purpose was to control people.

Even so, the only way one can prove one is a Cherokee today is to produce the registration number of an ancestor and through such documentation be accepted as a tribal member. The children and grandchildren of those who did not register cannot prove they are Indian.

Now the numbering and registering have returned to haunt us. On November 29, 1990, President Bush signed into law the Indian Arts and Crafts Act, which stated that a person who exhibits Native American art for sale must be able to prove, through tribal membership or certification, that the maker is indeed an American Indian. If a person not certified as an Indian is convicted of selling Native American arts or crafts, or exhibiting them for sale, he or she and the exhibiting space—whether commercial or nonprofit—are subject to a $250,000 fine and up to a year in jail. The members of no other racial group in the United States have ever had

to prove their ethnic heritage in order to sell their art.

The goal of the act is to update a law on the books since 1935, its purpose is to promote and protect Indian arts and crafts and to prevent misrepresentation. At present, there are no regulations for defining or imposing the new law— legislators have yet to decide, for instance, how many objects made by Indian artists who are citizens not of the United States but of Mexico, Canada or South and Central America will be sold here, and whether or not the law applies to film, video, performance, and computer-generated art. According to Geoffrey Steam, of the Indian Arts and Crafts Board (IACB), which will handle complaints, the formulation and implementation of regulations will take about a year. Until then, the chances of anyone being brought to trial are negligible.

Once the regulations are in place, however, individuals will be able to make a complaint to the IACB, and tribes will be able to bring civil suit. And the regulations are not intended to address the basic premise of the law,

which is problematic. For there seems to be no consistent rule for tribal membership among the hundreds of tribes in the United States. The conditions of membership are decided by each sovereign tribal nation. To be a tribal member of the Salish of Montana, for example, one must have been born on the Salish reservation. In order to be a Hopi, one's mother must be a Hopi tribal member. This means that if your father is Hopi and your mother is Salish and you were born in St. Louis, you cannot be a member of either tribe, even though you are a full-blooded Native American.

In addition, many tribes are not recognized by the government, some tribes that were formerly recognized are no longer, and some are recognized by their state but not by Washington. The net result is that many people who identify themselves as Indian are not recognized as such by the federal government. (It often happens that Indians in need of the assistance that the government has promised native peoples through treaty cannot prove their Indian identity.) Furthermore, there are Native Americans who reject the whole idea of formal

tribal membership to the extent that they see it as a foreign, bureaucratic imposition alien to their own traditions of thought.

This problem in the classification system on which the law is based is accompanied by considerable worry over how it will be applied. A foretaste has been provided by an organization called the Native American Art Alliance (NAAA), out of Santa Fe, which has been vociferously leading a fight to prevent unregistered Indian artists from selling their artwork as "made by Native Americans." The NAAA has made accusations against many prominent artists. This July they were able to prevent the opening of an exhibition at Santa Fe's Center for Contemporary Art by the Cherokee artist Jimmy Durham, on the grounds that Durham is not registered—this despite the fact that the NAAA has no judicial power (it is only a political lobbying group); that the IACB, according to Steam, will not support any civil or criminal charges under the law until the regulations are complete; and that the law allows an exhibition venue to protect itself from civil or criminal suit

simply by printing a disclaimer that although the artist identifies him- or herself as Native American, he or she is not regarded as a member of a tribe.

The most convincing voice I have heard in support of the law is that of the Mohawk artist and educator Richard Glazer-Danay. Glazer-Danay doesn't want his culture defined by the art of non-Indians. He doesn't want his grandchildren to pick up an art book and see a painting by a non-Indian who claims to represent Indian culture. The law is intended to prevent this possibility, but its longterm effects may also be negative. We do have to prevent non-Indians from marketing American Indian-style objects as authentic. We must protect collectors of Native American art. We have to stop fraudulent behavior; surely no one would argue that view. Yet through this law some of our most important artists may be stopped from exhibiting their work and affirming their identity. How are we to get them out of the tribal membership trap written into law?

It is our Cherokee custom to consider the welfare of the next seven generations in all

the decisions we make. Grandfather WalkingStick may have made the wrong decision in taking translation work in Tahlequah—but he was trying to foster the longterm common good of his tribe, within the framework of turn-of-the-century federal Indian policy. That policy was based on the economics of real estate, with little regard for the individual Indian. This present law is also about economics. Its intention is to protect the individual Indian artist and craftsperson, but it is crippled, and may end up hurting our fellow artists. The law needs to be re-examined to work for the longterm common good of Native American people. ✳

This article first appeared in the November 1991 issue of *Art Forum* (Vol 30: 20-21), entitled "Kay WalkingStick on Indian Law." Reproduced by permission.

THE LIVED EXPERIENCE
AMERICAN INDIAN LITERATURE AFTER ALCATRAZ

Kathryn Shanley

On November 20, 1969, a group of seventy-eight Indian young people, calling themselves Indians of All Tribes, sailed out to occupy Alcatraz Island in San Francisco. A previous attempt to claim the island for Indian use had resulted in a legal suit, which was dismissed after four years. The 1969 Indian claim to the island was based on an aspect of the Fort Laramie Treaty of 1868, negotiated a century before, and in many respects long forgotten, which states that any Sioux tribesman and a

> resident or occupant of any reservation or Territory not included in the tract of country designated or described in this treaty for the permanent home of the Indians, which is not mineral land, nor reserved by the United States for special purposes other than Indian occupation, and who shall have made improvements thereon of the value of $200 or more, and continuously occupied the same as a homestead for the term of three years, shall be entitled to receive from the United States a patent for 160 acres of land....[1]

The provision was no doubt intended to accommodate the occasional Sioux (the people themselves prefer to be called Lakota, Dakota, or Nakota) who chose to homestead on other than Indian land and thereby become the farmer the

FROM TOP: VINE DELORIA, JR. *CUSTER DIED FOR YOUR SINS*. NORMAN AND LONDON: UNIVERSITY OF OKLAHOMA PRESS, 1988 (1969). N. SCOTT MOMADAY. *HOUSE MADE OF DAWN*. NEW YORK: HARPER & ROW, 1968 (1966). JOHN G. NEIHARDT. *BLACK ELK SPEAKS*. LINCOLN AND LONDON: UNIVERSITY OF NEBRASKA PRESS, 1961 (1932). OPPOSITE PAGE 119: VINE DELORIA, JR., LAKOTA AUTHOR. COURTESY, *WINDS OF CHANGE* MAGAZINE.

government envisioned. The purpose stated for seizing the island was in diametric opposition to the government's intent in creating the legal situation in the first place, to subdue and "civilize" Indians, one by one, by turning them into individual capitalistic entrepreneurs; the Indian activists' purpose was: "first, to gain title to Alcatraz and build a Native American cultural center there, and second, to use the occupation as a psychological-political basis for launching a major pan-Indian movement known as the Confederation of American Indian Nations."[2] Although two years later federal marshals removed the remaining Indian occupants who hadn't obtained title to the land, the activists had "succeeded, as no one had before, in dramatizing the Native American demand for self-determination, tribal lands, and tribal identities."[3]

The importance of the Alcatraz movement, and other movements energized through or parallel to its vision, in terms of "tribal identities" is a point to which I will return. The year 1969 also marked the blossoming of an Indian literary movement, beginning with N. Scott Momaday's Pulitzer Prize for *House Made of Dawn* and Vine Deloria, Jr.'s best-selling *Custer Died for Your Sins*. Both texts awakened the American public to the fact that Indians had not disappeared from the landscape and were indeed able to speak for themselves (declared not-too-subtly by the title of Deloria's second book *We Talk, You Listen*).

Another text essential to the revitalization of tribal identities, *Black Elk Speaks*, became a "veritable Indian bible" to youth of the 1960s and 70s, particularly to assimilated Indians and to non-Indians, according to Vine Deloria, Jr., who wrote the introduction to the 1979 reprinted edition.

Despite the tragic romanticist tone of its editor and shaper, John G. Neihardt, it functioned at the time as testimony that "Indians had retained their spiritual truths and values...."[4] Black Elk's spiritually-centered vision lent a moral authority to Indian reform movements as the media began to focus upon Indians during those tumultuous times, and, especially, played on white guilt as the dismal living conditions in urban Indian communities and on reservations began to come to light. According to Olson and Wilson, for example:

> In 1970 the median income for Native American men over the age of sixteen was barely more than $3,500, compared to an average for European Americans of nearly $9,000, and $5,400 for Afro-Americans. Average annual earnings for Native American women in 1970 were $1,700, compared to $6,823 for European American and $5,258 for Afro-American women. On reservations it was even worse, with annual per capita income for Native Americans averaging less than $1,000 in 1980. In 1983 only 25 percent of reservation workers were earning more than $1,000 per year.[5]

To understand those statistics relative to reservation Indian concerns goes beyond the present topic; nonetheless, such dismal statistical indicators underscore a difference in living conditions that led to the problems inherent with poverty—high infant mortality rates, disease, poor housing conditions, contaminated water sources, and so forth. It is in this context that the happenings surrounding political and literary social movements of those times must be viewed.

In keeping with the spirit of those times, Indians spoke out of "lived experience," as implied in the statistics cited above and as exemplified by the power of Black Elk's vision

LEE MARACLE, A PROLIFIC CANADIAN NATIVE WRITER, PRESENTS HER LATEST WORK, *RAVENSONG*, TO A CLASS AT THE STATE UNIVERSITY OF NEW YORK AT BUFFALO IN 1993. HER BOOKS INCLUDE *BOBBI LEE: INDIAN REBEL, I AM WOMAN, SOJOURNER'S TRUTH, AND SUNDOGS*. PHOTO BY MILLIE KNAPP.

to retain a vitality of tribal belief. By rooting authority in experience, a new kind of leadership and credibility became possible, the sort of Indian leadership required to foster self-determination, rather than the strangling overlay of bureaucratic rules and foreign values. Most of all, this new leadership superseded other people's ideas about who Indians are and what Indians ought to do.

Anthropologist Michael Jackson, in arguing for a "lived experience" approach to cross-cultural study, speaks skeptically of "all

efforts to reduce the diversity of experience to timeless categories and determinate theorems, to force life to be at the disposal of ideas."[6] Indians in America have, from first contact to the present, suffered the effects of categorizing practices turned into bad policy. The spirit of Jackson's remarks, as he attempts to describe his philosophy, serves to characterize what I see as an essential direction in American Indian writing since the 1960s. He writes,

> I want to stress that lived experience encompasses both the rage for order and the impulse that drives us to unsettle or confound the fixed order of things. Lived experience accommodates our shifting sense of ourselves as subjects and as objects, as acting upon and being acted upon by the world, of living with and without certainty, of belonging and being estranged, yet resists arresting any one of these modes of experience...."[7]

Perhaps no other modern text depicting American native life as "lived experience," of "acting upon and being acted upon by the world...of belonging and being estranged," equals *Black Elk Speaks*. A text of multiple voices and vision, *Black Elk Speaks* is John G. Neihardt's study of the life of Nicolas Black Elk; it is an expression of Neihardt's poetic and visionary aesthetic, a text which excites scholarly and popular interest; and most importantly, it is a partial, though powerful, record of the Oglala medicine man's vision, Black Elk's story. Despite its somewhat fatalistic tone, *Black Elk Speaks* has moved Indians and non-Indians alike beyond fixed or static conceptual models of Indians as defeated—victims of the steamroller of Manifest Destiny—and helped to open the way for American Indian authors to write out of their experiences. Texts such as Black Elk's have affected the passage of the American Indian Religious Freedom Act in 1978, an act that for the first time granted Indians the religious freedoms most Christian Americans had had since the beginnings of the nation. *Black Elk Speaks* introduced new (or renewed old) ways of seeing, for "if memory is indeed polymorphic and historically situated... it will be called continually into question."[8] Natalie Zemon Davis and Randolph Starn outline the contours of what they term "counter-memory" in a way that illuminates how historical and fictive narratives can construct Indian defeat and subjugation, as well as how other narratives can subvert such constructs:

> [M]emory operates under the pressure of challenges and alternatives. A private fetish or a public injunction to forget—a decree of amnesty would be an instance of a politics of forgetting—are forms of counter-memory; for Michel Foucault counter-memory designated the residual or resistant strains that withstand official versions of historical continuity .[9]

America's "politics of forgetting" where Indian peoples are concerned has neglected to remember the timeless nature of treaties made with sovereign nations and the long memory of peoples whose lives are a fabric, woven carefully together with threads of memory spun from the minds and hearts of survivors. Prior to the 1960s, America remembered to remember Indians on Thanksgiving or, ironically, Columbus Day, but had an agenda, however unconscious, to forget Indians on reservations—the Nicolas Black Elks and subsequent generations of Native peoples whose sense of lived history runs counter to the dominant narrative by virtue of the people's survival and continuance. Defeat is there—wherever "there" is—but so are the seeds for regeneration. The "counter-memory"

represented by texts such as *Black Elk Speaks, House Made of Dawn,* and *Custer Died for Your Sins,* therefore, cannot be underestimated.

Just as the Alcatraz Occupation was not the first pan-Indian resistance movement, the writing it inspired is not the beginning of American Indian literature. American Indians have been writing in English at least since 1772, when Samson Occom (a Mohegan Methodist minister) published his impassioned *Sermon Preached at the Execution of Moses Paul,* indicting Euro-Americans for their role in introducing alcohol and continuing to profit from its sale. The violent acts such as murder and the general debauchery that have ensued with the manipulation of Indians through alcohol, he argues, result from a failure of non-Indians' Christian vision. William Apes, a Pequot Indian who published three important books in the early nineteenth century, is described by A. LaVonne Brown Ruoff as "one of the most forceful Indian protest writers of his time."[10] American Indian writers of the late eighteenth and early nineteenth centuries—such as Occom, Apes, David Cusick (Tuscarora), George Copway (Ojibwe), Peter Jones (Ojibwe), Ella Deloria (Lakota), and others—amassed a body of works that contains literature and literary and historical scholarship. Early American Indian writers contribute essential voices to the canon of American literature, voices which balance and enrich our understanding of the early periods in United States history and expressive culture.

Since the 1970s, American Indian literary scholars have set to work uncovering and analyzing early writings by Indians. Autobiographies of various types, some well-known and others buried in archives or

AUTHOR PAULA GUNN ALLEN IS A PROFESSOR OF NATIVE AMERICAN STUDIES AT THE UNIVERSITY OF CALIFORNIA AT BERKELEY. HER MOST RECENT PUBLICATIONS INCLUDE *SKINS AND BONES, WYRDS* (POETRY), *THE SACRED HOOP: RECOVERING THE FEMININE IN AMERICAN INDIAN TRADITIONS* (ESSAYS AND CRITICSM), AND *THE WOMAN WHO OWNED THE SHADOW* (NOVEL). PHOTO BY MILLIE KNAPP.

academic publications, have come to constitute a new field of study, as well as to provide a legacy of literary predecessors to contemporary peoples. Five major studies of Indian autobiography have appeared since 1973: Lynn Woods O'Brien's *Plains Indian Autobiography* (1973); Gretchen Bataille and Kathleen Sands' *American Indian Women: Telling Their Lives* (1984); Arnold Krupat's *For*

LESLIE MARMON SILKO, *ALMANAC OF THE DEAD*.
NEW YORK: PENGUIN BOOKS, 1992 (1991).
LOUISE ERDRICH, *BINGO PALACE*. NEW YORK:
HARPER COLLINS, 1994.

Those Who Come After: A Study of Native American Autobiography (1985); H. David Brumble, III's *American Indian Autobiography* (1988); and Hertha Dawn Wong, *Sending My Heart Back Across the Years* (1992). These works function as resource guides to any eager reader who would like to embark on a journey through the intellectual landscapes of early periods, other places and sensibilities. Native individuals, who have long tenure on this continent and provocative things to say about indigenous life from their unique perspectives, have typically been the most sought-after voices by American audiences. In reading such works, we must always be careful, however, not to generalize one person's experience into a representative voice for a people.

The present period in Indian literary production—both criticism and creative writing—opens vistas of several kinds into the past. During the nineteenth century, Indian writers of fiction and poetry had been more rare than were Indian collectors of their people's histories and oral literatures and "as told to" autobiographers. Bernd C. Peyer's recent collection of early short stories by North American Indians, *The Singing Spirit*, however, attests to the fact that intellectuals, most of them born in the mid-to late-1800s, were writing and publishing fiction at the turn of the century—authors such as Gertrude Bonnin, Francis and Suzette LaFleche, William Jones, Alexander Posey, Charles Eastman, Pauline Johnson, John Joseph Matthews, D'Arcy McNickle, and others. In addition, several of those writers produced autobiographical pieces, ranging from essay to book length, as with Charles Eastman's several works. Bonnin, working in conjunction with William E. Hanson,

composed an opera *Sun Dance,* which in 1937 was named the American opera of the year.[11]

Although in the early 1970s, young American Indian writers began producing fiction and poetry as never before, what is most notable for my purposes here is that they began doing so in a manner that suggests the emergence of a writing community—as Kenneth Lincoln suggests, a literary renaissance, spurred by the events and texts of the late 1960s. James Welch took his place among the first writers of that generation inspired by N. Scott Momaday when his first novel *Winter in the Blood* (1974) was reviewed on the front page of the *New York Times Book Review,* prompting the republication of his first book of poetry, *Riding the Earthboy 40* (1971; 1976). Duane Niatum (with two books of poems to his credit at the time) edited the much celebrated *Carriers of the Dream Wheel,* a collection of poetry by American Indians, in 1975; and it was followed four years later by Geary Hobson's *The Remembered Earth: An Anthology of Contemporary Native American Literature* (1979), a collection that takes its title from Momaday's *Way to Rainy Mountain* (1969)—affirming a pan-Indian intertextuality not previously evident among Indian writers. The Niatum and Hobson collections (both produced by Indian editors) became popular pedagogical texts. Leslie Marmon Silko's *Laguna Woman* (1974), *Ceremony* (1977), and *Storyteller* (1981) affirm both cultural continuities and change, as do Simon Ortiz's early works: *Going for the Rain* (1976), *A Good Journey* (1977), and *Howbah Indians* (1978). In characterizing that period of new literary excitement and what has been published since, critic and novelist Louis Owens speaks of the unity and diversity of that generation, saying, "[T]here is to a remarkable degree a shared

consciousness and identifiable world view reflected in novels by American Indian authors, a consciousness and world view defined primarily by a quest for identity."[12]

Anyone who teaches or reads extensively in the field of Indian literature would agree that there is a "shared consciousness and identifiable world view." I would add that the "quest for identity" relates to the need for overcoming the devastating effects of assimilationist educational policies, the undermining power of superimposed governance structures and imperatives, and the forced relocation or migration of various peoples because of the destruction of their homelands through flooding, dam construction, and the like. We witness individual protagonists in these novels who cannot see their way clearly beyond a holocaust of sorts that has been imposed upon their people, yet who struggle (often tragically, sometimes triumphantly) to enter a clearing to a brighter day. The more serious literary treatments aside, the identity quest theme also takes shape in humor, perhaps the most well-known example of which occurs when the nameless protagonist of James Welch's *Winter in the Blood* suddenly experiences an epiphany, brought to him when his horse Bird farts. The trickster motif in the works of Gerald Vizenor and Peter Blue Cloud also twist the ironies into new shapes, new weapons.

Since Alcatraz, we have witnessed growth and transformation among the early writers as well as the emergence of important new voices and movements within the movement. Welch's third novel *Fools Crow* (1986) and Ortiz's *From Sand Creek* (1981), a collection of poems, engage a re-memory, a commemoration of Indian lives

SHERMAN ALEXIE

The Sharpest Sight

A Novel By Louis Owens

SHERMAN ALEXIE, *THE LONE RANGER AND TONTO FIST FIGHT IN HEAVEN*. NEW YORK: THE ATLANTIC MONTHLY PRESS, 1993.

LOUIS OWENS, *THE SHARPEST SIGHT*. NORMAN AND LONDON: UNIVERSITY OF OKLAHOMA PRESS, 1992.

lost at the St. Marias and Sand Creek Massacres, and in Ortiz's case, lives lost since to the continuing effects of colonial dominance. Writing since the renaissance began has become an interweaving of re-envisioning with recovering through "counter-memory," the past denied us in our history books or overwhelmed in the mainstream literature by the non-Indian perspectives of such writers as Cooper or Longfellow. Important new books include Leslie Marmon Silko's *Almanac of the Dead*; two novels by Thomas King, *Medicine River* and *Green Grass, Running Water*; two novels by Louis Owens, *Wolf Song* and *The Sharpest Sight*; Louise Erdrich's fourth novel of her quartet, *Bingo Palace*; Ron Query's *The Death of Bernadette Lefthand*; Gerald Vizenor's *Dead Voices*; and Sherman Alexie's *The Lone Ranger and Tonto Fist Fight in Heaven*.

Not the least among contemporary voices are those of women writers such as Joy Harjo, Elizabeth Cook-Lynn, Anna Lee Walters, Luci Tapahonso, Linda Hogan, Beth Brant, Paula Gunn Allen, Elizabeth Woody, Janet Campbell Hale, Louise Erdrich, and Betty Louise Bell, to name but a few; and with them often comes a reassertion of the woman's place in native communities, as well as an assertion of activist ideals and issues based on Indian women's life struggles, conjoined but not necessarily in harmony with mainstream feminist thought and goals. American Indian gay and lesbian writers have likewise become increasingly recognized for their literary and other artistic achievements at the same time that cultural studies projects within universities have begun to focus on ancient native traditions, which in precontact times honored diverse individual human expressions of sexuality

and social function, the visions visited upon individuals by the Creator.

Regional and tribally based literary focuses, related to the ethnic backgrounds of particular writers, frame particular geographical experiences and histories in intriguing ways; for example, a cluster of Navajo writers has emerged who, taken together, give us a more well-rounded sense of Navajo life and ways: Luci Tapahonso, Irvin Morris, Rex Jim, Nia Francisco, Rachael Arviso, Esther Belin, Patroclus Eugene Savino, Brent Toadlena, Gertrude Walters, and others—many of whom appear in a new book, *Neon Powow: New Native Voices of the Southwest.* In this collection, Irvin Morris speaks of his impetus to write, "What I am and what I write about arises out of that [reservation] experience. I write about what I see and what I know. I write to honor the things I am most proud of: my language, my culture, and my people. Whatever else I may do, I will always write."[13]

Perhaps it goes without saying that: "lived experience is never identical with the concepts we use to grasp or represent it."[14] But where American Indian experience is concerned, the gap between the thing itself and terms and concepts used to grasp it have historically been great to the point of extreme distortion. Actual native "lived experience" must not be denied its diversity or forced through easy categorization to be at the disposal of ideas, just as the making of literature must not become secondary to literary criticism or language theory. We can perhaps imagine, as the American Indian satirist Gerald Vizenor does through his character Shaman Truth Lies, "the mythic world in the tribal mind where the white man is tricked from illusions of power and dominance and then taught to walk backwards in dreams…." We may perhaps like to imagine the white man walking "backwards right out of the country,"[15] or at least talk as if we do, but our strength rests with our ability to embrace the contraries of what we have been, are, and are becoming. And that seems to me to be the essence of American Indian literature after Alcatraz. ✳

Notes

1. Rupert Costo, "Alcatraz," *Indian Historian* 3 (Winter 1970):.
2. James S. Olson and Raymond Wilson, *Native Americans in the Twentieth Century* (Urbana and Chicago: University of Illinois Press, 1984), 169.
3. Olson and Wilson: 170.
4. Gretchen Bataille, "Black Elk: New World Prophet," *A Sender of Words: Essays in Memory of John G. Neihardt* (Salt Lake City, Utah: Howe Brothers, 1984): 137.
5. Olson and Wilson: 186.
6. Michael Jackson, *Path Toward A Clearing: Radical Empiricism and Ethnographic Inquiry* (Bloomington: Indiana University Press, 1989): 2.
7. Jackson: 3.
8. Natalie Zemon Davis and Randolph Starn, eds., *Representations: Memory and Counter-Memory,* number 26 (Spring 1989): 2.
9. Davis and Starn.
10. A. LaVonne Brown Ruoff, *American Indian Literatures: An Introduction, Bibliography Review, and Selected Bibliography* (New York: Modern Language Association, 1990): 62.
11. Bernd C. Peyer, *The Singing Spirit: Early Short Stories by North American Indians* (Tucson: University of Arizona Press, 1989): 76.
12. Louis Owens, *Other Destinies: Understanding the American Indian Novel* (Norman: University of Oklahoma Press, 1992): 129.
13. Anna Lee Walters, ed. *Neon Powwow: New Native American Voices of the Southwest* (Flagstaff, Arizona: Northland Publishing, 1993): 129.
14. Jackson: 2.
15. Gerald Vizenor, "Reservation Café: The Origins of American Indian Instant Coffee," in *Earth Power Coming: Short Fiction in Native American Literature,* ed. Simon J. Ortiz (Tsaile: Navajo Community College Press, 1983): 32.

CONSTRUCTING THE IMAGINED SPACE OF NATIVE AMERICA

LESLIE SILKO, JOY HARJO, AND LUCY TAPAHONSO

VICTORIA BOMBERRY

Several years ago, shortly before my eldest son was born in 1980, I read Leslie Marmon Silko's first novel, *Ceremony*, which had been published in 1977. The title had languished in the back of my mind as something I would read soon, but soon was always a day away. Fortunately pregnancy, by its very nature, is a moment of expansiveness and renewal and I found myself drawn towards my early love of storytelling and reading. In my mind both were closely linked to the comfort of the feminine domestic sphere. I remembered from my young girltime the women's voices: mama, grandma, and aunties telling stories around the kitchen table, or out by the railroad tracks on the outskirts of Oklahoma City where our kinfolk had found a choice spot to gather wild onions, which always meant spring and home, even though it seemed that luck and circumstances had taken us miles and miles away from both. I also remembered the pleasure of seeing the pictures and images coming to life in my mind as I hung onto their every word.

When I was old enough to read, the same pleasure greeted me once again. The images took shape and form and the story flowed with a life of its own. As the years passed the images didn't come to life as vividly as they had before. More often than not, a dull coating, as heavy as the used oil that slowly seeped from the underside of our 1950 dark green Chevy, seemed to slow the pictures that had so recently run like a wild river through my imagination. The words on the printed page slowly disconnected from the voice, but the sensation of keen pleasure in a story come to life remained, quiescent in some secret part of myself. The pleasure resurfaced at odd moments here and there.

Nestled in a favorite spot with the book resting on my pregnant belly, I found the opening page of *Ceremony* as inviting as my earliest memories. I could hear the spoken words of the poetry bringing me into the story. Even though the words were English, the cadence was as sweet as my native language. In that co-mingling of language, sound, and sign was what had been stalled in my mind. So much of what was available left native readers out. On the vast white pages, our voices were still or, even worse, what were supposedly our words and stories were the work of clever writers who distorted our reality and in so doing claimed it for themselves. In reading

Ceremony I knew as the narrator reminded me, "You don't have anything if you don't have the stories." The story that grew from the pages was answered by experiences in my own life. The words of relatives spoke from the pages.

Ceremony forcefully engages a number of issues as Silko's mixed-blood protagonist, Tayo, begins a spiritual quest that will restore him to the circle of life in the Indian community. Silko undercuts the familiar racist language that denies mixed-bloods a proper identity. According to the racist paradigm, which achieved its perfect articulation in the United States, a mixed-blood can never be a part of one world or another. They are always doomed, tragic figures who often come to a bad end through violence, or live out a hopeless destiny determined by the forbidden mixing of blood. Never mind that Native Americans have adeptly incorporated each other into various tribal communities since the beginning of time without insisting upon the magical qualities of blood. Blood was never as important as the complex network of relationships that recognized the importance of everyone and everything in maintaining the balances and harmonies of the world.

In exploding the deeply ingrained American myth of the mixed blood, Silko forces both Indian and non-Indian to take a close look at our cultures. The desire for pure, pristine culture is exposed as a path to sterility and stasis; moreover, Silko illustrates that the desire is relatively new to Indian communities that recognized the endlessly dynamic nature of our existence. We tapped the rhythms of change and rode them for the wild joy they gave us. In change we found our strength that has carried us through even the most difficult times. Through Old Betonie's hazel eyes (the medicine man who lives on the outskirts of Gallup whom Tayo goes to for help) we see the constantly shifting character of our being. His hogan is littered with notebooks, old calendars, phone books, boxes full of rags, and assorted junk. Yet, out of this weird array of seemingly random bits of ephemera, Betonie is able to construct a powerful counter-narrative to the one put in motion by the destroyers. Betonie's gift lies in his ability to perceive the messiness of power and the vulnerability it creates in its own misrepresentation as order and stability. Betonie's skill allows him to see the gaps in the power that oppresses us and restores hope in the future. Blood and race drop out of this formulation and you become either a part of the witchery that seeks to destroy the world, or you are a part of that which seeks to harmonize and balance the forces of the world. Blood quantum is never in question as Old Betonie reminds Tayo: "'Nothing is that simple,' he said, 'you don't write off all the white people, just like you don't trust all the Indians.'"

Ceremony is often read as a novel whose primary aim is to deal with the dilemma of the mixed-blood. There is certainly enough in the novel to support that argument. Nevertheless the most fertile project of the book is Silko's enunciation of the power and necessity of telling and retelling our stories, which she makes even more explicit in her second book, *Storyteller.* Silko establishes the importance of storytelling through a series of poems and tales that emphasize the authority of our voices and memories. Unfortunately, in the postmodern world the term "tale" has lost its original intensity, but Silko's deft handling of old and new tales links time and place to an unbounded region of energy. In addition, she underscores the role each of us plays in passing on culture and identity. Although the creative act of telling the story has the power to bring

that reality into being, the storyteller does not necessarily occupy a privileged position since storytelling is a communal activity where everyone is a part of the telling and remembering. In a later essay, Silko writes of the Pueblo people: "...the community was able to piece together valuable accounts and crucial information that might otherwise have died with an individual." Silko's first novel contains theorizing that preceded what later analysts approached through other methods. For example, Silko's in-depth explorations of the concepts of identity, performance, and narrative were pivotal points in the development of Native American literature over the past twenty-five years. Furthermore, Silko opened the door for many Native American writers to explore the constitutive elements of what it means to be Native American today. She made it absolutely clear how deeply rooted in landscape and place our stories and histories are. Yet, at the same time she presented the elements that unite us as native peoples sharing a continent.

Although her first novel had a hero very similar to those in at least two generations of Native American novels, Silko recuperated the feminine principle in a way that enabled both the male and female. In the opening page of *Ceremony,* Thought-Woman, the spider, spins the shimmering filaments that once again create our lives as Native Americans. It is as if Silko sowed the seeds that would later flower as the voices of Native American women engaging the difficult issues of our time, as well as showing us the beauty that surrounds us. By the 1980s there were many more women writing. Now the 1990s has witnessed the impact of virtually hundreds of Native American women writers who are actively contesting the webs of words that once surrounded and contained us.

Native American women are exploring ideas and pursuing strategies in their writing that not only resist, but are constructing new ways to undo the colonial processes that have plagued us. Three writers, Leslie Silko, Joy Harjo, and Lucy Tapahonso, came of age when the Native American movement was gaining momentum in the United States. They all spent their formative years in the southwest. In the interplay of their work is the imaginative space forged by the social and historical reality of the time. Their work also demonstrates interaction on many levels, as illustrated, for example, when Poetic Justice, a quintet led by the well-known Muscogee poet Joy Harjo. At a recent performance at Stanford University Harjo stepped up to the microphone to introduce one of the pieces, which she dedicated, "To Leslie, who showed me the importance of our stories." The clear melody of Harjo's tenor sax immersed the audience in the mood of the poetry that followed in a reunion of oral and written literature. Poetic Justice incorporates Harjo's poetry in an electrifying mix of tribal, jazz, and reggae rhythms that amplifies the concept that Silko's character, Betonie, demonstrated. The musical collage quickly filled the spacious auditorium including everyone in the experience Harjo recounted. Cradled by the music the images carried the stories that were not only heard but seen, and I was reminded of lines from Joy's prose poem, "Original Memory":

> In the Muscogee world, one would have a
> circle of relatives (everyone is ultimately a
> relative) recalling similar events, to establish
> connection, and to convey the event lovingly
> into the past. (But, how do we know it
> doesn't re-create a similar event again?)

Yes, how do we know? How do we know that we don't merely re-create a similar event, but we understand more about ourselves and create events that reflect what we have learned along the way? Identity is an ongoing process of re-creation and rebuilding from fragments of our past and future. As Walter Benjamin, the mystic Marxist critic, would remind us, we have the added burden of wresting our past from the hands of those who would use it against us. Harjo is able to take everyday happenings, uncover their fantastic/mythic dimensions, and imbue these otherwise ordinary occurrences with the healing power of the sacred. In "Deer Dancer," a beautiful woman who embodies the magic of the deer, enters a down-and-out bar and transforms the lives of the people who see her:

> All night he dreamed a dream he could not
> say. The next day he borrowed money, went
> home, and sent back the money I lent. Now
> that's a miracle. Some people see visions in a
> burned tortilla, some in the face of a woman.

It is no accident that the Deer Dancer is a woman. She represents the power of the feminine to engender a new consciousness, a new way of being in the world. Unlike the Devil in the guise of a white, handsome, well-dressed cowboy who shows up in bars and at dances throughout the west, the Deer Dancer doesn't make deals for which payment is our everlasting soul; instead she inspires visions of the totality of life, visions that span time and restore the power of our stories. "The deer who entered our dream in white dawn, breathed mist into the pine trees, her fawn a blessing of meat, the ancestors who never left."

Harjo writes of the pain that we experience as subjects working our way toward the postcolonial era. We see and feel that experience through the images that

JOY HARJO, IN MAD LOVE AND WAR.
MIDDLETOWN: WESLEYAN UNIVERSITY PRESS, 1990.

Harjo calls into being. The bar where the Deer Dancer works her magic is the perfect metaphor for the despair wrought by the colonial condition: "the bar of broken survivors, the club of shotgun, knife wound, of poison by culture." The deformities caused by colonization are laid bare, and in the stark, ugly image is a moment of clarity that ultimately allows us to move through the pain toward empowerment.

Sáanii Dahataał
The Women Are Singing

Luci Tapahonso

LUCI TAPAHONSO, *SÁNII DAHATAAL: THE WOMEN ARE SINGING*. TUCSON AND LONDON: UNIVERSITY OF ARIZONA PRESS, 1993.

Harjo has published four books of poetry including *She Had Some Horses,* and the award-winning *In Mad Love and War.* A new book, *The Woman Who Fell from the Sky,* is difficult to place within any single genre. Stretching the boundaries between written and oral tradition Harjo creates an indigenous literary form that answers a set of questions posed by the contributors to *Writing In the Enemy's Language* which Harjo edited. *The Woman Who Fell from the Sky* will be released in late 1994 and includes a CD featuring members of Poetic Justice.

Lucy Tapahonso understands the knowledge imparted by place. Her latest book, *Saanii Dahataal: The Women Are Singing* (1993), is a collection of poems and essays that focus on memories constructed and reflected by place and in the everyday intimacies of the domestic sphere. She writes tenderly of the connections among people, creating fine-grained portraits that remain with the reader. Her voice is as natural as the Southwest landscape she so eloquently describes. Navajo phrases and words are an integral part of the text, suggesting that language in and of itself conveys a sense of place and identity. Writing in Navajo also imparts the intimacy of family, friends, and lovers. While much of Native American literature is dominated by narratives of loss precipitated by the colonial experience, Tapahonso confirms the continuity of Native American life that such narratives obscure. Writing with wit and compassion, Tapahonso shows us a dynamic world where the small things in life matter because our relationships with people and the world around us are the center from which we gather our strength.

"Hills Brothers Coffee" is a poem that demonstrates Tapahonso's skill in portraiture. We recognize Little Father immediately. Moreover, she goes beyond simple description to give the reader a sense of a complicated lifeway that negotiates and integrates multiple levels of meaning. Little Father in Navajo becomes Tom Jim in the white way. The man on the Hills Brothers coffee can is "the man in the dress, like a church man." The church man is a reminder of an alien religion and reality. Coffee—a product introduced to Native America by the Europeans, but having been brewed and cultivated in Arab countries for centuries, yet having its origin in Africa—is a metanym that perfectly captures transculturation in

America and the complicated mediations that have to occur on a daily basis. Making the unfamiliar familiar is a survival strategy, however; the jarring juxtaposition reminds us of us of who we are. The poem's twist of wry humor has the hint of a television coffee commercial which allows us to laugh and take pleasure in Little Father's pleasure.

In "What I Am," Lucy Tapahonso movingly narrates the life history of her family through the passing of her great-grandmother. Told through three generations of women, the death of Kinlicíi'nii Bitsí reveals the strength of memory. Through the telling and retelling of Kinlicíi'nii Bitsí 's story her grandchildren come to know her and to love her as if she were living among them. A strong element of the narrative is the tremendous sense of place evoked by each telling. The landscape is embued with meaning and memory. The opening lines of the essay underscore the analogy between the meaning conveyed by the written word and the meaning written in the landscape. As Pretty Boy makes his way across "the vast whiteness" of the landscape we are reminded of the vast whiteness of an empty page. Thus, the story of Kinlicíi'nii Bitsí becomes a story of the origin of the female lines of the family. In addition, the visual images called into being summon us toward the unfolding story.

As each generation in turn tells of Kinlicíi'nii Bitsí, we learn about the gentle relationships between mothers and their daughters and sons, what it means to be a Navajo woman, what it is to be a mother; we see lives that are lovingly entwined through the generations. This world exists in the same world as "the bar of broken survivors" reminding us of the power of life. Even though we see the survivors of the Long Walk here, they flourish in the land of their ancestors, whole yet changed by history and experience. Thirty-three years after Kinlicíi'nii Bitsí's death her granddaughter remembers the ways of wise mothering as Kinlicíi'nii Bitsí expressed them throughout her life.

Last week when we were hoeing in the field, my mother told me, "Having a mother is everything. Your mother is your home. When children come home, the mother is always ready with food, stories, and songs for the little ones. She's always happy to see her children and grandchildren."

In 1987 Tapahonso leaves home for Europe and her grandmother admonishes her to remember who she is: "You're from Oak Springs, and all your relatives are thinking about you and praying that you will come back safely." This comforting moment allows her to find her way through far away countries. Tapahonso's epiphany occurs on top of the Eiffel Tower when she understands that who she is "[is] my mother, her mother, and my great-grandmother, Kinlicíi'nii Bitsí." Western psychology says that individual identity is achieved when the child separates from the mother. Tapahonso, however, finds her strength of purpose through the deep connections she perceives between herself and her mothers, which even death cannot extinguish. She is welcomed home by the embraces of her grandmother and mother—all children of Kinlicíi'nii Bitsí.

Leslie Marmon Silko, Joy Harjo, and Lucy Tapahonso have distinct voices that open the reader to a world where visions are not only possible, but are a source of knowledge of the world around us and a path toward the liberation of native peoples. ✳

Accomodating the World
Cultural Tourism Among the Pueblos

Rina Swentzell

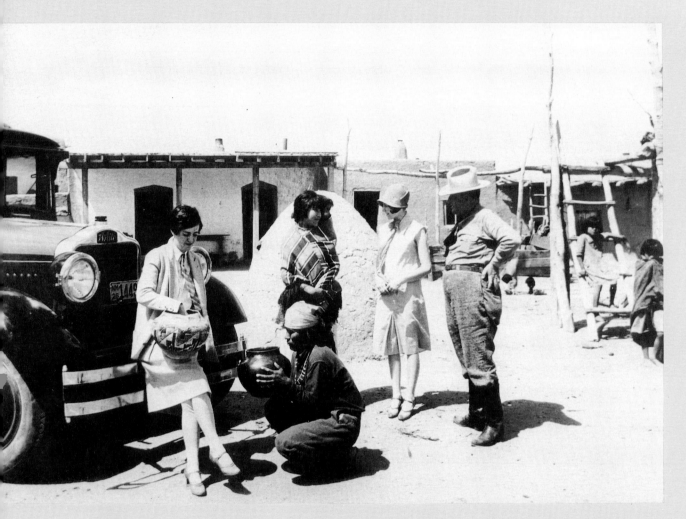

Tourists have been a part of Pueblo life since the late 1800s. In a sense, the early archaeologists and anthropologists were the first tourists and advertising agents. From 1879 to 1885, James Stevenson, Matilda Cox Stevenson, and Frank Hamilton Cushing shipped about ten thousand objects out of Zuni to Washington, DC. Their justification was to show the lifeways and art of the Zuni people. They also wrote about us. They told the world about our beliefs and practices. More and more people began to hear about us—and more and more people came to look at us and to buy our trinkets and "art pieces." And what has happened to us—and to them—in this strange encounter?

Dean MacCannell talks about tourism as an intense movement of armies of people to the remote regions of the world. These armies require

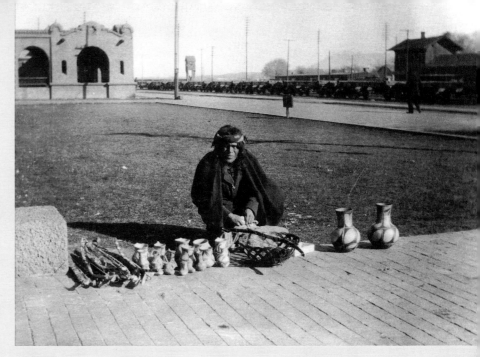

all sorts of institutions to support them—restaurants, hotels, etc. He says that tourism and its associated institutions have enormous power to shape and reshape culture according to the values of international capitalism. These values are frequently in contrast to those of the Pueblo communities in the Southwest.

Pueblo communities have existed for thousands of years in the arid southwestern United States. They have defined a philosophy that states that humans are not separate or outside of the natural order of the cosmos. Pueblo culture understands that all life is an expression of the breath or the flow of energy. Flowers, rocks, and animals are all dependent on the flow of the life-giving breath. Interdependence, interconnectedness, harmony, and balance are primary concepts upon which all of life is based. Within this philosophy, community is acknowledged as essential to any individual sense of well-being. Individual and family life are subsumed within community life, which is contained within the natural order of the cosmos. Everything has a context.

These values are embedded into the very structure of Pueblo life. Traditional houses are made of earth, or adobe. The mud walls flow out of the ground, showing an undeniable connectedness to the earth. They are born of the earth and eventually return to the earth. The pottery of Pueblo people, which has been produced since 300 A.D., is also earth-connected. The designs drawn on the pots tell about our universe and the interrelatedness of life-forms and activities. The mountains, which define and contain the Pueblo world, are shown in stepped patterns. The clouds, which remind us of cycles and movement, are drawn in semicircles with lightening or zigzag lines coming out of them. Birds, deer, and fish are shown turning into humans and vice-versa, another way of showing our interconnectedness.

ABOVE: PUEBLO MAN SELLS POTTERY IN FRONT OF THE ALVARADO. ALBUQUERQUE, N.MEX. 1907. PHOTO FROM THE CHURCHILL COLLECTION. COURTESY, NMAI (26672).

OPPOSITE: "INDIAN DETOURS" WERE ARRANGED BY THE SANTA FE RAILROAD, AS THIS 1926 PHOTOGRAPH DOCUMENTS. SEEN HERE, TOURISTS WERE TRANSPORTED BY BUSES TO COMMUNITIES LIKE SANTA CLARA PUEBLO TO BUY POTTERY AND JEWELRY. PHOTO BY T. HARMON PARKHURST. COURTESY, MUSEUM OF NEW MEXICO, NEG. NO. 46936

Pots are functional containers, but since everything useful is also beautiful and symbolic, they also remind people of the meaningful things in life—interconnectedness, compassion, nurturing, and caring. Such attributes attract the tourists who come to buy our products, thinking that Indians are close to nature. Today, our ceremonies and our designs on cloth and pots remind us of what our relationship is supposed to be, but in our daily living we are hardly closer to nature than anyone else. What has happened?

Pueblo culture and craft have changed to accommodate the outside world. At Santa Clara Pueblo, metal utensils for carrying water, cooking food, and storing seeds have replaced the old clay containers. Iron skillets, copper kettles, tin cups, enamel basins, and porcelain dishes were brought in by railroad, which also brought the constant flow of tourists. Many pueblos adjusted their types and production of pottery to meet the demands and tastes of the tourists. At the same time, from the late 1800s to the 1930s, "art objects," which duplicated the traditional wares, were being demanded by museums. Concerned advocates of Indian art in the early 1900s pointed out the lamentable deterioration in the products of most of the pueblos, both in the beauty and significance of the old designs and in the knowledge of clays and slips. Organizations were formed in the Southwest to save Indian

Indian art has turned into a multi-million dollar industry and arts festivals continue to allow collectors and casual buyers to buy direct from the artists. Photo by Murrae Haynes. Courtesy Southwestern Association for Indian Arts, Inc.

Left: Bowl (1925-1943). Maria Montoya Martinez (1886-1980), San Ildefonso Pueblo. Herbert F. Johnson Museum of Art, Cornell University. Photo by Jon Reis.

art for the Indians, who, it was assumed, were incapable of determining their own destiny.

In the long encounter between two cultural systems—in which Pueblo people have the role of the culturally invaded—Indian people have tended to appropriate the values of the tourists. Our art, for the most part, functions as an economic resource, and not as a way of understanding and nurturing ourselves. Pottery, which at one time was valued for its usefulness and symbolism, is now primarily valued for its economic and decorative uses. Increasingly, we are creating art according to

other people's demands and tastes. We repeat and imitate our own cultural traditions as a matter of economic necessity.

I lament the fact that my Pueblo world is becoming less remote from the Western world. At the same time, I do not want disconnection from the Western world so much as courage to resist the pressures and demands to change according to Western values. Any changes Pueblo people make should be in response to our own changing needs and understandings and not in response to external demands. ✳

ANCIENT WORDS
ORAL TRADITION AND THE INDIGENOUS PEOPLE OF THE AMERICAS

Victor Montejo

The oral tradition of the indigenous people of the Americas has not been recognized as a source of history for the past five hundred years. Instead, the Western world has reduced it to the category of folklore or the study of superstitions, in which the oral tradition of indigenous people has been seen as a remnant of the past, and the expressed ignorance of the people who created them.[1] The denial of indigenous creativity, knowledge, and histories during the process of Western capitalist expansion has created what Eric Wolf has called "a continent of people without history."[2] It is then assumed that indigenous peoples have nothing valuable to offer Western civilization other than their supposedly distorted or erroneous observations of nature expressed in their oral traditions.

This ethnocentric view of "otherness" was the milieu in which early scholars intended to explain the modes of life in traditional non-Western societies. During the same time there were several attempts to prove the opposite, but the aggressiveness of the explorers and the false explanation of the natives' "exotic"

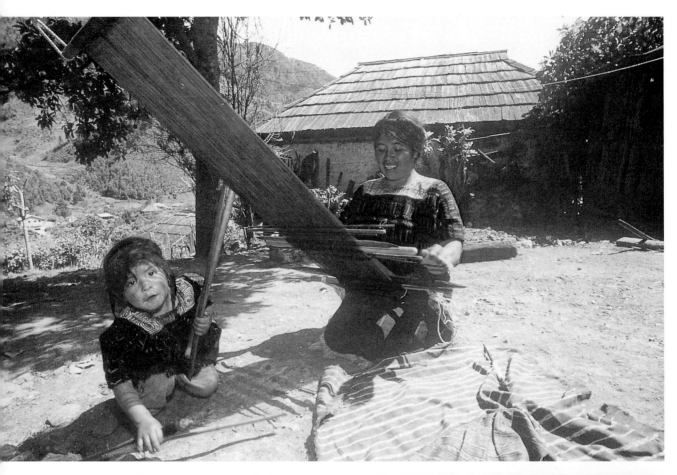

cultures by early evolutionists stereotyped the natives as having a prelogical mind—an assumption that cemented the denigrating and unequal treatment of indigenous people.[3] For indigenous people, however, the oral tradition is essential to the maintenance of each group's cultural identity, and serves as a reflection of how societies dynamically shape their destiny, adapting their oral tradition to different historical circumstances in time and space.[4] I emphasize the importance of the oral tradition as a historical method used by indigenous people to document and link the past with the present, while projecting into the future. In this process, which Victoria Bricker has called the "telescoping of time,"[5] memory is of vital importance in order to maintain such a connection. For this reason, it is important to recognize that oral

Opposite page 139: Shelley Niro, *Mother and Daughter Passing Tradition*, 1982.+

Top: Maya weaver, Todos Santos, Cuchumatan, Guatemala, 1982. Photo by Jeffrey J. Foxx, NYC.

Above right: Maya weaver, Mexico, ca. 1920. Courtesy, National Anthropological Archives, Smithsonian Institution, Neg. No. 79-14709.

traditions persist among indigenous people despite the impact of Western technology (mass media communication), literacy, and print capitalism.[6]

THE ORAL TRADITION AND INDIGENOUS COMMUNITIES

The oral tradition is an important mechanism for ensuring a culture's continued existence. The elders are usually the ones who tell their experiences to the young, and in the process they create or re-create new stories in relation to their personal or communal experiences. These experiences are related to their views of their relation to the earth, plants, animals, human beings, and the universe. In this context the oral tradition, be it from the religious, political, didactic, or aesthetic realm, is composed of multiple symbols that support native world views and cosmology. For indigenous people, the oral tradition teaches children about the origins of their own culture in order to strengthen the roots of their ethnic identities and learn about the world around them. For example, among the Inupiat of Alaska, storytelling has been one of the most popular forms of teaching and entertainment, "especially during the winter months when outside activity was sharply diminished. Typical stories involved autobiographical or biographical accounts of unusual incidents, accidents, hunting trips, or other events deemed interesting to the listeners."[7]

The spoken word was used by Native Americans as a tool to ensure their survival. For example, among the Iroquois, the tribal leaders were well trained in the oral tradition and when defending their cultures and their land "the orators were well aware of the issues, and knew that they were bargaining for nothing less than survival."[8]

The philosophy of Native Americans has been an integral part of their discourse as they relate to the natural world with which they strive to coexist harmoniously. In this sense, "their ideals of peace for all human beings and balance with the natural world are lessons which Iroquois people say all of us still need to learn."[9] The oral tradition is a concrete form of communication constantly repeated to remind the living people of their link to the land and the teachings of the ancestors (religion, medicine, art, folktales, etc.).

Similarly, among the Aztecs, the spoken word and the oral tradition were the daily form of communication and discourse. They had a category of discourse called *huehuetlatolli*, "ancient words" or "speeches of the elders," which was highly honored because it expressed the wisdom of the elders. According to Miguel Leon Portilla, these were discourses delivered in Nahuatl on important occasions such as a birth, election, transfer of power, and death of a ruler, "or a marriage when it was time for the fathers and mothers to let their children know about how life is on the earth."[10]

In other situations, the storytellers have been able to integrate past historical events that have strongly affected their culture into current perception. This is the case among the Runakunas of the Andes (Peru), where "the oral tradition apparently preserves the memory of the social and demographic holocaust that decimated the Andes' indigenous population in the wake of the Spanish Conquest."[11] But, more to the point, the oral tradition has proved important not only for the indigenous people themselves but also for the world at large. This is the case with knowledge of medicinal plants and curing

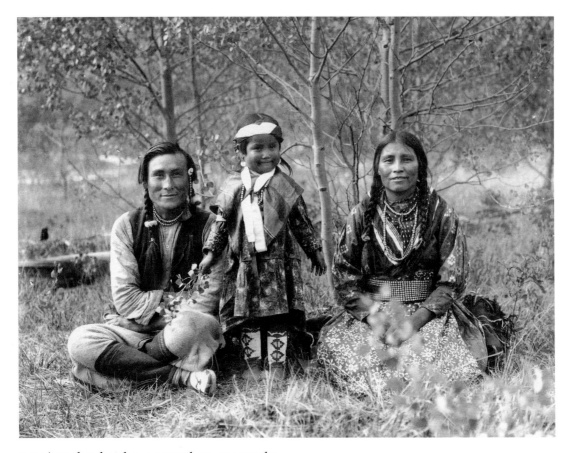

practices that has been passed on constantly through the oral tradition. This traditional wisdom has become important in the modern world after it has been appropriated. One major example is the native cure for malaria using the miracle drug called quinine after the Quechua word *quinaquina.* According to Jack Weatherford, "Europeans did not use the word quinine until 1820, when Parisian scientists Joseph Pelletier and Joseph Caventou finally extracted the active ingredient from the bark and named the substance after the original Quechua word."[12]

Among the Mayas of Mesoamerica, oral tradition has been and continues to be the essential way of passing on the culture's norms, sacred beliefs, and knowledge. In this process, the Mayan languages (there are thirty-one related languages in the Mayan area) are vivid, and the Mayas continue to create their Maya world with a strong link to

ALBERTA NATIVE FAMILY, SAMSON AND LEAH BEAVER WITH BABY FRANCES LOUISE, CA. 1907. GEORGE NOBLE COLLECTION, 1879 TO 1965. COURTESY, WHYTE MUSEUM OF THE CANDIAN ROCKIES, NEG. NO. 2771.

their ancient tradition. In the 1920s, J. Eric Thompson collected many oral histories and folktales among the K'eqchi' Mayas of San Antonio, Belize, stating that despite the atrocities committed against the Mayas, they "clung to the beliefs that clustered about the most sacred thing in their existence—the soil."[13] The same was found by Oliver La Farge among the Jakaltek Maya of the Kuchumatan highlands during his ethnographic research in this region in 1927. La Farge commented that "the Indians are very fond of telling stories, particularly around the fire at night. Certain ones enjoy a

reputation of storytellers, either from their knowledge of old myths, or lively style in narrating recent incidents."[14]

The oral tradition, then, deals with common themes, namely a universal concern with fundamental issues about the world in which we live, such as life and earth itself. In what follows, I will discuss the role of the storyteller and how the oral tradition is maintained and transformed.

STORYTELLING: A NATIVE WAY OF TEACHING AND KNOWING In nonliterate societies, storytelling has been the major source of information about the community's way of life and culture, passed from one generation to the next in order to ensure communal knowledge and histories. In this process the adults pass moral values and teachings to the children, who in turn are encouraged to tell the stories and continue the tradition. This creative form of expression or what is also called verbal art is found in all societies (literate and nonliterate) around the world. Unfortunately, the Western world, which has relied greatly on the written word, has tended to dismiss the oral tradition of indigenous people as untruthful or the antithesis of history. In other words, the Western world has viewed oral tradition (myths and folktales) simply as a form of entertainment without historical significance or moral value.

More recently, anthropologists have focused on the oral tradition as secondary material in their research and have included it as an appendix in their ethnographies. Their approach to oral tradition has been that of the collector of rare objects, or as Gary Gossen stated, "They have shown a preference for what Edmund Leach called butterfly collecting. This orientation, while valuable in providing a reservoir of reference material, nevertheless implies that oral tradition is marginal to the mainstream of social life."[15]

Within its context, the oral tradition not only provides entertainment but it also promotes socialization while providing moral instruction and a guide to appropriate behavior for the members of the community. The oral tradition serves didactic, religious, political and artistic functions for its practitioners. The oral tradition, especially stories that deal with the secular world (myths, legends, folktales, gossips, etc.), is accessible to all members of a community. There is also a category of specialized knowledge (holy or sacred) which is handled by the specialists who claim to obtain this religious and sacred knowledge through dreams and revelations. Among the Mayas of Chamula, Chiapas, Mexico, the category of "recent words" (myths, legends, folktales and gossips) is learned by listening to the storytellers in every social context. The other aspect of the oral tradition—for rendering holy, which is sacred and secret—is learned in a more formal way (seeing and doing in the context of a sacred performance). In this process, "aspiring shamans...attempt to listen to many curing sessions in addition to those in which they and their families are personally involved. Learning is greatly facilitated in the frequent cases when a son decides to follow the shaman's career of his own father."[16]

The oral tradition is then part of the expressive form of a culture in which people relate. Teaching through the oral tradition ensures the continuity of the social structure and the continuity of the world view of Indigenous cultures in spite of the strong impact of the Western world. The importance of oral tradition was minimized by early

evolutionists who thought that indigenous beliefs (myths, dreams, legends) were relics of the primitive mental state.[17] But indigenous people have persisted in using it in their daily life. For them, the oral tradition is a dynamic process and it continues to be essential in the education of the children to their own cultural ways, history, and traditions.

We can argue that modern storytellers are engaged in the revitalization of their cultures. The indigenous people of the Americas are taking pride in their heritage, and the oral tradition is again becoming a way of expressing their essential links to Mother Earth. For example, among the Seneca Nation of the Iroquois, the storyteller was known as Hageota, "one who stories." "Those storytellers often would carry a storytelling pouch, filled with such things as animal claws, various feathers, a cornhusk doll, a flint arrowhead—items which would remind the storyteller of a particular legend when he pulled something out at random."[18] And it is the role of the storytellers to maintain and promote these values, passing them from one generation to the next with the changes that they consider necessary for the survival of the culture. It is also important to recognize that in many cases Indigenous people documented their oral traditions as a result of the conflicts they confronted in maintaining their identities, origin, and claims on their communal properties. This is how the *Popol Vuh*, and the *Titulo de Totonicapan* were written in Mayan languages among the Mayas.[19]

The oral tradition is not fixed. Its survival and continuity depend on the memory of the storyteller, and as a consequence, it is subjected to changes. In modern times major changes are coming from outside, affecting the indigenous communities. This can be seen with the influence of the media (radio, television, films, and newspapers), which has contributed to the decline of the tradition of storytelling everywhere. Dramatic changes have occurred, and because the press is in the hands of the middle and upper classes throughout the world, the form and function of communication have changed from educational to informational. This is how "every morning brings us news of the globe, and yet we are poor in noteworthy stories."[20] There is, then, a major decline in storytelling in industrialized nations as compared to the indigenous communities.

CONCLUSION The oral tradition plays a critical role in the continued recreation of indigenous identities in the Americas. In this process, the storyteller has been essential to the construction of meaning and the representation of culture. The oral tradition is rapidly changing, however, because of the impact of Western technology. According to Walter Benjamin, the oral tradition in Western cultures "has already become something remote from us and something that is getting even more distant.... It teaches us that the art of storytelling is coming to an end."[21] This argument is based on the fact that people in this modern world are losing their ability to communicate with words, while news from the media is replacing the social form of sharing experiences through the spoken word, or oral tradition.

The oral tradition does not stem from a distorted version of reality held by indigenous people who lack a true sense of history. Vansina argues, in fact, that "even written sources can distort events in terms of the conscious or unconscious biases of their

IRENE JEROME, ALGONQUIN, HOLDS HER
GRANDDAUGHTER, AYLA, AS THEY SHARE SOME
MOOSE MEAT AT A TRADITIONAL GATHERING IN
CHOCHOQUIN, QUEBEC. PHOTO BY MILLIE KNAPP.

authors."[22] Within the oral tradition, the storyteller tells stories to a live audience. To motivate the listener, the storyteller may raise or lower his or her voice and make use of gestures and body movements. Native storytellers have direct contact with listeners and their message includes the collective experience. The oral tradition has experienced difficult historical periods, but it has persisted and it continues to be re-created by contemporary indigenous peoples who are increasingly proud of their heritage. ✳

Notes

1. J.W. Powell, The Lessons of Folklore, American Anthropologist, Vol. 2 (New York: Putnam's Sons, 1900).

2. Eric R. Wolf, Europe and the People Without History (Los Angeles and Berkeley: University of California Press, 1982).

3. Victor D. Montejo, "Oral Tradition: An Anthropological Study of the Jakaltek Folktale." (Master's thesis, State University of New York at Albany, 1989).

4. Victoria R. Bricker, ed., The Indian Christ, the Indian King (Austin: University of Texas Press, 1981) and Gary H. Gossen, Chamulas in the World of the Sun: Time and Space in a Maya Oral Tradition (Cambridge: Harvard University Press, 1974).

5. Bricker: 6.

6. Benedict Anderson, Imagined Communities: Reflections on the Origin and Spread of Nationalism (London and New York: Verso, 1991).

7. Norman A. Chance, The Inupiat and Arctic Alaska: An Ethnography of Development (Fort Worth, Texas: Holt, Rinehart and Winston, Inc., 1990) 103.

8. Robert M. Carmack, Harvest of Violence: The Maya Indians and the Guatemalan Crisis (Norman: University of Oklahoma Press, 1988).

9. Joseph Bruchac, Iroquois Stories: Heroes and Heroines, Monsters and Magic (Trumansburg, NY: The Crossing Press, 1985).

10. Miguel Leon Portilla, Native American Spirituality (New York: Paulist Press, 1980) 36.

11. Catherine J. Allen, The Hold Life Has: Coca and Cultural Identity in an Andean Community (Washington, D.C.: Smithsonian Institution Press, 1988) 101.

12. Jack Weatherford, Indian Givers: How the Indians of the Americas Transformed the World (New York: Crown Publishers, Inc., 1988) 177.

13. J. Eric Thompson, Ethnology of the Mayas of Southern and Central British Honduras. Anthropological Series, vol. XVIII, no. 2 (Chicago: Field Museum of Natural History, 1930) 114.

14. Oliver LaFarge and Douglas Byers, The Year Bearer's People (New Orleans: Department of Middle American Research, Tulane University of Louisiana, 1931) 112.

15. Gossen: viii.

16. Gossen: 164.

17. Alan Dundes, The Study of Folklore (Englewood Cliffs: Prentice-Hall, Inc., 1965).

18. Bruchac: 5.

19. Robert Carmack and James L. Mondloch, El Título de Yax y otros documentos quichés de Totonicapáan, Guatemala. (México: Universidad Autónoma de México, 1989) and Dennis Tedlock, trans., Popol Vuh : The Definitive Edition of the Mayan Book of the Dawn of Life and the Glories of Gods and Kings (New York: Simon and Schuster, 1985).

20. Walter Benjamin, Illuminations (New York: Schocken Books, 1968) 89.

21. Benjamin: 83.

22. Jan Vansina, "Oral Tradition: A Study in Historical Methodology," in Bricker, The Indian Christ, The Indian King: 3.

LANGUAGE AS CULTURE
PRESERVATION AND SURVIVAL

CAROL CORNELIUS

Years ago the elders told us, "If you don't speak the language you can't understand the culture." Many of us experienced anger, hurt, and frustration because we were the second or third generations removed from our languages. The elders had experienced the trauma of United States government policies in boarding schools, where they were severely punished if caught speaking their languages and were indoctrinated to believe that native languages were inferior to English. These boarding schools, which operated from the late nineteenth century into the 1930s, were praised for helping the American Indian "assimilate" into the Western world. Since the 1970s those of us who were denied our languages through this process understand clearly that the United States policy which attempted to destroy our languages amounted to a form of ethnocide.

The results of the boarding school policy are troubling: some native communities have entirely lost their language, while in other communities the remaining speakers of the language are the elders and the younger generations speak only English. Thankfully, there are also some native communities where, despite the integrationist policy, the languages continue to be spoken throughout the community. Some of the elders, who as children were subjected to boarding schools, refused to teach their languages to the next generation to spare the children the pain and suffering they experienced. Others stubbornly refused to forget their languages. When we asked this generation to teach us, they willingly invested years of their lives to do so. The contemporary struggle to learn our languages, or relearn because they are within us, has depended on those rare elders who continue to speak the languages despite, and in resistance to, the boarding school policies. Most of these elders have been teaching for twenty to twenty-five years and are now well into their seventies and eighties.

During the 1970s, the federal government funded language renewal, or bilingual education, programs for the second and third generation of indigenous peoples who had been denied their languages and were reasserting their right to speak them again. Bilingual education in many cases emphasized writing and reading as teaching methods for the indigenous languages. Up until that time, in most cases, the languages remained oral, with just a few linguists

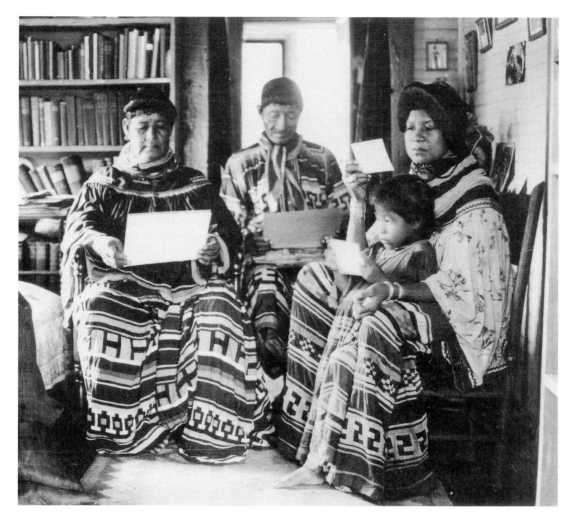

developing writing systems. For example, during the WPA programs of the 1930s, a linguist developed a writing system for the Oneida language (Wisconsin), but it did not become widely used until the bilingual programs of the 1970s. Across the nation, these bilingual programs developed "survival" curricula to teach the basics with booklets and cassette tapes. For the first time, native languages were incorporated into public school systems by pulling Native American students out of regular classes to participate in native language instruction. Elders were taped, their words were transcribed and translated, and booklets were printed. Across the country, language classes were held in schools and community centers. The survival curriculum included basic words—colors, numbers, foods, animals, and sentences such as "Are you hungry? How do you feel? I want to eat," in set patterns using memorization methods. In some cases, much of the complexity of the language was diminished because it lost a connection to the earth. For example, the color of the "inside of rotten logs" might be translated to mean simply "brown." The emphasis was on writing and reading the language. As with many federal programs, eventually the funding dwindled and most programs ended.

By the 1980s, some native peoples had regained control over their children's education by establishing their own schools, which enabled them to continue language classes during the regular school day. Some communities wrote proposals to obtain additional funding. In other communities, the people continued on their own by holding classes in the home. One of the most found a way to continue learning the languages. Technology had expanded to include videotaping speakers, slide and cassette materials, and even dial-a-phone, which enabled a person to call 24 hours a day to hear a language tape.

Today, despite the years of funding and classes, it is quite rare to find people who have become fluent speakers as a result of

innovative approaches was having the elders conduct home-based education, in which the entire family would participate. Some tribal governments also funded language programs. In each case, indigenous people those efforts. Fluent speakers often point out that the person must first make a serious commitment to the goal of fluency. Secondly, teaching must include the full variety of methods, incorporating writing, tapes,

ABOVE: ELDER AND BOY. PHOTO BY FRED CATTROLL.

OPPOSITE: PAULINE DECONTIE, ALGONQUIN, INSTRUCTS AN ALGONQUIN LANGUAGE IMMERSION CLASS AT THE KITIGAN ZIBI SCHOOL IN MANIWAKI, QUEBEC. PHOTO BY MILLIE KNAPP.

stories, and classes. Thirdly, fluent speakers unanimously say the key to really learning was establishing a relationship with an elder who would speak with them. This is difficult because it takes time and commitment. The few who have become fluent have had to convince the elders of their dedication and sincerity.

The fourth vital key to learning indigenous languages is understanding how the culture and language intertwine. For example, in learning the Oneida language the student learns the culturally specific Oneida values or philosophy in the Thanksgiving or Opening Address, which contains the philosophy and world view of the culture and many of the words used in daily communication and language. The Thanksgiving Address expresses gratitude for all beings, including the People, Mother Earth, Plants, Grasses, Birds, Waters, Trees, Three Sisters (corn, beans and squash), Animals, Grandmother Moon, Elder Brother the Sun, Winds, the Thunderers, Stars, the Four Messengers, Handsome Lake, and the Creator. The Address sets forth the natural law that each of these elements has duties and responsibilities that help our lives, and that human beings have a responsibility to reciprocate. The student, in learning the Thanksgiving Address in the native language, also comes to understand the philosophy, world view, way of life, and the respectful relationship of human beings to the universe.

I think now that what had seemed so negative and hurtful in the elders' admonitions was simply the expression of their own pain because they saw us—the future leaders—unable to speak our own language. In learning native languages we begin to view our world differently; we learn respect for all forms of life and we learn and understand that culture and language are intimately linked. Recently, as I saw a twelve-year-old opening a social dance by presenting the Thanksgiving Address in the Oneida language, my heart soared with joy, realizing that language instruction is finally coming full circle to its intended, culture-based purpose. ✳

INDIAN GAMING
NEW IMPACT ON TRIBAL CULTURES

George Cornell

The rise of gaming on Indian reservations in recent years has stirred considerable controversy. The issue has been litigated, legislated, regulated, and written about time and again in the popular press. Some Indian communities are making "big money" an ironic twist to the last two centuries of Indian-white relations in the United States. In addition, there seems to be no clear Indian consensus on the activity. In some regions of the country gaming has not been at all controversial, while in other areas gaming has been the most divisive debate of the twentieth century.

The vast majority of these tribal cultures have a history of wagering on and engaging in games of chance. Dice

games, stick games, and moccasin games have been known to exist for centuries, while horse racing became a major pastime after the introduction of the horse. Obviously, the advent of Christianity has had some impact on the formation of tribal opinions regarding gaming and the morality of endorsing it. One should not rule out, though, the opposition to gaming that is fueled by a concern about what is an appropriate developmental strategy for a community over time. Some people simply believe that a community built on gaming revenues and tourism is not what they want as a part of their future. Of course, the reasoning behind such decisions is complex and steeped in historical interaction, and observations and should not be down-played in favor of overly simplistic interpretations.

Indian communities have governments which, like all governments, are prone to differences of opinion on major issues that affect the quality of life for constituents and members.

One of the most frequently asked questions in relation to tribal gaming operations is: What impact will the activity have on tribal culture? One can only assume that the question is an attempt to get at how gaming will affect the continuity of language, tribal customs, and ritual life. Sometimes the question is asked with the inherent assumption that somehow Indians will become less "cultural" because they support gaming or derive benefits from casino revenues. That idea harkens back to arguments that eighteenth and nineteenth century indigenous peoples were becoming less "Indian" because they adopted Western material culture. Culture is

dynamic, not static: things change over time. The escalation of Indian gaming does not necessarily mean that there has to be a decrease in the cultural life of the community. As a matter of fact, some tribal governments are currently using gaming revenues to

federal paternalism, Indian tribes are producing a surplus of revenue. That money, in the context of American culture, clearly indicates enhanced power and more options for tribal governments. Gaming is creating new patterns of tribal employment and allowing

tribal culture. Tribal governments, with increased economic power, are now in a position to decide how to use that money. Cultural programs appear to be emerging as important priorities for tribes with gaming revenues. There is little doubt that tribal governments will increase support for cultural programs over levels supported by the federal government. This seems to be particularly true when one considers this issue in the context of the cultural "revitalization" that has been going on for almost three decades.

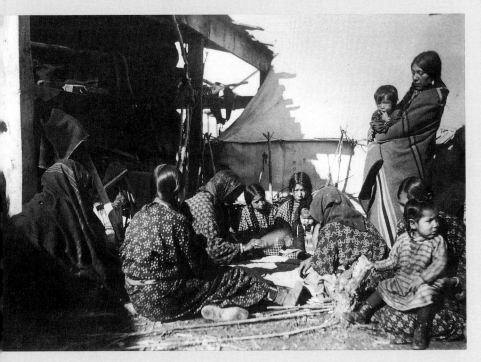

CROW WOMEN GAMBLING. PHOTO BY FRED MILLER. COURTESY, NMAI (13731).

support language programs, powwows, and other cultural forms of tribal life.

Without question, the rise of Indian gaming over the last decade has signaled remarkable changes in Indian Country. For the first time since the beginnings of

tribal governments to diversify their economies. It is also allowing tribal governments the autonomy to make decisions independent of the federal government and programs that have been offered as a part of the federal menu of programming options. In truth, the federal government has supported few programs that were aimed at continuing and promoting

The revitalization movement, as it has been called, has been the outgrowth of American Indian commitment to maintaining and promoting culture, not the outcome of federal programs and prerogatives. Even though the idea of building a tribal economy on gaming revenues may be controversial, there seems to be little evidence that it will necessarily undermine or erode tribal culture. In some quarters there has even been talk of tribal governments using gaming revenues to create foundations that support the cultural life of the community. These foundations

PUBLICITY PHOTOGRAPH PRODUCED
BY THE ONEIDA CASINO, GREEN
BAY, WISCONSIN. COURTESY,
ONEIDA BINGO AND CASINO,
SALES AND MARKETING.

would provide funding for cultural seminars and training sessions, language programs, powwows, and spiritual gatherings. They could also provide funding to purchase lands for ceremonial purposes. The lands would become tribal properties and would be maintained for the use of tribal members and regional Indian populations.

Gaming, in some form or other, has been a part of Indian life for centuries. At the present time, it appears that it will, in some communities, play a more significant role in contemporary life than it did historically. Whether this is a good thing or not is for members of respective communities to decide. Today some Indian communities see gaming as a "window of opportunity," while for others it is a highly controversial activity. It can safely be assumed, though, that tribal cultures will continue to flourish. They will change over time, as they have in the past, and they will gain strength and experience in areas where increased financial support is available. In this context, gaming can be an important contributor to tribal self-determination. ✳

EMERGENCE AND DISCOVERY
NATIVE AMERICAN THEATER COMES OF AGE

Bruce King

Theater is a wondrous art form that creates illusions from the abstract and written work. These structured illusions transcend time, languages, and cultures. With the use of form, symbology, dialogue, and mood structure we are able to epitomize situations, convey issues, orient views and identifications, understand characters and the situations that affect them, and instill emotionally charged moments through the use of an underlying plot which an audience comes to recognize and identify with.

With the power of this art form, we, as theater artists, are able to manipulate, empower, move, and construct an audience's emotional and physical reaction to the things that affect them directly. Within the lighted, magical box, through the invisible fourth wall, theater artists are able to enlighten, entertain, explore, and discover ourselves and the world around us. In giving voice to stories rooted in culture and imagination, we cultivate awareness and instill a sense of esteem.

Unlike television or film, theater is a living art. Theater production involves the commitment, skills, and abilities of many people who share in the effort of

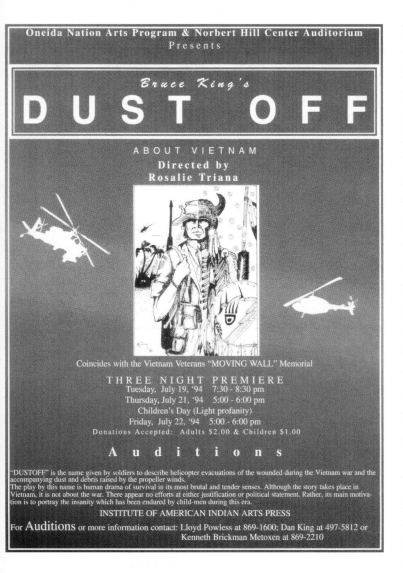

PLAYBILL OF BRUCE KING'S "DUST OFF," 1994. COURTESY, BRUCE KING.

OPPOSITE PAGE 155: THEATRE PASSE MURAILLE AND NATIVE EARTH PERFORMING ARTS PRODUCTION OF "DRY LIPS OUGHTA MOVE TO KAPUSKASING," CAST: ERROL KINISTINO, SEATED; BEN CARDINAL, GRAHAM GREENE AND GARY FARMER, STANDING; DORIS LINKLATER, ON TABLE. PLAYWRIGHT TOMSON HIGHWAY, 1989. COURTESY, NATIVE EARTH PERFORMING ARTS.

bringing the invisible to life. While film and video are chemical and electrical processes that record and play back continuously, each theatrical production is a new experience every time the curtain rises. Actors render living, breathing characterizations, sharing a vision in proximity to an involved audience. A good show is determined by the acting efforts of its performers and the reaction of the audience. This art form is not restricted to any one culture or language. The direction a performance takes may be influenced by these factors but the dramatic presentation strives to encapsulate a situation, spectacularize a phenomenal event, revere contact with the divine, observe and study the many facets of human nature, and make an audience feel. The end result should always strike a chord of awe and wonder in an audience.

The theater community in general has undergone significant changes in recent years. Gone is the construction of monumental buildings designed specifically for theater. Grassroots storytelling efforts that used to serve specific communities have dwindled. The industry that used to adhere to its own values has given way to the demands of the film industry. Commercialism and box office success are paramount, and most productions are restricted to formula-oriented material that replaces the risk-taking new material that was the norm not so long ago. Highly competitive theater communities exist in many major cities but most actors in those communities use theater as a stepping stone to break into film. So what is the state of the art as it pertains to Native Americans?

Native American theater groups come and go depending on many factors, most

having to do with funding and facilities. In many native colleges, the curriculum focuses on courses that are academic and business-oriented, while the arts are offered only when and where they can be afforded. Most Indian colleges are localized, so their progress reflects the needs of their particular nations. This is understandable considering the dire health care, employment and resource management needs of all the nations, but it also places the arts near the bottom of the priorities list in a "maybe next year" time frame. In contrast, many provinces throughout Canada wholeheartedly support native theater endeavors regardless of other financial needs. The questions of appreciation of the arts, attitudes in relationships between governing bodies, and collective priorities, all of which shape and define Native American theater, must be considered.

Even though the word "theater" is European, the art form, being universal, is quite at home in Indian Country. The very first forms of theater were devised to recount phenomenal events that were reenacted for the benefit of the cultural memory and to keep those events alive. Some of these reenactments became the basis for many of the religious ceremonies that take place every Sunday throughout the world, reverence for visitations from the divine, and manifestations of tribute. Viewing theatrical productions as spectacles followed shortly thereafter, and ancient cultures built huge amphitheaters.

Indian people also experience the phenomenal events that shape the world. The divine has visited this land and ceremonies all over Indian country attest to this. Even though Native American people are so diverse, a community dance from any of the nations conveys a sense of the spectacular through symbols, masks, color, music, stories, and the representation of passionate contemporary life. Native Americans bring skill, talent, vision, and intellectualism to the world of the theater. We understand commitment, discipline, regimen and trust. We have imaginations, senses of humor and feelings, and we are not afraid to take risks. Nevertheless, those of us practicing theater constantly confront preconceived notions of what Native American people should perform on stage. Most of the time these notions reinforce what others believe Indians should be—sharing, demonstrating, creating, understanding, quaint, colorful, and …safe. If, on the other hand, a story, structured in play form, deals with an issue that indicts and holds certain individuals or peoples responsible for our contemporary situations, that is not considered native theater. It's called controversial, political, and biased. It is not entertainment.

People constantly ask me about the role of Native American theater within the cosmology of Native American culture. I often answer, "What is the role of non-native American theater to the cosmology of America?" Countering the question in this way doesn't satisfy them. They have a list of rationalizations about serving community needs, providing forums for cultural and individualized examinations, paying tribute to classical figures through reenactment of their material, offering insight into what affects them today, generating funds to ensure the existence of theatrical events, creating opportunity in the arts, and on and on. When I say, "Well, there you go," they ask about pageantry, the sacred dances, the

eloquence of historical figures, environmental messages that will save everybody, universal themes and connections reinforcing the brotherhood of man, and cultural bridges to non-Native American people. That, I am told, is what Native Americans should be doing with the stage.

There is nothing wrong with these forms of expression but many non-native people see native performance as a device to suit their own needs. If there are no feathers, it's not Indian. These styles of presentation serve a valid purpose, but they can also restrict us and place our voices in antiquity. That way no one is indicted or responsible for the issues that affect us today. When performances depart from these "acceptable" genres, the material is considered questionable, and thought-provoking impact is unraveled in controversy.

Native Americans must be accepted first as real people, in theater as in life. We don't dance, sing, write, design, and perform because of marketing value or to make some powwow a financial success. Creative expression is no longer a device for gaining acceptance into the mainstream. Cultural institutions, though, reinforce the drumming, feathers, and exhibition dances, but scrutinize and question material involving political controversy. In 1989, for instance, the Native American Center for the Living Arts in Niagara Falls, New York, applied for funding to produce *Dust Off*, a play about Vietnam. The criteria for funding favored productions of the song, feather, and dance variety, and discouraged contemporary, issue-oriented Native American work.

Theater and performance are about storytelling. Is Vietnam not a story? We are here today because we survived. Oral tradition, shaped and held through performance, maintains a sense of identity with the past, but it also has a sense of continued existence. Paula Gunn Allen says,

Since the coming of the Anglo-European beginning in the fifteenth century, the fragile web of identity that long held tribal people secure has gradually been weakened and torn. But the oral tradition has prevented the complete destruction of the web, the ultimate disruption of tribal ways. The oral tradition is vital. It heals itself and the tribal web by adapting to the flow of the present while never relinquishing its connection to the past. Its adaptability has always been required, as many generations have experiences.

Theater is the ideal vehicle for the presentation and preservation of oral tradition, but more than that, it empowers us to confront and examine the present, to look at who we are today so that we may better understand ourselves.

Theater is about storytelling. We as a people are about storytelling. We have wonderful stories of other worlds, of creations of life, of mystical figures like Coyote, Raven, Deer Woman, and countless others. There are detailed accounts of how we came to be, that tell of twins, prophets, magical entities, and the Creator. With those come all the stories that contain lessons on morality and behavior, about respect for all that surrounds us, about healing and giving, wisdom and courage. These stories are about us. We cannot look to others to define and determine these stories. We must assume this responsibility ourselves.

We have an opportunity to recognize, imagine, and validate stories that affect who we are today. Because theater lends itself to seeking a balance, we are free to examine and portray both the positive and negative aspects of life. Life is about elements of both, and theater is about life. When stories of alcoholism, corruption, treachery, exploitation, racism, child abuse, prostitution, AIDS, political oppression, and cultural relinquishment arise, they cannot be discounted as being non-cultural or non-native.

Storytelling is also about insight. With insight we are able to examine and pass on valid messages to the generations to come. With theatrical impact we are able to make positive, indelible impressions on our youth, making them aware of who we once were and how these societal mores and values can be carried into the future. At one time, all our nations held similar notions about the care of children, the sick, and the elderly, the reverence of the land and one another. These values have been eroded and the reality is that we are all responsible. Theater creates a possibility of getting back to that place where values carry a great deal of weight. One might ask, how can a play achieve all that? A play, well done, can move and intellectually stimulate an audience. The effect is doubled if an audience has a cultural investment and identifies with its pertinent messages.

It is safe to say that the general state of the art of theater is turmoil. Ask anyone trying to produce a show. Funding falls far short of what productions require, facilities are few and far between for new works and shows of the experimental nature. The state of the art of Native American theater, however, is discovery. We are still finding our way. We are beginning to look to each other for what we need to pursue this art form. Many of the people who were involved in native performing arts in its early stages are still at it and new groups are emerging in Minnesota, California, New Mexico, and Wisconsin. We are discovering the possibilities that theater can offer, but to achieve a true sense of Native American theater we must first realize that strength among ourselves. We must first offer this art form to our own communities and audiences, so the reflection we receive can be true in nature. The stage must be made to offer us what it offers everyone else—a forum for our voice. ✳

BEYOND THE IMAGES
NATIVE VOICES AND VISIONS IN NEW YORK THEATER

Elizabeth Theobald

In the theater, when we characterize a particular director's, writer's, or ensemble's impact and importance, we put it in physical terms—we speak of their "voice" and their "vision." Recent images of Native Americans on Broadway have ranged from the laughable stereotypes in *Will Rogers' Follies* to complete erasure, as in this past season's Pulitzer Prize-winning drama *The Kentucky Cycle*, which featured several native characters, none of whom were played by native people.

The youngest of our theater community summed it up best this year in a youth project entitled *My Ugly Child*, by Steve Elm. "Images are just that—images," pronounced Nicole Bennett, a black native woman, whose character, Roxanne, comes to the rescue of an HIV-positive Cree girl addicted to drugs. The addict desperately wants her life to be different: she wants it to be like *Dances With Wolves* or *Black Robe*. In the course of this *Wizard of Oz*-like play, she learns from "Spearmint Woman" (a New Age wannabe who throws sage at the audience), "MaryAnn Running Jumping Skipping Laughing Crying Walking Talking Singing Bear Smith" (a model who is cashing in on her native thing), and from "Rez Man" (who gives lessons in how to speak rez and cries at the sight of garbage), that Hollywood's idea of who she is has nothing to do with her realities. In order to move forward, she has to love herself for who she is.

Each generation of theater artists that I have spoken with has shared a common thought: there came a point when they realized that their stories were important to tell—not only traditional stories, but the stories of their own lives and experiences, as confusing as their identities might be to outsiders. Irene Bedard, an Inupiat actress living in New York, is currently Hollywood's ideal face and voice of the native woman (she is the star of three upcoming feature films: Disney's *The Indian Warrior* and newly-animated *Pocahantas,* and TNT's *Lakota Woman*). She is also one of the six founding members of a young theater ensemble in New York called Chuka Lokoli, which means "community" in Choctaw/Chickasaw. Bedard is passionate about her work with the company, and shared that

the biggest reason that Chuka Lokoli came together was that we had no means of expressing ourselves—no scripts! When we got together and started talking to each

SPIDERWOMAN THEATER PERFORMING IN NEW YORK CITY. PHOTO BY TIM JOHNSON.

other—accepting our nativeness, sharing our own stories of who we were. We decided we needed to say it. Of course at first we wanted to stretch ourselves as actors, but it's hard to write. But we were going to do it, keep on doing it ...why not do it?

Lisa Mayo of Spiderwoman reminded me that her company is not just a native theater company, "we're a New York theater company—we're from Brooklyn!" Since 1975, sisters Muriel Miguel, Gloria Miguel, and Lisa Mayo who are both North and South American Indians (Kuna/Rappahannock) have created performance-based pieces that deal with feminist issues and their own identities. They have performed in Europe and throughout North America. Lisa told me,

"Native theater used to be so boring! There were pageants and the like. Indians weren't people, they were romanticized and historicized, well, we still are! I had come from music and musical theater. I auditioned for native roles but I never got them because I didn't look like a casting director's idea of an Indian, and if I was in another play, I'd have to fit myself in. Then I realized—I'm not an ordinary Indian, I was brought up in Brooklyn, trained in musical and converted to Judaism. I have to tap into my own resources. With Spiderwoman I could find my own voice."

A good portion of Native American theater in New York is developed through improvisation and workshops. Spiderwoman, Chuka Lokoli and Las Colorados-Coatlique (Vera and Hortensia Colorado), have all inadvertently become playwrights because of the dearth of appropriate scripts. My own work as a producer and director in New York centers around the development and support of native playwrights. The idea that there is a

CHUKA LOKOLI, NATIVE THEATRE ENSEMBLE, AUGUST 1994. FROM LEFT TO RIGHT: ELIZABETH THEOBALD, GORDON TSON, KIM BASSETT, IRENE BEDARD, KIM SNYDER, VICKIE RAMIREZ. PHOTO COURTESY, ELIZABETH THEOBALD.

shortfall of playwrights is only partially the truth—playwrights such as Bruce King, William S. Yellow Robe, Jr., E. Claude Richards, and Tomson Highway are currently writing significant plays. Nevertheless, we crave even more original native voices and need more directors with the vision to produce the plays that currently exist.

In the fall of 1993, New York Theater Workshop in Manhattan's East Village presented Tomson Highway's *Rez Sisters*, co-

produced with New York City's American Indian Community House. Highway's play is about six blood and in-law related women from a fictional Indian reserve on Manitoulin Island, Ontario. Each sister wants out of her desperate life and looks to a big bingo jackpot in Toronto as the way to escape.

An examination of the replacement of spiritual footing with fast money, *Rez Sisters* ran for four weeks Off-Broadway. The production was a coming together of a powerful conglomeration of native actresses in New York: Lisa Mayo, Gloria Miguel, and Muriel Miguel of Spiderwoman Theater, Muriel's daughter, Murielle Borst, an actress and dancer with the Thunderbird American Indian Dancers, Vera and Hortensia Colorado of Las Colorado-Coatlique, and Sheila Tousey, a formidable native actress who has had leading roles in films (including *Thunderheart*) and in regional theaters such as Arena Stage in Washington, D.C. and the New York Shakespeare Festival/Joseph Papp Public Theater. Louis Mofsie of the Thunderbird American Indian Dancers played the trickster Nanabush in the guise of a seagull and a nighthawk-harbinger of death. The production was co-directed by Muriel Miguel and Linda S. Chapman, a staff director with the New York Theatre Workshop. Largely misunderstood by the press as an "ethnic piece," *Rez Sisters* was actually about common themes in life and in dramatic literature: isolation, despair, and laughter—realities that affect us all. The production was also an interesting mix of mainstream Off-Broadway and native community support—an important ingredient for further productions.

The New York Shakespeare Festival/Joseph Papp Public Theater also took a few steps forward this past year in supporting the native voice: they presented

two pieces created by native people in their New Work Now! Festival: *Sneaky* by William S. Yellow Robe, Jr., and *In the Spirit* by Chuka Lokoli. The festival is a series of thirty-five staged readings of new plays performed over fifteen days, with the intent of presenting a wide variety of new voices, from many different constituencies in New York City.

In the Spirit is about a group of Native American activists who decide to blow up Mount Rushmore and find out a lot about themselves in the process. The production, directed by Kim Snyder, featured Irene Bedard, Steve Elm, Gordon Ison, Elisa Cato, Kim Bassett, Vicky Ramirez, and Nic Billey. First performed at the Ensemble Studio Theater in October of 1992, the piece was developed through improvisation and has gone through several development stages. In the words of Irene Bedard, *In the Spirit* is "a look at all the things that make us what we are now."

Sneaky, by William S. Yellow Robe, Jr., is about three brothers who steal their mother's body from a funeral parlor in order to give her a traditional native funeral. Mr. Yellow Robe is a master playwright, particularly in fusing dramatic tension with bouts of laughter. The cast featured Gloria Miguel, Sean Colorado, Steve Elm, J.C. Whiteshirt, and Gordon Ison.

The recent observation of the Columbus Quincentennial was an opportunity to celebrate survival. Our voices are currently rising above the reverberations of that event to go beyond survival. Spiderwoman has received a grant from the Rockefeller Foundation to work on a piece, which is tentatively titled the Kuna Project. The grant has enabled the sisters to travel to the San Blas Islands to research their Kuna heritage and to "conjure up" their paternal grandparents in order to create a fully

realized theater piece. Sisters Gloria Miguel and Lisa Mayo are creating from their research a work called *Voices from the Criss Cross Bridge,* which is, in Lisa's own words, "about the mixtures in us" and will be performed both in New York and Minneapolis. Las Colorados-Coatlique is creating *Moments in Tlalteuctli,* about abuse of the earth, abuse of women and recent events in Chiapas, Mexico. Both of these projects have received work-in-progress productions at the American Indian Community House. Chuka Lokoli has also moved on to their next project entitled *Point Hope,* which follows the life of an Eskimo family in Alaska from the 1950s, when the United States government buried 1,000 tons of radioactive material in their village.

This season, audiences also experienced performance artist James Luna, who presented his piece *My Way* at the Cooper-Hewitt Museum, and Muriel Miguel in *Hot and Soft,* a one-woman show at the WOW! Café in the East Village. In addition, the American Indian Community House presented a reading of Tomson Highway's newest play, *Dry Lips Oughta Move to Kapuskasing* (the male counterpart to *Rez Sisters)* in their gallery space.

The New York native community's theater productions are fraught with the same challenges faced by any other theater artists, and our forms are as diverse as any community's. There is a significant amount of exciting cross-pollination in our theater world: we act in each other's pieces, we step in and direct, we join together, we go solo, and we take on several projects at once. We look forward to more opportunities to express our different styles, influences, ages, levels of training, tribal affiliations, and creative processes. ✳

Then she gave something to the chief, and it was a pipe with a bison calf carved on one side to mean the earth that bears and feeds us, and with twelve eagle feathers hanging from the stem to mean the sky and the twelve moons, and these were tied with a grass that never breaks. "Behold!" she said. "With this you shall multiply and be a good nation. Nothing but good shall come from it....Then she sang again and went out of the teepee; and as people watched her going, suddenly it was a white bison galloping away and snorting, and soon it was gone.

—Black Elk

SUMMER OF 1994 IN JANESVILLE, WISCONSIN, FIRST KNOWN BIRTH OF A WHITE BUFFALO CALF IN FIFTY YEARS. PHOTO BY MORRY GASH, AP. COURTESY AP/WORLD WIDE PHOTOS.

CONTRIBUTORS

JOSÉ BARREIRO is a novelist and editor in chief of *Akwe:kon Journal.*

DUANE BLUE SPRUCE is assistant facilities planner for the National Museum of the American Indian.

ELAINE BOMBERRY is co-owner of the All Nations Talent Group and chairperson of the Music of Aboriginal Peoples Juno Award.

VICTORIA BOMBERRY teaches in the Modern Thought and Literature Program, Stanford University.

SIMON BRASCOUPÉ is an artist, economic development specialist, and professor at Carleton University.

ABE CONKLIN is Nu Da Honga of the Ponca He-thus-ka society in Oklahoma and participated as a selector in the "All Roads are Good: Native Voices on Life and Culture" exhibition of the National Museum of the American Indian.

RAY COOK is executive director of the Indigenous Communications Association.

CAROL CORNELIUS is director of Native American Studies at the University of Wisconsin, Green Bay.

GEORGE CORNELL is director of the Native American Institute of Michigan State University.

GARY FARMER is an actor and publisher/ executive editor of *The Runner: Native Magazine for Communicative Arts.*

DENNIS FOX is assistant director of First Nations Arts.

CHARLOTTE HETH is assistant director for Public Programs, National Museum of the American Indian.

RICHARD HILL is special assistant to the director, National Museum of the American Indian.

BRUCE KING is a playwright, actor, musician and instructor in the Theater Department, Institute of American Indian Arts.

RICHARD LACOURSE is associate editor of the *Yakama Nation Review.*

LYNNE MARTIN is folk arts coordinator, State Foundation of Culture and the Arts, Hawai`i.

MARSHA MCDOWELL is curator of Folk Arts at the Michigan State University Museum.

JOHN MOHAWK is assistant professor of American Studies, State University of New York, Buffalo.

VICTOR MONTEJO is a novelist, a 1994-95 Presidential Research Fellow, University of California, Davis and assistant professor of Native Studies, Department of Anthropology, University of Montana, Missoula.

DAN NAMINGHA is an internationally known artist.

FRED NAHWOOKSY, former community services coordinator for the National Museum of the American Indian, is Cultural Center Planner for the Oneida Nation of Wisconsin.

JOSEPH OROZCO is special projects coordinator for Indigenous Communications Association and the former station manager KIDE station in Hupa Valley, California.

CARLA ROBERTS is the director of ATLATL, a Phoenix-based Native American Arts Service organization.

MARI LYN SALVADOR is chief curator of the Maxwell Museum of Anthropology and associate professor in the Department of Anthropology, University of New Mexico.

KATHRYN SHANLEY is assistant professor of English, Cornell University.

RINA SWENTZELL is a consultant on Native cultural and artistic issues.

ELIZABETH THEOBALD is managing director of the Obie Award-winning Cucaracha Theater and producer of "In the Wake of the Flood," a documentary film.

KAY WALKINGSTICK is assistant professor in the Department of Art at Cornell University.

MARGARET WOOD is a quilter, teacher and president of ATLATL.

GLORIA YOUNG is education coordinator of museums and adjunct associate professor of anthropology at the University of Arkansas, Fayetteville.

BIBLIOGRAPHY

Aboriginal Voices: Amerindian, Inuit, and Sami Theater. Baltimore: Johns Hopkins University Press, 1992.

"Ak-Chin EcoMuseum Staff Work on Certification through CAC." *Ak-Chin O'odham Runner* IV(3) (March 1990).

"Ak-Chin Holds Groundbreaking for EcoMuseum." *Arizona Preservation News* (January 1991).

Albers, Patricia and Beatrice Medicine. "The Role of Sioux Women in the Production of Ceremonial Objects: The Case of the Star Quilt." In *The Hidden Half: Studies of Plains Indian Women.* Lanham, Md.: University Press of America, 1983.

Allen, Catherine J. *The Hold Life Has: Coca and Cultural Identity in an Andean Community.* Washington, D.C.: Smithsonian Institution Press, 1988.

All Roads are Good: Native Voices on Life and Culture. Washington and London: Smithsonian Institution Press with the National Museum of the American Indian, Smithsonian Institution, 1994.

Altamirano, Leon et al. *Trajes y danzas de Mexico.* Mexico: Joaquin Porrua, 1984.

American Indian Art Magazine Quarterly. (Scottsdale, Ariz.)

The Ancestors: Native Artisans of the Americas. New York: Museum of the American Indian, 1979.

Anderson, Benedict. *Imagined Communities: Reflections on the Origin and Spread of Nationalism.* London and New York: VERSO, 1990.

Arrom, José Juan. *Mitologia y Artes Prehispanicas de las Antillas.* Mexico: Siglo Veintiuno Editores, 1975.

Barreiro, José. *Indian Chronicles.* Houston: Arte Pubblico Press, 1993.

Bataille, Gretchen. "Black Elk: New World Prophet." In *A Sender of Words: Essays in Memory of John G. Neihardt.* Salt Lake City, Utah: Howe Brothers, 1984.

Bataille, Gretchen and Kathleen Mullen Sands. *American Indian Women: Telling Their Lives.* Lincoln: University of Nebraska Press, 1984.

Benjamin, Walter. *Illuminations: Essays and Reflections.* New York: Schocken Books, 1968.

Berlo, Janet Catherine, ed. *The Early Years of Native American Art History: The Politics of Scholarship and Collecting.* Seattle: University of Washington Press, 1992.

Boremanse, Didier. "Ortogenesis en la literatura lacandona." In *Mesoamerica.* Vol. 17. Antigua, Guatemala: Plumsock Mesoamerican Studies and CIRMA, 1989.

Bouysse-Cassgne, Therese. *La Identidad Aymara (The Aymara Identity).* Bolivia: Hilbol, 1987.

Boylan, Patrick, ed. *Museums 2000: Politics, People, Professionals, and Profit.* London and New York: Museum Association in conjunction with Routledge, 1992.

Brandon, Reiko Mochinaga. *The Hawaiian Quilt.* Tokyo: Kokusai Art, 1989.

Bricker, Victoria R. *The Indian Christ, The Indian King.* Austin: University of Texas Press, 1981.

Brown, Bill. "The Art of Native American Music." In *Songs of Indian Territory,* edited by W. Smyth. Oklahoma City, Okla.: Center of the American Indian, 1989.

Bruchac, Joe. *Iroquois Stories: Heroes and Heroines, Monsters and Magic.* Trumansburg, N.Y.: The Crossing Press, 1985.

Brumble, H. David, III. *American Indian Autobiography.* Berkeley: University of California Press, 1988.

Buechler, Hans C. The *Masked Media: Aymara Fiestas and Social Interaction in the Bolivian Highlands.* The Hague: Mouton Publishers, 1980.

Buechler, Hans C. and Judith-Maria Buechler. *The Bolivian Aymara.* New York: Holt, Rinehart and Winston, Inc., 1971.

Carmack, Robert and James L. Mondloch. *E1 Titulo de Yax y Otros Documentos Quiches de Totonicapan,* Guatemala. Universidad Nacional Autonoma de Mexico, 1989.

Carmack, Robert M. *Harvest of Violence: The Maya Indians and the Guatemalan Crisis.* Norman: University of Oklahoma Press, 1988.

Chance, Norman A. *The Inupiat and Arctic Alaska: An Ethnography of Development.* Fort Worth, Texas: Holt, Rinehart and Winston, Inc., 1990.

Circle of Life: Cultural Community in Ojibwe Crafts. Duluth, Ga.: St. Louis Historical Society, Chisholm Museum and Duluth Art Institute, 1984.

Coe, Ralph T. *Lost and Found Traditions: Native American Art, 1965-1985.* New York: The American Federations of Arts, 1986.

Collaer, Paul. *Music of the Americas: An Illustrated Music Ethnology of the Eskimo and American Indian Peoples.* New York: Praeger Publishers, 1973.

Collecting Southwestern Indian Arts and Crafts. Tucson, Ariz.: Ray Manley Publishing, 1979.

Costo, Rupert. "Alcatraz." *Indian Historian* 3 (Winter 1970).

Creativity is Our Tradition. Santa Fe, N. Mex.: Institute of American Indian and Alaska Native Culture and Arts Development, 1992.

Davis, Natalie Zemon and Randolph Starn, eds. *Representations: Special Issue: Memory and Counter-Memory.* 26 (Spring 1989).

Deloria, Vine Jr. *Custer Died for Your Sins: An Indian Manifesto.* Norman: University of Oklahoma Press, 1988.

———. *We Talk, You Listen: New Tribes, New Turf.* New York: Macmillan, 1970.

DeMallie, Raymond J. "Introduction." In *The Ghost Dance Religion and the Sioux Outbreak of 1890,* by James Mooney. Lincoln and London: University of Nebraska Press, 1991.

Densmore, Frances. *Pawnee Music.* Bureau of American Ethnology Bulletin 93. Washington D.C.: Smithsonian Institution, 1929.

Dixon, Susan. "The Essential Spirit." *Unbroken Circles: Traditional Arts of Contemporary Woodland Peoples, Northeast Indian Quarterly.* Ithaca, N.Y.: Akwe:kon Press, 1990.

Dundes, Alan. *The Study of Folklore.* Englewood Cliffs, N.J.: Prentice-Hall, Inc., 1965.

Erdrich, Louise. *The Bingo Palace.* New York: HarperCollins Publishers, 1994.

Fienup-Riordan, Ann. "Yupik Dancing." *1984 Festival of American Folklife Program Book.* Washington, D.C.: Smithsonian Institution, Office of Folklife Programs, 1984.

Fitzgerald, Ruth and Marsha MacDowell, eds. *Michigan Quilts: 150 Years of a Textile Tradition.* East Lansing: Michigan State University Museum, 1987.

Fleras, Augie and Jean Leonard Elliot. *The Nations Within: Aboriginal-State Relations in Canada, the United States, and New Zealand.* New York: Oxford University Press, 1992.

Fletcher, Alice. "The Messiah Superstition." *Journal of American Folk-Lore* 4 (1891).

Fowler, Loretta. *Arapahoe Politics, 1851-1978: Symbols in Crises of Authority.* Lincoln and London: University of Nebraska Press, 1982.

Frisbie, Charlotte J. *Southwestern Indian Ritual Drama.* Albuquerque: University of New Mexico Press, 1980.

Frisbie, Charlotte J. and David P. McAllester, eds. *Navajo Blessingway Singer: The Autobiography of Frank Mitchell, 1881-1967.* Tucson: University of Arizona Press, 1978.

Fuller, Nancy J. "The Museum as a Vehicle for Community Empowerment: The Ak-Chin Indian Community Ecomuseum Project." In *Museums and Communities: The Politics of Public Culture,* edited by Ivan Karp and Christine Mullen Kreamer. Washington and London: Smithsonian Institution Press, 1992.

Gossen, Gary H. *Chamulas in the World of the Sun: Time and Space in a Maya Oral Tradition.* Cambridge, Mass.: Harvard University Press, 1974.

Gritton, Joy L. "The Institute of American Indian Arts: A Convergence of Ideologies." In *Shared Visions* exhibition catalogue. Phoenix, Ariz.: The Heard Museum, 1991.

Gross, Larry P. "Art as the Communication of Competence." *Social Science Information* 12, no. 3 (1973).

Harcourt, Marguerite Beclard d'. *La musique des Aymara sur les haut plateaux Boliviens.* Paris: Societe Des Americanistes, 1959.

Harper, Kenn. Give Me My *Father's Body: The Life of Minik, The New York Eskimo.* Frobisher Bay, Northwest Territories: Blacklead Books, 1986.

Heth, Charlotte, ed. *Native American Dance: Ceremonies and Social Traditions.* Washington, D.C.: National Museum of the American Indian Smithsonian Institution with Starwood Publishing, Inc., 1992.

———. "American Indian Dance: A Celebration of Survival and Adaptation." In *Native American Dance: Ceremonies and Social Traditions,* edited by Charlotte Heth. Washington, D.C.: National Museum of the American Indian Smithsonian Institution with Starwood Publishing, Inc., 1992.

Highway, Tompson. *The Rez Sisters: A Play in Two Acts.* Saskatoon, Saskatchewan: Fifth House, 1988.

Hobson, Geary. *The Remembered Earth: An Anthology of Contemporary Native American Literature.* Albuquerque: University of New Mexico Press, 1979.

Horse Capture, George P. *Powwow.* Cody, Wyo.: Buffalo Bill Historical Center, 1989.

Howard, James H . *The Ponca Tribe.* Bureau of American Ethnology Bulletin 195. Washington D.C.: Smithsonian Institution, 1965.

Indian Theatre: Traditions of Performance. Honolulu: University of Hawaii Press, 1990.

Jackson, Michael. *Path Toward a Clearing: Radical Empiricism and Ethnographic Inquiry.* Bloomington: Indian University Press, 1989.

Kanahele, George, ed. *Hawaiian Music and Musicians: An Illustrated History.* Honolulu: University of Hawaii Press, 1979.

Katz, Jane, ed. *This Song Remembers: Self Portraits of Native Americans in the Arts*. New York: Houghton Mifflin, Co., 1980.

Katzeek, David. "Introduction." In *Celebration of Tlingit, Haida, and Tsimshian Culture* . Juneau, Alaska: Sealaska Heritage Foundation, 1992.

Keeling, Richard, ed. *Women in North American Indian Music: Six Essays*. SEM Special Series no. 6. Bloomington, Ind.: Society for Ethnomusicology, 1989.

————.*Cry for Luck: Sacred Song and Speech Among the Yurok, Hupa, and Xarok Indians of Northwestern California*. Berkeley: University of California Press, 1993.

Kelley, Helen. *Scarlet Ribbons: American Indian Technique for Today's Quilters*. Paducah, Ky.: American Quilter's Society, 1987.

King, Thomas. *Green Grass, Running Water*. New York: Bantam Books, 1994.

————. *Medicine River*. New York: Viking Penguin, 1990.

Krupat, Arnold. *For Those Who Come After: A Study of Native American Autobiography*. Berkeley: University of California Press, 1985.

Kurath, Gertrude P. *Dance and Song Rituals of the Six Nations Reserve Ontario*. National Museum of Canada Bulletin 220. Ottawa: National Museum of Canada, 1968.

Kurath, Gertrude P. with Antonio Garcia. *Music and Dance of the Tewa Pueblos*. Santa Fe: Museum of New Mexico, 1970.

La Farge, Oliver and Douglas Byers. *The Year Bearer's People*. New Orleans: The Department of Middle American Research, The Tulane University of Louisiana, 1931.

LaFrance, Ron. "Inside the Longhouse: Dances of the Haudenosaunee." *In Native American Dance: Ceremonies and Social Traditions,* edited by Charlotte Heth. Washington, D.C.: National Museum of the American Indian Smithsonian Institution with Starwood Publishing Inc., 1992.

Landa, Diego de. *Relation de las Cosas de Yucatan*. Mexico: Ediciones Dante, S.A., 1983.

Laughlin, Robert, collector and trans. and Carol Karasik, ed. *The People of the Bat: Mayan Tales and Dreams from Zinacantan*. Washington and London: Smithsonian Institution Press, 1988.

Liberty, Margot. "The Sun Dance." In *Anthropology of the Great Plains,* edited by W. R. Wood and M. Liberty. Lincoln and London: University of Nebraska Press, 1980.

Livingston, Lili Cockerille. "The American Indian Powwow: Tribal Splendor." *Dance* 66, no. 6 (1992).

Logan, Linley B. "Dancing the Cycles of Life." In *Native American Dance: Ceremonies and Social Traditions,* edited by Charlotte Heth.

Washington, D.C.: National Museum of the American Indian Smithsonian Institution with Starwood Publishing, Inc., 1992.

Lucie-Smith, Edward. *The Story of Craft: The Craftsman's Role in Society*. Ithaca, N.Y.: Cornell University Press, 1981.

Manz, Beatriz. *Refugees of a Hidden War: The Aftermath of Counterinsurgency in Guatemala*. Albany: State University of New York Press, 1988.

Marr, Helen Hubbard. *Voices of the Ancestors: Music in the Life of the Northwest Coast Indians*. Greenwich, Conn.: The Bruce Museum, 1986.

Mayhall, Mildred P. *The Kiowas*. Norman: University of Oklahoma Press, 1962.

McAllester, David P. Enemy Way *Music*. Papers of the Peabody Museum of American Archaeology and Ethnology, Harvard University, XLI(3). Cambridge, Mass.: Harvard University, 1954.

————. Peyote *Music*. Viking Fund Publications in Anthropology, vol. 13. New York: Johnson Reprint Corp., 1971.

McKinzie, Edith. "Hawaiian Performing Arts Traditions." In *Folklife Hawaii Program Book*. Honolulu: The State Foundation on Culture and the Arts, 1990.

McMaster, Gerald and Lee-Ann Martin, eds. *Indigena: Contemporary Native Perspectives*. Vancouver: Douglas & MacIntyre, 1992.

McMaster, Gerald, et al. *In the Shadow of the Sun: Perspectives on Contemporary Native Art*. Canadian Ethnology Service Mercury Series Paper 124. Hull, Ontario: Canadian Museum of Civilization, 1993.

McWillie, Judith and James Luna. *Two Worlds/Two Rooms* (exhibition catalogue). New York: INTAR Gallery, 1989.

Momaday, N. Scott. *House Made of Dawn*. New York: Harper, 1968; reprint, 1981.

————. *Way to Rainy Mountain*. Albuquerque: University of New Mexico Press, 1969.

Montejo, Victor D. *The Bird Who Cleans the World and Other Mayan Fables*. Willimantic, Conn.: Curbstone Press, 1991.

————. "The Dynamics of Cultural Resistance and Transformations: The Case of the Guatemalan Mayan Refugees in Mexico." Ph.D. diss., The University of Connecticut, 1993.

————. "The Essential Land: Recharging Mayan Traditions." *Akwe:kon* X(4). (Winter 1993).

————. "Oral Tradition: An Anthropological Study of a Jakaltek Folktale." Master's thesis, State University of New York at Albany, 1989.

Montejo, Victor D. and Lyle Campbell. "The Origin of Corn: A Jakaltek Tale in a Comparative Mayan Perspective." *Latin American Indian Literatures Journal 9(2)* (1993).

Monture, Joel. *The Complete Guide to Traditional Native American Beadwork: A Definitive Study of Authentic Tools, Materials, Techniques and Styles.* New York: Collier Publishing Company, 1993.

Mooney, James. *Calendar History of the Kiowa Indians.* Annual Report of the Bureau of American Ethnology, vol. 17. Washington, D.C. Smithsonian Institution, 1898.

———. *The Ghost Dance Religion and the Sioux Uprising of 1890.* Annual Report of the Bureau of American Ethnology, vol. 1. Washington, D.C.: Smithsonian Institution, 1896.

Morgan, Lewis Henry. *Houses and House-Life of the American Aborigines.* Chicago: University of Chicago Press, 1965.

Murie, James R. *Pawnee Indian Societies.* The American Museum of Natural History Anthropological Papers, 11(7). New York: The American Museum of Natural History, 1914.

Nabakov, Peter and Robert Easton. *Native American Architecture.* New York and Oxford: Oxford University Press, 1989.

Native American Graves Protection and Repatriation Act of 1990. Congressional Record, vol. 136. Washington, D.C.: U. S. Government Printing Office, 1990.

Native American Videotape Archives Catalog. Santa Fe, N. Mex.: s.n. 197-.

Native Peoples Magazine Quarterly. Phoenix, Ariz.

Neihardt, John G. *Black Elk Speaks: Being the Life Story of a Holy Man of the Oglala Sioux,* with an introduction by Vine Deloria, Jr. Lincoln: University of Nebraska Press, 1932; reprint 1972, 1979.

Nettl, Bruno. *Blackfoot Musical Thought: Comparative Perspectives.* Kent, Ohio: Kent State University Press, 1989.

Nettl, Bruno, Charlotte Heth, and Gertrude P. Kurath. "American Indians." In *The New Grove Dictionary of American Music,* Vol. 2. London: Macmillan Press Ltd., 1986.

Niatum, Duane, ed. *Carriers of the Dream Wheel: Contemporary Native American Poetry.* San Francisco: Harper, 1975.

Nickelson Wright, Margaret. *HODj Silver: The History and Hallmarks of HODj Silversmithing.* Flagstaff, Ariz.: Northland Press, 1972.

O'Brien, Lynne Woods. *Plains Indian Autobiography.* Western Writers, vol. 10. Boise, Idaho: Boise State College Press, 1973.

Occom, Samson. *Sermon Preached at the Execution of Moses Paul, an Indian Who Was Executed at New-Haven, on the 2d of September 1771.* Bennington, Vt.: William Watson, 1772.

Oklahoma Historical Society. Oklahoma City, Okla. Newspaper Archives and Manuscript Division. Cheyenne and Arapaho Indian History, Culture, and Acculturation.

Oklahoma Historical Society. Newspaper Archives and Manuscript Division. Indian and Pioneer History.

Oklahoma Historical Society. Newspaper Archives and Manuscript Division. Messiah Craze.

Olson, James S. and Raymond Wilson. *Native Americans in the Twentieth Century.* Urbana and Chicago: University of Illinois Press, 1984.

Orozco, Gilberto. *Tradiciones y leyendas del Istmo de Tehauntepec.* Mexico: Revista Musical Mexicana, 1946.

Ortiz, Alfonso. *The Tewa World: Space, Time, Being and Becoming in a Pueblo Society.* Chicago: University of Chicago Press, 1969.

Ortiz, Simon J. *From Sand Creek: Rising in the Heart which is Our America.* New York: Thunder's Mouth, 1981.

———. *Going for the Rain.* New York: Harper, 1976. 1981.

———. *A Good Journey.* Tucson: University of Arizona Press, 1977; reprint, 1984.

———. *Howbah Indians.* Tucson: University of Arizona Press, 1978.

Owens, Louis. *Other Destinies: Understanding the American Indian Novel.* Norman: University of Oklahoma Press, 1992.

———. *The Sharpest Sight.* Norman: University of Oklahoma Press, 1992.

———. *WolfSong.* Albuquerque, N.Mex.: West End Press, 1991.

Paredes Candia, Antonio. *La Danza folklorica en Bolivia.* La Paz: Libreria-Editorial Popular, 1991

———. *Fiestas populares de Bolivia.* Vols. 1 and 2. La Paz: Isla, 1976.

Penney, David W. *Art of the American Frontier: The Chandler-Pohrt Collection.* Detroit and Seattle: The Detroit Institute of Arts with University of Washington Press, 1992.

Peterson, Susan and Maria Martinez . *Five Generations of Potters.* Washington, D.C.: Smithsonian Institution, Renwick Gallery, National Museum of American Art, 1978.

Peyer, Bernd C. *The Singing Spirit: Early Short Stories by North American Indians.* Tucson: University of Arizona Press, 1989.

Portilla, Miguel Leon. *Native Mesoamerican Spirituality.* New York: Paulist Press, 1980.

Powell, J. W. *The Lessons of Folklore.* American Anthropologist, n.s. 2. New York: Putnam's Sons, 1900.

Powers, Marla N. *A Century of Vision: The Star Quilt, A Symbol of Dakota Identity.* Kendall Park, N.J.: Lakota Books, 1990.

Powers, William K. *War Dance: Plains Indian Musical Performance.* Tucson: University of Arizona Press, 1990.

Pulford, Florence. *Morning Star Quilts.* Los Altos, Calif.: Leone Publications, 1989.

Rivard, Rene. "Opening up the Museum, or Toward a New Museology: Ecomuseums and 'Open' Museums." Unpublished mss. Quebec City, 1984.

Roberts, Helen H. *Ancient Hawaiian Music.* New York: Dover Publications, Inc., 1967.

Rouse, Irving. *The Taino: Rise and Fall of the People Who Greeted Columbus.* New Haven: Yale University Press, 1992.

Royce, Anya Peterson. The *Anthropology of Dance.* Bloomington: Indiana University Press, 1977.

————. *Movement and Meaning.* Bloomington: Indiana University Press, 1984.

Ruoff, A. LaVonne Brown. *American Indian Literatures: An Introduction, Bibliography Review, and Selected Bibliography.* New York: Modern Language Association, 1990.

Schrader, Robert Fay. *The Indian Arts and Crafts Board: An Aspect of New Deal Indian Policy.* Albuquerque: University of New Mexico Press, 1983.

Schuerman, Laurell E. *Native American Media Needs: An Assessment.* Lincoln, Neb.: Native American Public Radio Broadcasting Consortium, 1979.

Sekaquapetwa, Emory. "The Hopi Dictionary." In *1991 Festival of American Folklife Program Book.* Washington, D.C.: Smithsonian Institution, Office of Folklife Programs, 1991.

Silko, Leslie. *Ceremony.* New York: Viking, 1977.

————. *Laguna Woman.* Greenfield Center, N.Y.: Greenfield Review, 1974.

————. *Storyteller.* New York: Arcade, 1981.

Skinner, Alanson. *Societies of the Iowa, Kansa, and Ponca Indians.* American Museum of Natural History Anthropological Papers, vol. 11. New York: The American Museum of Natural History, 1915.

Sweet, Jill D. *Dances of the Tewa Pueblo Indians: Expressions of New Life.* Santa Fe, N. Mex.: School of American Research, 1985.

Speck, Frank G. Leonard Broom, and Will West Long. *Cherokee Dance and Drama.* Berkeley and Los Angeles: University of California Press, 1951; reprinted by University of Oklahoma Press, 1983.

Tabrah, Ruth M. *Hawaii: A Bicentennial History.* New York: W.W. Norton & Company, Inc., 1980.

Taino Nation Bulletin. René Marcano, ed. Vol 1&2 (1991, 1992)

Tatar, Elizabeth. *Nineteenth-century Hawaiian Chant.* Honolulu: Bishop Museum, 1982.

Taussig, Michael. *The Devil and Commodity Fetishism in South America.* Chapel Hill: University of North Carolina Press, 1980.

Tedlock, Dennis, trans. *Popol Vuh.* New York: Simon & Schuster, Inc. 1985.

Theisz, R.D. and Ben Black Bear, Sr . *Songs and Dances of the Dakota.* Rosebud, S. Dak.: Sinte Gleska College, 1976.

Thompson, J. Eric. *Ethnology of the Mayas of Southern and Central British Honduras.* Anthropological Series XVII(2). Chicago: Field Museum of Natural History, 1930.

Tiulana, Paul. *A Place for Winter: Paul Tiulana's Story.* Anchorage, Alaska: CIRI Foundation, 1988.

Todd, Loretta. "What More do They Want?" In *Indigena: Contemporary Native Perspectives.* Edited by Gerald McMaster and Lee-Ann Martin. Vancouver: Douglas & MacIntyre, 1992.

Trimble, Stephen. *Talking with the Clay: The Art of Pueblo Pottery.* Santa Fe, N. Mex.: School of American Research Press, 1987.

Vander, Judith. *Songprints: The Musical Experience of Five Shoshone Women.* Urbana: University of Illinois Press, 1988.

Vansina, Jan. *Oral Tradition: A Study in Historical Methodology.* Translated by H. M. Wright. Chicago: Aldine, 1965.

Vennum, Thomas. *The Ojibwa Dance Drum: Its History and Construction.* Smithsonian Folklife Studies 2. Washington, D.C.: Smithsonian Institution Press, 1982.

Vizenor, Gerald. *Dead Voices.* Norman: University of Oklahoma Press, 1992.

————. "Reservation Cafe: The Origins of American Indian Instant Coffee." In *Earth Power Coming: Short Fiction in Native American Literature*, edited by Simon J. Ortiz. Tsaile: Navajo Community College Press, 1983.

Wachs, Eleanor. "Traditional Crafts and Tourism on Cape Cod and the Islands." In *1988 Festival of American Folklife Program Book.* (Washington, D.C.: Smithsonian Institution, Office of Folklife Programs, 1988).

Wade, Ed, Carol Haralson and Rennard Strickland. *As In a Vision—Masterworks of American Indian Art.* Tulsa: University of Oklahoma Press, 1983.

Wallace, Ernest and E. Adamson Hoebel. *The Comanches: Lords of the South Plains.* Norman: University of Oklahoma Press, 1952.

Walters, Anna Lee, ed. *Neon Pow Wow: New Native American Voices of the Southwest.* Flagstaff, Ariz.: Northland Publishing, 1993.

Wauchope, Robert, ed. *Handbook of the Middle American Indians.* Austin: University of Texas Press, 1969.

Weatherford, Jack. *Indian Givers: How the Indians of the Americas Transformed the World.* New York: Crown Publishers, Inc., 1988.

Welch, James. *Fools Crow.* New York: Penguin, 1986.

———. *Riding the Earthboy 40.* New York: Harper 1971; 1976.

———. Winter *in the Blood.* New York: Penguin, 1974.

West, W. Richard, Jr. "Foreword." In *Native American Dance: Ceremonies and Social Traditions,* edited by Charlotte Heth. Washington, D.C.: National Museum of the American Indian Smithsonian Institution with Starwood Publishing, Inc., 1992.

Western Apache Material Culture: The Goodwin and Guenther Collections. Tucson: University of Arizona Press, 1987.

Wissler, Clark. *General Discussion of Shamanistic and Dancing Societies.* American Museum of Natural History Anthropological Papers, 11(4). New York: The American Museum of Natural History, 1916.

Witherspoon, Gary. *Language and Art in the Navajo Universe.* Ann Arbor: University of Michigan Press, 1977.

Wolf, Eric R. *Europe and the People Without History.* Berkeley: The University of California Press, 1982.

Wong, Hertha D. *Sending My Heart Back Across the Years: Tradition and Innovation in Native American Autobiography.* New York: Oxford University Press, 1992.

Wood, Margaret. *Native American Fashions: Modern Adaptations of Traditional Designs.* New York: Van Nostrand Reinhold Company, 1981.

Worth, Sol with Larry Gross. "Symbolic Strategies." In *Studying Visual Communication.* Philadelphia: University of Pennsylvania Press, 1981.

Young, Gloria A. "Plains Intertribal Religious Movements of the Nineteenth Century." In *Handbook of North American Indians, Plains Volume.* Washington, D.C.: Smithsonian Institution, in press.

———. "Powwow Power: Perspectives on Historic and Contemporary Intertribalism." Ph.D. diss. Bloomington: Indiana University, 1981.

———. "The Dream Dance and Ghost Dance of Oklahoma." In *Songs of Indian Territory,* edited by W. Smyth. Oklahoma City, Okla.: Center for the American Indian, 1989.

Young Man, Alfred. "The Metaphysics of North American Indian Art." In *Indigena: Contemporary Native Perspectives.* Edited by Gerald McMaster and Lee-Ann Martin. Vancouver: Douglas & MacIntyre, 1992.

" A L L O F U S "

EXPRESSIVE CULTURE COLLABORATION GROUP

AKWE:KON PRESS
José Barreiro
Susan R. Dixon
Tim Johnson
Jennifer Bedell
Brendan White
Melissa Bataglia
Jennifer Hanna-Martinez
Elizabeth Shedd

NATIONAL MUSEUM OF THE AMERICAN INDIAN
Richard Hill
Fred Nahwooksy
Charlotte Heth
Carolyn Rapkievian
Caleb Strickland
Terence Winch
Robin Rone
Louis Stancari
Holly Stewart
Clara Sue Kidwell

SPECIAL THANKS TO:
Judy Kirpich and Julie Sebastianelli, Grafik Communications, Ltd.

CONTRIBUTING PHOTOGRAPHERS
Dan Agent
Elaine Bomberry
Victoria Bomberry
Fred Cattroll
Pam Dewey
Jeffrey J. Foxx
Karen Furth
Larry Gus
Janine Jones
Tim Johnson
Colleen Keane
Milicent Knapp
Bill McLemore
Larry McNeil
Fred Miller
June Nash
Catherine Whipple

Funding has been made available by The Booth Ferris Foundation, The Educational Foundation of America, The New York Times Company Foundation, and the American Indian Program, Cornell University

Akwe:kon (a-GWAY-gohn) is a Mohawk word meaning "all of us."

AKWE:KON PRESS STAFF
José Barreiro, Editor-in-Chief
Susan R. Dixon, Managing Editor
Jennifer Bedell, Assistant Editor
Tim Johnson, Coordinating Editor
Brendan White, Office Assistant
Julius Charlie
Wade Jacobs
Student Assistants

EDITORIAL ADVISORY COMMITTEE
Frank Bonamie
Kate Shanley
Daniel Usner
Jane Mt. Pleasant
Gould Colman
Brian Earle
Charles Geisler
James McConkey

AMERICAN INDIAN PROGRAM
Barbara Abrams, Interim Director
Sandra Rourke, Student Development Specialist
Shawn Herne, Residence Hall Director
Debbie Bannister, Accounts Representative
Sandy Cook, Administrative Assistant
Melissa Bataglia, Office Assistant

NATIONAL MUSEUM OF THE AMERICAN INDIAN STAFF

EXECUTIVE OFFICE
W. Richard West, Jr., Director
Douglas E. Evelyn, Deputy Director
Richard Hill, Special Assistant
Pablita Abeyta
Michelle Dauphinais
Lee Ann Fahey
Sean Jenkins
Sheila McGuire
Lisa Meredith
Elsie Mosqueda
Michele Sengsourinh

HEYE CENTER ADMINISTRATION
Duane H. King, Assistant Director
Karen Savage
Connie Baum

OFFICE OF PUBLIC PROGRAMS
Charlotte Heth, Assistant Director
Carolyn Rapkievian
Maria Brown
Adalgisa Castillo
Johanna Gorelic
Rodney Johnson
Carmen Sanchez
Carolyn Williams

OUTREACH/COMMUNITY SERVICE DEPARTMENT
Cynthia Evans
Alyce Sadongei
Caleb Strickland

PUBLICATIONS DEPARMENT
Terence Winch
Ann Kawasaki
Robin Rone
Louis Stancari
Holly Stewart
Cheryl Wilson

RESOURCE CENTER
Marty Kreipe de Montaño
Mary Ahenakew
Stephanie Betancourt
Gaetana deGennaro
John Dwight
Clinton Elliott
Ellen Jamieson
Georgetta Stonefish

CONSERVATION DEPARTMENT
Marian Kaminitz
Scott Merritt
Susan Heald
John Moses
Raymi Taylor
Leslie Williamson

REPATRIATION DEPARTMENT
Ray Gonyea
Kenneth Yazzie

PHOTO ARCHIVES DEPARTMENT
Pamela Dewey
Shilice Clinkscales
Sharon Dean
Karen Fogden
Janine Jones
Wynema Magovern
Laura Nash

MOVE OFFICE
Linda Diane Fraher
Vincent Brave
David Martine

OFFICE OF ADMINISTRATION AND FINANCE
Donna Scott, Assistant Director
David Frable
Tamara Levine
Augustine Acevedo
Berquis Arias
Carol Belovitch
Robert Billingsley
Duane Blue Spruce
Catherene Boyd
Linda Bunch
Angela Diggs
Rebecca Graham
Diane Gunn

Nancy Kaiser
Regchenal Johnson
Kristen Lamorte
Cynthia Smith
Todd Taylor

FACILITIES STAFF
Myroslaw Riznyk
Robert Amadei
William Cabeza
Fred Casaburi
Marco Cevallos
Henry Dwight
James Flowers
Clarence Jackson
Simon Turkynak
Jose Rentas
Pedro Santiago
Manuel Soto
William J. Mann
Albert O'Neil

FILM/VIDEO DEPARTMENT
Elizabeth Weatherford
Gina Fuentes
Robert Mastrangelo
Emelia Seubert
Erica Wortham

EXHIBITIONS DEPARTMENT
James Volkert, Deputy Assistant Director
Peter Brill
Kelton Bound
Karen Fort
Andrea Hanley
Stacey Jones
Allan Kaneshiro
Mary Jane Lenz
Danyelle Means
Jennifer Miller
Douglas Mossman
Evelyn Oehler
Lori Shundich
Teresa West

PUBLIC AFFAIRS
Dan Agent
Lee Anne Fahey

HUNTINGTON FREE LIBRARY
Mary Davis

OFFICE OF CULTURAL RESOURCES
Clara Sue Kidwell, Assistant Director
Lawan Tyson

REGISTRATION DEPARTMENT
Lucia Belci
Lee Callander
Margaret Cintron
Kevin DeVorsey
Ann Drumheller
Mary Nooney

COLLECTIONS MANAGEMENT DEPARTMENT
B. Lynne Harlan
Mark Clark
Allison Jeffrey
Timothy Ramsey
Wiley Stephen Thornton

CURATORIAL DEPARTMENT
George Horse Capture
Kathleen Ash-Milby
Eulalie Bonar
Andrea Gaines
Cecile Ganteaume
Ramiro Matos
Nancy Rosoff

NATIONAL CAMPAIGN OFFICE
John L. Colonghi
Susannah Kellems
Elizabeth Gray Kogen
Megan Kane Bowan
Sarah Collum
Patricia Davis
Arlette Draper
Lisa Gills
Michelle McLean
Ernestine A. Potter
Lon Saavedra
Hope Slaybaugh
Julie Smith
Mary Thomson
Ashley Tripplehorn
Carol Grace Woodruff

AKWE:KON JOURNAL, PUBLISHED QUARTERLY BY THE AMERICAN INDIAN PROGRAM AT CORNELL UNIVERSITY, REPORTS ON ISSUES OF CONCERN TO INDIGENOUS PEOPLES THROUGHOUT THE HEMISPHERE. *AKWE:KON* PRESENTS COMMUNITY-BASED AND SCHOLARLY PERSPECTIVES ON NATIONAL AND HEMISPHERIC TRENDS AND THEMES. IT INTEGRATES TRADITIONAL, ORAL EXPOSITION WITH THE DOCUMENTARY METHODOLOGY OF WESTERN SCIENCE. THE AKWE:KON EDITORIAL CONCEPT ASSERTS THE EXISTENCE OF A NATIVE TRADITIONAL INTELLIGENCE AND PERCEPTIVE ABILITY THAT CAN AND SHOULD INTERPRET AND INFORM ONGOING RESEARCH AND PUBLISHING, NOT ONLY ON NATIVE TOPICS BUT ALSO ON BROADER THEMES OF IMPACT FOR THE GENERAL SOCIETY.

AKWE:KON JOURNAL PRESENTS OPINION-LEADING CRITIQUES OF POLITICS, ECONOMICS, EDUCATION, HEALTH, CULTURE AND THE ARTS, EXPLORING TRADITIONAL AMERICAN INDIGENOUS THINKING TO ANALYZE AND UNDERSTAND LIFE, CULTURE AND NATION IN THE AMERICAS. AKWE:KON SEEKS TO STIMULATE DISCUSSION AMONG INDIGENOUS PEOPLES AND PEOPLES OF OTHER ETHNICITIES, AND BETWEEN INDIGENOUS PEOPLES AND THE VARIETY OF WESTERN RATIONALES PREVALENT IN ACADEMIA AND NATIONAL CULTURE.

ONE YEAR SUBSCRIPTION TO *AKWE:KON*
$18.00 (U.S. FUNDS)

SPECIAL PUBLICATIONS
AS LISTED PLUS $2.00 SHIPPING

ORDER FROM

THE AKWE:KON PRESS
300 CALDWELL HALL
CORNELL UNIVERSITY
ITHACA, NY 14853

PHONE: (607) 255-4308
FAX: (607) 255-0185

UNBROKEN CIRCLES: TRADITIONAL ARTS OF CONTEMPORARY WOODLAND PEOPLES

Unbroken Circles
Traditional Arts of Contemporary Woodland Peoples

Cultural Encounter Edition
NORTHEAST INDIAN Quarterly, Winter 1990
Susan R. Dixon, Special Issue Editor

THIS VOLUME TAKES A LOOK AT continuing forms of artmaking within Native communities of the northeast that—like stories handed down from generation to generation—carry culture over time. Features articles on beadworking, basketmaking, antler carving, textiles, corn husk dolls, storytelling, and Native Art History.

7:4 WINTER 1990. 96 PP. $10.00

CHIAPAS: CHALLENGING HISTORY

A SPECIAL ISSUE of *Akwe:kon Journal* designed to provide the important background themes and a chronology of the events in southern Mexico since the Maya uprisings in early January, 1994. It offers a forum to Indigenous points of view, providing a range of articles that frame the background of the issues and give a feel for the grassroots reality.

11:2 SUMMER 1994. 96 PP. $12.00

INDIAN ROOTS OF AMERICAN DEMOCRACY

INDIAN ROOTS
of American Democracy

Edited and with Introduction by
José Barreiro

WHEN EUROPEANS ARRIVED on this continent, the Haudenosaunee (Iroquois) helped them find their way in the new land, taught them to raise food, and introduced them to the Iroquois rule of law, the Great Law of Peace.

This book explores Iroquois influences on the formation of American government in the eighteenth century and on the development of women's rights movements in the early nineteenth century. John Mohawk, Oren Lyons, Audrey Shenandoah, Richard Hill, Donald Grinde, and Sally Roesch Wagner are among the featured authors.

(ISBN: 1-881178-00-5) PAPERBACK, 1992. 209 PP. $12.00

INDIGENOUS ECONOMICS: TOWARD A NATURAL WORLD ORDER

Indigenous Economics
Toward A Natural World Order

Akwe:kon Journal
Summer 1992

INDIGENOUS NATIONS THROUGHOUT the hemisphere share common values and face similar challenges in developing sustainable economies. This issue focuses on analysis of environmental and developmental issues from indigenous perspectives and includes articles prepared for the Rio Summit (UNCED '92). Rebecca Adamson, Winona LaDuke, Martha Johnson, Garnet Joseph, Simon Brascoupé, John Mohawk, and others incorporate traditional knowledge into the discussion of potential solutions for environmental and economic problems.

9:2 SUMMER 1992. 112 PP. $10.00

INDIAN CORN OF THE AMERICAS: GIFT TO THE WORLD

INDIAN CORN
of the AMERICAS
Gift to the World

CORN—PERHAPS THE MOST significant American Indian contribution to world civilization—holds deep spiritual and cultural meanings for Indigenous peoples. This volume—based on the proceedings of a conference held at Cornell University in 1988—explores corn's many layers of importance through tradition, myth, agriculture, economics, and language.

6:1, 2 SPRING/SUMMER 1989. 96 PP. $10.00

❑ **1:1 Spring 84**◆*Indian education, Akwesasne pollution, Floyd Westerman, Land claims, Women's thread.*[†]

❑ **1:2 Summer 84**◆*Appeal to justice, Mayan ways, Women's nutrition, Research ethics, Rights of Indigenous peoples.*

❑ **1:3 Fall 84**◆*An Elder's concern, Development through appropriate technology, Ecuador, Archaeology and Native Americans.*[†]

❑ **2:1 Winter 84**◆*Old Indian nutritional ways, Indians and sugar, People, resources and communities, Language of survival.*

❑ **2:2 Spring/Summer 85**◆*Erl Bates file, Assimilation of the Iroquois, Breastfeeding and toxic contaminants, Indians and computers, Indians and U.S. Law.*

❑ **2:3 Fall 85**◆*Gardening and language, Honoring Corbett Sundown, Photography, Women's dance, Vanishing Indian stereotypes, Land, language, and culture.*[†]

❑ **2:4 Winter 85**◆*Indian burial sites in New York State, Gannagaro, Renewing Native language, Family album, Message from the Tadadaho.*

❑ **3:1 Spring 86**◆*Oren Lyons on lacrosse, Maine tribes reject nuclear waste, Native language preservation, Northeastern Indian Centers, Akwesasne environments.*

❑ **3:2 Summer 86**◆*Contemporary Iroquois art, Fishing rights and the Voight decision, Piscataway burial traditions, Pennsylvania Indian day, Origins of Iroquois political thought, Honoring Johnson Jimerson.*

❑ **3:3 Fall 86**◆*Iroquois confederate law and the U.S. Constitution, State accreditation for Seneca language, Permaculture design, Life and agriculture of early Iroquois, Review of Lost and Found traditions: 1965-1985.*

❑ **3:4 Winter 86**◆*Resource Guide for New York State.*

❑ **4:1, 4:2 Spring/Summer 87**◆*Press Freedom in Indian country, Europe meets the Indian mind, Native seeds, Gifts of the maple, Images of Indians.*

❑ **4:3 Fall 87**◆*Jake Swamp and the Tree of Peace movement, Iroquois Thanksgiving address, Last speech of Deskaheh, Founding belts of the Confederacy, Franklin and the Iroquois, Enlightened French view of American Indians, Continuity of Haudenosaunee government, Selected reading on Iroquois contributions to U.S. Constitution.*

❑ **4:4, 5:1 Winter 87/Spring 88**◆**Indian Roots of American Democracy.** *Special double issue covering influences of Iroquois Great Law of Peace on the American Constitution. (Available as paperback book. Price: $12.00.)*

❑ **5:2 Summer 88**◆*First Indian free press, Lumbee country photographs, Poetry of Barney Bush, Native people's exhibits at New York State Museum.*

❑ **5:3 Fall 88**◆*Portraits of life along the St. Lawrence River in the 20th century, Toxics in the St. Lawrence, Iroquois soldiers in the Civil War.*

❑ **5:4 Winter 88**◆*A Piscataway oral history, Vox Americana, Native media environments, Genesis of American Indian journalism, Snowsnakes.*

❑ **6:1, 6:2 Spring/Summer 89**◆**Indian Corn of the Americas—Gift to the World.** *Special double issue on the most significant American Indian contribution to world civilization. **

❑ **6:3 Fall 89**◆*Interview with George Longfish, Iroquois gambling controversy, Carlos Nakai, Ownership of traditional information, Native American contributions to democracy.*

❑ **6:4 Winter 89**◆*Follow-up issue to Indian Roots: latest findings on the influence of Iroquois on American Constitution,*

Poetry by Roberta Hill Whiteman.

❑ **7:1 Spring 90**◆*Wampum issue: Return of the wampum, Views of the Two Row wampum, Wampum belts as living symbols, Cayuga Indian festival, Wounded Knee 1890.*

❑ **7:2 Summer 90**◆*Native American perceptions of the environment, Religious freedom and land management, Interview with Dennis Sun Rhodes.*

❑ **7:3 Fall 90**◆**A View From the Shore—American Indian Perspectives on the Quincentenary.** *American Indian stereotypes, The cost of Columbus, Survey results, Resource guide, Carib gallery, Notes on Tainos, Art and literature of encounter, and more. Special double size issue.**

❑ **7:4 Winter 90**◆**Unbroken Circles—Traditional Arts of Contemporary Woodland Peoples.** *A survey of many arts including storytelling, beadwork, cornhusk dolls, antler carving, textiles, basketmaking, Condolence Canes and urban art. Special double size issue.**

❑ **8:1 Spring 91**◆*Treaty rights in Wisconsin, Chippewa off-reservation treaty harvest, Internal politics in the 1990 crisis at Kahnawake, Agricultural survey of New York State Iroquois.*

❑ **8:2 Summer 91**◆*Black walnut on Iroquoian landscapes, James Bay Hydro-electric project, Beaded hoods, Reburial of American Indian remains, Naskapi tales, The good mind.*

❑ **8:3 Fall 91**◆**Literary Issue.** *A collection of new fiction and poetry from fourteen Native American writers. Includes book reviews and a critical essay.* [Δ]

❑ **8:4 Winter 91**◆**James Bay Reader.** *Articles on the Cree of the James Bay region of northern Quebec and the effects of hydro-electric power development on their way of life.* [Δ]

❑ **9:1 Spring 92**◆*Iroquois Influence on women's rights, Language of museums, Columbus in history, Origins of the pledge of allegiance, New poems.*

❑ **9:2 Summer 92**◆**Indigenous Economics: Toward a Natural World Order.** *Fourth world analysis of environment and development issues, including articles prepared for the Rio Summit (UNCED '92).**

❑ **9:3 Fall 92** ◆ *Native Americans and Environmental Thought, Thanksgiving Address: An Expression of Haudenosaunee Worldview, Tribal Decision-Making. Also stories, essays.*

❑ **9:4 Winter 92** ◆ *Interview with National Museum of the American Indian Director Richard West, Review of Pathways of Tradition, Interview with Ray Youngbear, Reviews, stories, poetry, Commentary.*

❑ **10:1 Spring 93** ◆ *Interview with Norton Rickard, Legal Basis for Iroquois Land Claims, Interview with Anishnabe Artist George Morrison, Papers from Returning the Gift Conference, Poetry.*

❑ **10:2 Summer 93** ◆ *Interview with Maidu Artist Harry Fonseca, Native Women's Dialogue, Native Voices and the Diffusion of an Idea, Poetry, Children's Book Reviews.*

❑ **10:3 Fall 93** ◆ *Nuclear Waste in Indian Country, A Talk by Reuben Snake, Portrait of Artist Phil Young, James Bay Update, Poetry, book reviews.*

❑ **10:4 Winter 93** ◆ *Return of Sacred Textiles, Indians and Children in Education, Economic Development and Intellectual Property Rights, Recharging Mayan Traditions, Poetry, book reviews, review essay.*

____ back issues @ $5.00 plus .50 postage $_____

____ copies of *Indian Roots* @ $12.00 plus $2.00 postage $_____

____ special issues @ $10.00 plus 2.00 postage $_____

____ readers @ $8.00 plus $2.00 postage $_____

***special issues:** *Indian Corn of the Americas, View From the Shore, Unbroken Circles, Indigenous Economics*

Δ **readers:** *Literary Issue, Readings on James Bay*

† *indicates issue available in photocopy only.*

300 CALDWELL HALL•CORNELL UNIVERSITY•ITHACA, NY 14853 •PHONE: (607) 255-4308•FAX: (607) 255-0185